Feminist Ethics in Film:
Reconfiguring Care through Cinema

For Judy

Feminist Ethics in Film:
Reconfiguring Care through Cinema

Joseph Kupfer

intellect Bristol, UK / Chicago, USA

First published in the UK in 2012 by
Intellect, The Mill, Parnall Road, Fishponds, Bristol, BS16 3JG, UK

First published in the USA in 2012 by
Intellect, The University of Chicago Press, 1427 E. 60th Street,
Chicago, IL 60637, USA

A catalogue record for this book is available from the
British Library.

Cover designer: Holly Rose
Copy-editor: MPS Technologies
Production manager: Jelena Stanovnik
Typesetting: Planman Technologies

ISSN 978-1-84150-406-3

Printed and bound by Hobbs, UK

Contents

Introduction

Films can do more than entertain us. They can prompt and sustain philosophical reflection on important aspects of human experience and the ethical theory that is meant to inform it. Of course, we have always had our share of serious cinema that paralleled good literature. Films that shed light on the moral complexities of the human condition in the same way that novels, such as those of Tolstoy and Austen, have long invigorated philosophical analysis of such subjects as betrayal, forgiveness, and love. The depth of well-developed narrative examples furthers reflection on moral life. This book, however, examines the ways in which popular film, rather than art house or foreign cinema, conveys and configures a particular philosophical view—the ethics of care.

The cinematic stories presented in these mass-marketed movies can go beyond providing helpful auxiliaries to philosophical theorizing. As Alasdair MacIntyre persuasively argues, narrative may be essential for moral understanding. Actions become intelligible only when we can situate intentions and purposes within "a concept of a self whose unity resides in the unity of a narrative."[1] The intelligibility of the concept of personhood requires a history, a narrative, within whose structure we can locate the individual responsible for action. And such intelligibility is presupposed by moral philosophy.

The rounded portraits of humanity found in film narrative are even more critical to the ethics of care. It is fair to say that without the concrete quasi-biographies of fiction— of film and literature—the ethics of care is inconsistent with itself or radically incomplete. Recall that care ethics de-emphasizes universal principles in abstraction from particular individuals and the contingencies of their relationships. Because caring is always a response to the needs of particular persons in their determinate circumstances, narrative becomes paramount. Analyzing care in the context of a variety of cinematic stories grounds the philosophy in the concrete lives, relationships, and responses that feminist ethics itself both commends and requires. But before delving into the interplay between film and philosophy, we should review the ethics of care.

The ethics of care

The general orientation of care ethics has been around at least since the sermons of the New Testament. And central tenets of the theory, such as the social nature of the self, have been the mainstay of philosophers from Hegel to Habermas. However, during the past few decades, care ethics has blossomed as a unified approach to moral issues and human flourishing. Under the aegis of feminist philosophy the ethics of care has woven together different strands of theory and moral psychology, and addressed a range of moral issues. The perspective of care arose as an antidote to approaches that took the isolated individual as their starting point and emphasized abstract principles such as those defining justice and rights. For such approaches, obligations arose as a result of the voluntary choices of independent agents, most prevalently in the case of contracts.

Instead, care ethicists focused on interpersonal relationships, stressing the particular individuals in the relationships, their needs and history. Morality turned upon the ability of people to respond to one another's needs and interests in their contingent circumstances. Many of these relationships are not chosen by the individuals in them, such as those structured by family, work, or community membership. Contrary to the perspective of justice and rights, then, virtues that clustered around personal strength or sufficiency were deflated in the ethics of care. Rather, virtues integral to affiliation and support gained ascendancy; sympathy, attentiveness, and responsiveness came to be considered core features of the attitude of caring. In addition, care takes as its starting point connectedness rather than the separation underlying an ethics of individual rights or justice.

As care ethicists responded to criticism and reevaluations of its basic commitments, several changes occurred. Of particular interest in the present context are the shifts in the scope of the theory and its treatment of autonomy. The first involved expanding the purview of care beyond the intimate spheres of family and friendship. In its early phase, care theory was content to relegate investigation of the public sphere to other ethical views such as Kantianism or Utilitarianism. A division of theoretical labor saw care theorists focus on the complexities of face-to-face relationships, while conceding macro social issues to theories that implemented abstract principles and policies.

More recently, however, philosophers have begun to question, and reject, the view that allocates the public realm to justice while consigning the private domain to care. Feminists and others have argued that questions of justice do indeed arise in the private sphere and that the care perspective is vital to public affairs. Susan Moller Okin, for example, shows why considerations of justice must be brought to bear on the personal interactions of family. She persuasively argues that unless we incorporate considerations of justice into our analysis of the so-called private life of the family, women and children will continue to be oppressed and exploited.[2] Still other ethicists have gone in the opposite direction, applying the care ethics to public policy and practice. Proceeding from the maternal thinking that exemplifies care, Sara Ruddick draws out the implications of the care ethics for international politics, war, and prospects for peace.[3] Grace Clement develops Ruddick's

views on political pacifism, but also proposes a public ethics of care in her investigation of the public funding of long-term provisions for the elderly.[4]

Along with the shift that enlarged care ethics to include the social and international arenas, many proponents of care have ceased to regard autonomy as hostile to it. Associating autonomy with the liberal tradition and its emphasis on the isolated, contracting individual, care ethicists initially opposed care to autonomy (as well as to justice and rights).[5] Perhaps because philosophers simply realized that the ability to think and act for oneself is truly valuable in ordinary life, they reconceived autonomy to fit more snugly within the care ethics. Following the social conception of the self, then, feminists reexamined autonomy for its relational aspects. At its most extreme, social relations were said to constitute autonomy. For example, Marilyn Friedman writes that autonomy is "itself [simply] the capacity for a distinctive form of social and, in particular, dialogical engagement."[6]

Such a view seems too strong and overly restrictive since autonomy includes the ability to do many things besides interact socially. For example, autonomy is instrumental in deciding on a career, whom to marry, and how to invest our wealth. Social relations do not exhaust the meaning of autonomy. As we will see, even feminists view autonomy as a set of competencies that are conducive to independence in thought and action, and those competencies are in the possession of individuals—however socially situated they may be. Nevertheless, the emphasis on the tie between personal relationships and autonomy points the discussion in a productive direction. We certainly need to heed the ways in which interpersonal life can both foster and impede an individual's autonomy.

So, far from being antagonistic to care, autonomy seems essential to establishing and maintaining worthwhile relationships. Grace Clement, for example, notes the importance of autonomy to healthy caring relationships.[7] Only if the members of a friendship, for instance, possess roughly equal autonomy will they be able to function as genuine friends: helping, encouraging, criticizing, and questioning. Unless the relationship is imbued with mutual autonomy, one or more of the individuals in the relationship is liable to be exploited, oppressed, or dependent in a debilitating way.

Although theorists have differed with regard to the details and implications of the relational conception of autonomy, most agree that autonomy begins with a set of competencies. Diana Meyers argues that the autonomous person will have developed "a repertory of skills through which self-discovery, self-definition, and self-direction are achieved."[8] Inter-subjectivity is relevant even at this basic level of competencies or skills, moreover, because our various relations with other people can be decisive to our range of choice. Caring relationships further our autonomy even as oppressive relationships, such as those driven by racism, obstruct it.

The dependence of autonomy on relationships with others includes the processes by which we reflect on ourselves and make our decisions. Much serious self-reflection and decision-making requires caring relationships buttressed by trust, sympathy, and unselfish concern. As Linda Barclay observes, "Our ongoing success as an autonomous agent is affected by our ability to share our ideas, our aspirations, and our beliefs in conversation

with others."[9] Most of us require a caring upbringing to develop the competencies of autonomy, but the need for others continues into adulthood. We also need people we trust to help us examine our values, make important decisions and critically assess our social norms. Competence in critically assessing the norms of our society is pivotal in feminist ethics because the care-giving typical of women has often been reinforced by roles and norms that entail their subordination and exploitation. Critical assessment is needed in order for women to have a chance at extricating themselves from second-class status.

Besides addressing these major shifts in care theory, the expanded scope of care along with relational autonomy, analysis of the films featured in this book will elaborate upon our understanding of the traditional elements of care. A brief review of those components should pave the way for an overview of how the films contribute to our understanding of the care perspective. We will canvas the following topics that have been the staples of care theory: the social self; the virtues of care; family and friendship.

The social self

Within care theory, the conception of the self as social has meant several things. Among them is the notion that our identities are the result of our relationships with other people. The ability to understand ourselves as individuals, for example, presupposes human relationships, as well as a minimal level of care within them. As Hegel points out, we learn to understand ourselves by discovering how we are viewed by others. Our self-conception, then, is freighted with the conceptions other people have of us. Hegel argues, "The individual finds concrete duties and social situations, which are what they are, before he entered them and which offer opportunities and demand fulfillments."[10]

Construing our identities as social can also mean that we view personal identity as fundamentally constituted by our relationships with other people. Virginia Held notes, "Every person starts out as a child dependent on those providing us care, and we remain interdependent with others in thoroughly fundamental ways throughout our lives."[11] To change who we are, as Hank does in *Monster's Ball*, requires changing our relationships with other people because "our relations are part of what constitute our identity."[12] Crucial to this identity are the ends that direct our thought and govern our action. These ends are socially shared as well as socially derived.[13] The social character of our goals will prove to be pivotal in Hank's self-transformation, as he must distance himself from his long-held ideals and the particular social relationships that support them.

Besides influencing the ends that we pursue, interpersonal relationships also shape our habitual modes of thought, action, and emotional response. Whether we are even disposed to care about other people is itself a matter of our entrenched forms of social interaction. We will see how several films draw upon the way habitual modes of feeling and interaction are engendered by social relationships. The self is also socially constituted by virtue of our identification with other people. Incorporating the values and interests of others into our

own identities often occurs unwittingly, through family life and group affiliation. But crisis may move us to self-consciously identify with another individual's dominant concerns. The cinematic interpretation offered here reveals how identifying with another individual can be either liberating or stultifying with regard to personal growth.

The virtues of care

Philosophers working within care theory typically draw on the virtues of attentiveness, responsiveness, and sympathy. These are, after all, the staples of mothering from which care theorists take their bearings. Attentiveness may be demanding, requiring a serious, sustained effort of looking and listening. The effort demanded may also involve asking questions or putting ourselves in position to see what is easily missed. The ability to respond constructively to the needs and aims of other people typically presupposes attentiveness. Otherwise we are liable to offer simply what we think or wish would benefit others. Complementing the work of attention and responsiveness is a sympathetic imagination. Nel Noddings describes such sympathy as a "feeling with" the other person, a receptivity or openness to what the other person is going through.[14] The sympathetic imagination is needed to link attentiveness with responsiveness. Only by being imaginatively receptive to what other individuals are experiencing can our listening and looking yield a helpful response, one that is suited to the actual needs of the individuals in their particular situation.

As we examine our films, we will see how these building blocks of care figure in the lives of various characters. Where they are in full force, we see how individuals are able to do a good job of caring for others and themselves. Several of the films also show the repercussions for individuals who are deficient in attentiveness, responsiveness, or sympathy. We see, in very concrete terms, how lack of care for others often stems from preoccupation with oneself. The causes for self-involvement are myriad and stories provide specific bases for this all-too-common reason for the inability to care for others.

Family and friendship

The *locus classicus* for discussions of care are the everyday spheres of intimacy—friendship and family. Recall that care ethicists initially sought to remedy the tendency of the dominant ethical theories to apply universal principles to types of actions detached from context, relationships, and personal identity. Where better to find particularity than in the idiosyncrasies of family life and the permutations of friendship? Yet here, too, much work remained to be done. For example, how best to characterize the parent–child relationship or how explain the duties or prerogatives of friendship?

With the introduction of autonomy into the care model, the issue of parental nurture of children's independence gains in prominence. As children develop, their efforts at

self-exploration and understanding need parental support and encouragement. For children, the dimension of autonomy that is most pressing is authenticity: the ability to understand and define oneself. The challenge of helping our children develop authentically into their own persons faces the obstacles of undue parental influence and childhood dependence. Although we can articulate general precepts to the effect that parents ought not be overly restrictive or censorious, there are no recipes for promoting the authenticity of our children. This is why the details and temporal aspects of narrative are indispensable in fleshing out the implications of care for the parent–child relationship. For example, other virtues will be needed besides the foundational care virtues of attentiveness, sympathetic imagination, and responsiveness. Parents will need to be generous, sometimes with money but often with non-economic resources such as time or thought. Parents will inevitably have to be emotionally generous, giving of their own emotional resources or providing the opportunities for their children to receive such emotional benefits as self-confidence, compassion, or the satisfaction of being generous themselves.

Along with the joys and comforts of friendship come responsibilities and obligations. The demands and limits of help, so basic to care, is a case in point. Some proponents of care endorse the adage made famous by Marx (first coined by French Socialist Louis Blanc): From each according to ability, to each according to need. The precept counsels determining giving favors and receiving them on the grounds of mutuality; need and the ability to meet it are all that matters. Mutuality is understood as preferable to reciprocity, in which favor-giving creates debts, which the recipient is obliged to repay. Care ethicists have been attracted to mutuality because it turns upon the particular contours of the lives of the friends rather than the impersonal abstractions of credits and debits found in marketplace accounting.

As with family, general maxims will only take us so far in understanding the complexities of friendship. Questions of how to provide help and which friend is in the best position to do so surely cannot be answered independent of the nature of the friendship, its alterations over time, and the people in it. Those with more ability to give (wealth, knowledge, skill) may err on the side of giving too much, at the wrong time, or in the wrong manner. Inequality can, and often does, create problems in coming to the aid of friends. There are all sorts of inequalities: from wealth to happiness, from occupational satisfaction to virtue.

Various inequalities will create different impediments to the friendship as well as to the expression of care within the friendship. For instance, even though one friend is much wealthier than another, given the history of the relationship, it may be inadvisable to give as much as is needed, as the precept commends. Problems of dependency or resentment might arise, contingent on the makeup and narrative of the relationship. Similarly with disparities in work or family life. To understand how friends navigate or fail to navigate such discrepancies requires immersion in extended examples—in the sort of stories found in a popular film such as *Friends with Money*.

Among the charges of friendship is the delicate matter of giving criticism or advice. Again, care is found in the details. Relevant to what criticism or advice to give, and how to present it, are the specifics of what the friends are experiencing in their lives—separately

as well as in the relationship. Even if a friend may have good ideas with regard to child-rearing, for example, the fact that she is childless or has a superstar for a child may indicate that she is not the one whose response will be most welcomed or heeded. Conversely, someone who is struggling at work may not be in the best position to offer advice or criticism to a friend who must make a difficult decision about her career.

It may be fairly obvious that in discussing family and friends, care ethics must take into account the texture of the particular as opposed to the abstractions of universal principles. We have to situate the needs and interests of families and friends in contexts that will enable the care perspective to yield insights. Yet even on the bigger stage of social and international problems, the role of narrative is important. The distinctive history of the group, community, or state continues to exert a strong influence in the moral analyses offered by care ethicists. For example, examining crime and punishment in the United States may require taking into account the history of racism in this country, just as the caste system of India conditions relationships within it.

The interplay of film and philosophy

The crucial role of narrative in care ethics points to the special value of the narrative arts, such as film, in understanding various aspects of the theory. For it is by reference to the concrete details of these stories that we round out the care approach to moral life. A theory that lays such importance on relationships as well as their development over time has a unique need for narrative to contextualize and ground its general views.

As we proceed, we will see that examining film will do more than simply illustrate features of the ethics of care. Interpreting these half dozen popular films from the perspective of care will broaden our understanding of the theory by evoking a fuller and more nuanced appreciation of its necessarily general claims and qualifications. Because of modifications and extensions of care theory wrought by viewing it through the lens of film appreciation, we can speak of reconfiguring our conception of care as an evolving philosophical view.

At the same time, the perspective of care will enhance our appreciation of the movies. Emphasis on the components of care will bring out and organize features of the films that would otherwise be missed altogether or receive scant attention. The philosophical substance of the films articulated in their interpretation will add depth and, in some cases, unity to their aesthetic enjoyment. But because our interest in these films is primarily philosophical, the contribution of care to cinematic enjoyment will tend to remain more implicit and less foregrounded. The following are a few of the theoretical areas of care that are developed and repositioned by applying the theory to film interpretation.

As befitting a philosophical viewpoint that sees narrative as central to the ethics of care, we will explore the way the ability to create narratives can be crucial to realizing several basic values in care. We will see how envisioning a narrative for oneself facilitates

autonomous functioning and, consequently, to caring for oneself. In *Saturday Night Fever*, for example, the protagonist, Tony Manero, has to resist and reject the narratives for him that are being thrust upon him by family, friends, and employer. He has to keep these competing accounts at bay, moreover, before he has a clear conception of the narrative he will fashion for himself. In a similar vein, Hank Grotowski (*Monster's Ball*) must disavow the narrative that he has previously chosen to shape much of his adult life. He too is not sure of the new direction his future should take; however, he realizes that it will include the very caring relationships that have been missing from his life to date.

Imagining a narrative for oneself requires in itself a certain degree of autonomy. Consequently, we see Hank exercise his autonomy to embark on an open-ended narrative for the sake of the values of care, including sympathy, attentiveness, and responsiveness to the needs of others. Yet the story also discloses, in negative fashion, the social dimensions of autonomy. Hank's black female counterpart, Leticia, is unable to function autonomously. She is handicapped precisely because she lacks the family, friends, or community through which we develop and exercise the competencies needed for autonomous deliberation and action. The films thereby develop the role of narrative within care theory, as well as reciprocal dependencies between care and autonomy.

We also see that various moral virtues are enmeshed in care. First, a cluster of virtues are needed in the efforts at self-care. Courage and integrity are needed to assert oneself against countervailing pressures and obstacles that stand in the way of caring for oneself. At the same time, honesty with oneself and the ability to recognize dishonesty in others are also needed to avoid settling for less than healthy relationships. Providing care for other people also presupposes several virtues. We will see in films involving parenthood that caring for children demands humility and generosity, in addition to the traditional care virtues of attentiveness, responsiveness, and sympathy.

In *The Squid and the Whale*, we watch a father incapable of truly paying attention to his children because he is too self-absorbed. Preoccupation with himself also keeps Bernard from giving freely—whether it is books, time, emotion, or even money. The film furthers our understanding of care by showing how the non-material generosity of heart is a foundation for truly caring for those we love. Generous-heartedness involves giving of our own emotional strength, or giving non-materially for the sake of the emotional security or satisfaction of others. The story of the Berkman family is especially clever at combining lack of generous-heartedness with economic stinginess in the character of Bernard.

Central to the ethics of care is the social nature of the self; however, not much attention has been paid to the ways in which social relationships can prove detrimental to personal growth. *The Squid and the Whale* investigates in particular how the parent–child relationship can obstruct autonomy through the workings of identification. Of course, some identification between children and parents is inevitable and often beneficial to the child. But in the film, one of the boys is hampered by what we could consider over-identification. Walt's over-identification with his father keeps him from self-discovery and self-definition that comprise authenticity, which is an important dimension of autonomy.

At the heart of the ethos of care is providing help to others, especially friends. Recall the maxim that commends giving according to ability and receiving according to need. Subscribing to the maxim is natural, that is, until we reflect on how it might be realized in concrete situations between particular people, actual or fictional. *Friends with Money* provides a window into the subtleties and pitfalls of trying to help our friends. The story homes in on problems of inequality, most conspicuously in wealth, but also with regard to fulfillment and independence. How do we help a friend who is struggling financially without fostering dependence? How do we help a friend, including a spouse, out of a prolonged malaise? The film explores the nature of constructive criticism and the Kantian notion of sharing ends, all the while keeping one eye on that touchstone of care—attentiveness. With humor and pathos, *Friends with Money* underscores the importance of truly seeing and hearing what our friends are experiencing. The story also unobtrusively reveals how the act of expressing care or concern can itself be an essential ingredient in care.

To be adequate, an ethics of care must go beyond family and friendship to investigate the place of the individual in the larger community. After all, we do not live exclusively in the company of those with whom we share intimacies and a personal history. Participating in school, neighborhood, and town is essential to personal growth. The film *Radio* investigates how developing moral virtues and talents, as well as expressing them, is entwined in the fabric of communal interaction. The title character is a mentally challenged, albeit high-functioning, young man. By focusing on an extreme, the film illuminates the importance of community for care in the ordinary case of the typical citizen. Paralleling the narratives that the characters create for themselves in *Monster's Ball* and *Saturday Night Fever,* the football coach in *Radio* fashions a narrative for his friend that emphasizes inclusion: in the football program, the school, the whole town. Coach Jones intuitively grasps that without inclusion in social life, Radio will not thrive, either personally or morally.

The film also deals with the tension between the ethics of care and the perspective of rights and fairness. In *Monster's Ball*, the plotting indicates that appeals to rights may be overridden or bypassed in favor of considerations of care. But in *Radio*, we see that the rights and needs of the majority cannot always be dismissed or suspended in favor of caring. Instead, the rights of the members of community must be balanced against the requirements of caring for the more needy individual. The interests of Radio have to be negotiated within the legitimate demands of the group, and this takes sacrifice and a bit of creative thinking. The civic lesson from the film is that the ethics of care may require creativity to accommodate an individual with special needs without ignoring the rights and interests of others. The importance of adapting to the contingencies and exigencies of context is writ even larger in the film *Gandhi*.

The character of Gandhi embodies the care perspective at the level of the nation-state. Pursuing independence from Britain and equality within India, Gandhi demonstrates how the ethics of care is more than merely compatible with the aims of justice. The film suggests that various elements of justice may best be achieved within the purview of the

ethics of care. For Gandhi the only morally acceptable way to change the law is non-violent resistance. Only non-violence treats the oppressor in a respectful, caring way, and only non-violence keeps the protester from descending into the viciousness that violence produces. Moreover, non-violence forces the oppressors to pay attention to the criticisms directed at them and encourages rational discussion instead of furthering violence.

From the outset, Gandhi's strategy expresses his intention to engage the British as participants in an ongoing relationship. The importance of inclusiveness moves Gandhi to eradicate the stigma of the Untouchables and to strive for harmony between the factious Muslim and Hindu populations. Unlike most of the educated elite of India, Gandhi's chief concern is meeting the basic needs of the impoverished masses. Before he can respond to the problems of the peasants, however, Gandhi must understand them; he must be attentive.

An ethics of care upholds meeting needs within the relationship as a primary responsibility. British dominance is thereby translated by Gandhi as failure to meet the central requirements of a caring relationship. Economic protest and independence, as in the making of salt and reliance on homespun rather than British manufacture, issue from the perspective of care that takes responsibility for meeting basic needs.

Overall structure of book

Each of the six substantive chapters presents an interpretation of one popular film working at a progressively larger scale from within the ethics of care. As we proceed through the book, the frame of interpretation enlarges, moving from the individual to the nation-state. The analysis of *Saturday Night Fever*, for example, is shaped by considerations of self-care for the individual and the importance of narrative to it. The focus is on the protagonist, Tony Manero, and his social interactions with family and friends, at work and dance. We see a young man begin to figure out who he wishes to become, creating the outlines of a narrative for himself.

Introduced in the story of Tony, the intimate spheres of family and friendship are then explored in greater depth in *The Squid and the Whale* and *Friends with Money*. The first shows the importance of care negatively, by means of its absence in the familial interaction among the Berkmans. Of particular importance is the failure of the parents to nurture the authenticity of their sons as the family is torn apart by the parental separation. Not only does the story indicate the virtues of care, but it also investigates the risks that arise from the social nature of the self.

As its title suggests, *Friends with Money* is indeed about friendship. The movie delves into the difficulties that surround trying to help our friends, give constructive criticism, and provide needed support. The story portrays these difficulties against the backdrop of various inequalities between the friends, including inequalities in family life, contentment, and of course money. By creating definite characters in different circumstances but with a shared history, the film discloses both the bonds and limits of friendship.

Monster's Ball serves as a bridge from films about self, family, and friendship to stories that situate care within community and country. The interpretation of the film offered here emphasizes the transformative power of care for the individual and for his relationships with others. The deficient parenting of Hank and Leticia echoes the parental failure to care found in *The Squid and the Whale*; however, the story provides a counterpoise to their unsuccessful parenting with a subtly wrought, yet penetrating example of a caring parent. The story of Hank Grotowski also turns our attention toward community by virtue of the prison in which Hank and his son work, and which houses Leticia's husband. Prison is examined from the care perspective as a social institution, including its influence on the lives of the people who work and are incarcerated in it.

As indicated, *Radio* and *Gandhi* portray the importance of care in the context of community and country. The former shows how social interaction beyond friends and family is needed for the individual to flourish. We develop our talents, pursue our goals, and express our moral virtues within the daily give and take of community. Exclusion from communal life is stunting for everyone, not just people who are slower of thought such as Radio. The importance of inclusion is revisited on a still greater scale by Gandhi. For him, all the people of India must be included in political decisions, and even the alien power, the British, should take part in the process by which India gains her freedom. Unlike most of the Indian intelligentsia, Gandhi's main aims for India arise from care: to meet the needs of its people, with whom Gandhi creates an enduring relationship. It is a relationship founded on the mutuality of care and informed by attentiveness, responsiveness, and a sympathetic imagination. Thus, the film demonstrates in very concrete terms how the basic features of the care ethics, originally understood within the private patterns of family and friendship, can be extended to the nation-state, and beyond.

The book is written to be read as a whole, to encompass the widening scope that expands from the individual to family, friends, community, and finally reaching the level of the state. However, the chapters can also stand alone, making the work amenable to readers who wish to pick and choose as the interest or mood suits them. This introduction is designed to accommodate such selectivity, yet some repetition among the chapters is still required lest the reader be without the theoretical resources needed for the most philosophically and aesthetically satisfying outcome. In the spirit of care ethics, the organization of the chapters as integrated yet with relative independence from one another is meant to respond to the needs and interests of the reader.

Notes

1. Alisdair Macintyre, *After Virtue* (Notre Dame, IN: Notre Dame Press, 1981), p. 191.
2. Susan Moller Okin, *Justice, Gender and the Family* (New York: Basic Books, 1989).
3. Although Ruddick does not define care as maternal thinking, her analysis of maternal thinking seems in large part to inform the conception of care that she offers. Ruddick does

claim that "the work of mothering is a central instance and symbol of care," and "the notion of 'caring labor' lends itself to feminist labor politics." Sara Ruddick, *Maternal Thinking: Toward a Politics of Peace* (Boston: Beacon Press, 1989), p. 46.

4. Grace Clement, *Care, Autonomy, and Justice* (Boulder, CO: Westview Press, 1996).

5. Among familiar care ethicists who opposed care to theories centered upon autonomy or justice are: Nel Noddings, *Caring, A Feminine Approach to Ethics and Moral Education* (Berkely: University of California Press, 1984); Virginia Held, *Feminist Morality* (Chicago: University of Chicago Press, 1993); and Lorraine Code, *What Can She Know?: Feminist Theory and the Construction of Knowledge* (Ithaca, NY: Cornell University Press, 1991).

6. Marilyn Friedman, "Autonomy, Social Disruption, and Women," in *Relational Autonomy*, eds. Catriona Mackenzie and Natalie Stoljar (Oxford: Oxford University Press, 2000), pp. 35–51, 40–41.

7. Grace Clement, *Care, Autonomy, and Justice*, pp. 35–36.

8. Diana Meyers, "Intersectional Identity and the Authentic Self?" in *Relational Autonomy*, pp. 151–180, 174–175.

9. Linda Barclay, "Autonomy and the Social Self," in *Relational Autonomy*, pp. 52–71, 57.

10. G. W. F. Hegel, *Encyclopedia of Philosophy*, trans. and annot. by Gustav E. Mueller (New York: New York Philosophical Library, 1959), pp. 245–246, Sect. 431.

11. Virginia Held, *The Ethics of Care: Personal, Political, and Global* (Oxford: Oxford University Press, 2006), p. 14.

12. Ibid.

13. Linda Barclay, "Autonomy and the Social Self," pp. 61–62.

14. Noddings actually sees such receptivity as comprising a part of the attentiveness that is distinctive of care, *Starting at Home: Caring and Social Policy* (Los Angeles: University of California Press, 2002).

Chapter 1

Saturday Night Fever: Self-Care, Moral Growth and Narrative

I. "Stayin' Alive"

Sure, the bell-bottom pants, platform shoes, and layers of gold chains may be out of date, and the music may no longer dazzle the way it once did, but the story is a good one. What is more, the music still pulses with dance, and the lyrics, like a Greek chorus, comment on the protagonist's trials and tribulations. The fever of the title is just that—the hot grip that dancing at the local disco club has on the young adults who are the main characters of the story. Tony Manero (John Travolta) in particular spends his weekdays living for Saturday night. Through the character of Tony, the film investigates the importance of personal narrative to self-care, autonomy, and moral growth. Woven through the dancing and teenage angst, then, is a moral fable of emerging self-awareness and the hurdles one must face when taking responsibility for his or her future.

Tony's life consists of three social spheres: work at the paint store; home with his family; and play with his pals, with whom he hangs out and goes to the disco club. By the end of story, Tony will have distanced himself, permanently in some cases, from each of these areas of his current life. Each sphere harbors questions of moral personality and narrative for Tony, questions that the ethics of care can shed light on. The paint store will pose the question of what Tony will make of himself in the competitive world of work. Dance provides one possibility; as it is also the stage of Tony's artistic self-expression, it most dramatically engages his personal values and virtues. Because Tony's nights out dancing include his friends, they comprise a sphere of life from which Tony will have to break free if he is to take his future seriously. Tony's home life brings him into conflict with the entrenched view of him that his parents try to impose on him. As the movie progresses, we watch Tony's moral personality evolve in these three areas of his life as a result of observing the experiences of other people and taking stock of the likely trajectory of his own fate. The narrative of his future grows in concert with the development of Tony's moral traits, including his self-awareness.

Yet for Tony to create a viable narrative for himself, he must resist the narratives that the individuals in these three areas of his life both endorse and try to foist on him. In each

case, the narrative suits the purposes and serves the needs of the people with whom Tony has a relationship. At work, Tony's boss offers the prospect of Tony making a career of working for him. Tony's friends revel in the narrative of him as the king of disco dance, and his parents project an image of him as the inferior complement to his successful, older brother.

Care ethicists have put a premium on the role of narrative in articulating the morally salient features of social relationships and personal decisions. From the point of view of the philosopher who is assessing a moral situation, narrative is more important than universal principles in figuring out what is important and what constitutes a morally sound choice. The theorist is to locate the agents and their actions within a narrative that does justice to the particular people and their relationships. However, *Saturday Night Fever* demonstrates that narrative can play a pivotal role for the individuals who are actually in the situation. The story of Tony Manero indicates that constructing a workable narrative for oneself may be essential for both successful self-care and for autonomous living. The theme of creating a narrative for oneself will be further elaborated upon in *Monster's Ball*.

Saturday Night Fever illustrates the claim by Alisdair MacIntyre that narrative is essential to self-understanding. By providing a continuous subject of our different experiences, a personal history enables us to make sense of diverse and divergent episodes in our lives. For example, actions that we perform in various contexts, for a variety of reasons, make sense only when framed within a narrative unique to us. By connecting otherwise disparate actions and events, "we understand our own lives in terms of the narratives that we live out."[1] Stories about individuals establish an ongoing reference to what are, in themselves, separate and discrete episodes. Narrative links these episodes together as both the effects of an identical person and also as influences on that person's moral character. The film encourages us to expand upon MacIntyre's insight by showing how an individual's potential is part of his self-identity. Consequently, included in the individual's narrative of himself is the projection of a possible future as well as his past history.[2]

Yet a story of who I may become does more than merely make me intelligible to myself, as MacIntyre argues. The forward-looking dimension of narrative also provides a plan of action, perhaps a life plan, by which we shape our decisions. The story that someone like Tony envisions for himself is the vehicle of self-creation, suggesting a trajectory of choices through which he can define who he will become. The choices Tony makes and the reasons he makes them suggest that growth in virtue and autonomy and the story the individual tells about himself depend on each other. Just as narrative outlines a future that includes the individual's development, so does creating such a narrative require an array of moral strengths with which to begin. A moral base of autonomy and virtue on which to build the framework for Tony's story is necessary, so that he can develop more fully. For example, Tony must fend off competing views of who he is and what he can (or cannot) become and this takes moral strength, self-awareness, and honesty.

The image that may be most memorable at the beginning of John Badham's *Saturday Night Fever* (1977) is of Tony bopping down a busy city street. But that is not, in fact, how

the movie starts. The opening shot is actually of two bridges: the Brooklyn Bridge that links Brooklyn with Manhattan, and the Verrazzano Bridge, leading from Staten Island to Brooklyn. We may only recall these as the opening shots when the bridges take on significance later in the story. For then we are likely to see the Brooklyn Bridge as the path for Tony out of his old life and into a world in which he can develop as his own person. On the other side of Brooklyn, the Verrazano Bridge represents Tony's adolescent past, the site of playing games with his friends and the scene of his pipe dreams.

The film can be viewed as a tale of two bridges, one leading to the bright prospects of Manhattan and the other ending in the Italian Brooklyn of Tony's parents. The camera pans down from the Verrazano, past an elevated passenger train, to the legs and feet of someone walking in time to the soundtrack that is playing the Bee Gee's hit, "Stayin' Alive." As Tony walks rhythmically along, swinging a can of paint, we hear the lyrics, "You can tell by the way I use my walk, I'm a woman's man, no time to talk." And Tony does have an eye for the ladies, pausing to sweet talk a dismissive young woman and to admire clothing in storefront windows. We soon see that Tony is carrying the paint to his place of work, a paint store.

In the world of work we see that Tony is good with people and is a hard worker. It gives us a glimpse into the kind of employment he might find outside of Brooklyn, in a more challenging and fulfilling life. When he receives a raise, Tony is grateful. However, Tony also has an independence of spirit and self-respect to be skeptical of the picture his boss outlines for him of his future at the store. Although very brief, the scene is telling. It alerts us to the fact that Tony is not going to let other people create a narrative for his life. At this stage in the story and in his life, Tony knows what he does not want for himself: working indefinitely in a paint store. Implicit in this self-knowledge is a sense of his own worth and potential. Tony has knowledge of himself as potential, as yet pretty much undetermined and open-ended, but worth taking risks for.

Tony's family also tries to foist upon him their image of who he is and what he can become. His parents try to make him see himself as inferior and inadequate, especially in comparison with his older brother, the priest. Tony must summon up the strength of integrity to resist the destructive narrative with which his parents batter him. This is integrity in the sense of integration: the integrity that fortifies the self as an integrated whole in the face of assaults. Tony must stand up for himself and expose the projections of his parents as the distortions that they are. As with the narrative offered by the paint store owner, the narrative his parents press upon him is self-serving. Just as the paint store owner would like to have Tony in harness for the foreseeable future, so his parents need him to be the scapegoat for all the family's problems. They persist in forcing on Tony the portrait of himself as a loser, with no ability or chance at success. His father denigrates the raise he receives, as if that will ease his own feelings of inadequacy. And both his parents try to blame him for the brother's change of heart about the priesthood. But Tony will have none of it. He has enough strength to reject the interpretation his parents argue for and to try to figure out a more sustaining narrative of his own.

Tony is a very good dancer, maybe gifted enough to make a career of it. From the point of view of moral personality, what is most impressive is Tony's dedication and discipline. At various times in the movie we hear him tell his dance partners that they must practice and we watch his willingness, even eagerness, to practice the same steps over and over. Tony, then, combines discipline with exuberance—his joy in dancing makes the work a labor of love. It is this quality that seems to separate Tony from his friends as much as his talent for dancing.

As a maturing teenager, dance gives meaning to Tony's life. It is the sphere of activity in which he excels and consequently feels the most self-worth. Ironically, it is through their excessive praise of his dancing that Tony's friends alienate themselves from him. Inverting the parental denigrating image of Tony, his pals promulgate a portrait of him that inflates his ability and accomplishments. At this juncture, Tony's integrity enters again, when he objects to being given first prize that he thinks he does not deserve in a dance contest. Integrity here draws on a respect for oneself, as apprenticed to an art. This dimension of integrity involves honesty about who we are. Tony rebuffs his friends' flattering narrative of him as the "Lord of the Dance." He is able to do so because he knows who he is and is capable of objectively comparing his own talent to the abilities of others. His strength of character combines with his honesty to enable him to assess himself accurately—neither the loser his parents see nor the invincible folk hero his friends envision.

Yet Tony must distance himself from his friends for a deeper reason of which their illusions about him are but the expression. His friends have no self-awareness or sense of the power to create narratives for their own lives. They seem to be stumbling into their future, pushed by the local forces within which they live: family, friends, church, adolescent habits. Only Tony seems capable of self-consciously seizing the strands of his life and weaving them into a story of who he might become. One friend in particular, Bobby, is completely boxed in by circumstances. Although he realizes it and rails against it, Bobby is unable to construct a life-sustaining scenario for himself. Paradoxically, Tony's success in dance provides him with the self-esteem needed for him to envision a life in which dance, especially the Saturday night variety, is not so central. Tony senses that in a more fulfilling life, he would need dance less. He would not need to escape to the disco lights and pulse of dance clubs like *2001*. Tony is remarkable for seeing what his friends cannot: their fighting and fooling around and Saturday nights must soon come to an end.

Tony is able to change because he has moral virtues, intelligence, and talent. We will see that although not well-educated or well-spoken, Tony is observant and thoughtful. His talents for dancing and dealing with people are buttressed by the virtues of integrity, honesty, and the openness to learn from other people. Tony will need these virtues to outline a narrative for himself within which he can care for himself and develop autonomy. He has a sense of himself as valuable that must withstand the destructive dynamics of his family as well as the inertia of friends and work. The story, then, is a coming-of-age tale. It presents a pivotal time in a young man's life during which he can stay put (merely "stay alive") or break away and take some chances in the hopes of a more interesting, rewarding life. Over the course

of watching Tony come of age and come into his own, we see how he resists the illusions of family and friends concerning him, and how he respects himself through his love of dance.

Each sphere of his life contains values and obstacles that enrich Tony's life. From the disco realm of friendship, Tony develops his artistic talents and virtues of discipline and honesty. Challenging his parents' illusions about him strengthens Tony's integrity by calling forth his self-respect and autonomy. And work both nurtures Tony's winning ways with people while providing him a window onto one path his life could take. Through all the spheres, though, Tony seems to move to the beat of the music. It animates his thinking and courses through the film like oxygen-rich blood.

II. Disco king/family bum

After Tony returns to the store with a can of paint for a waiting customer, his boss refuses to give him an advance on his pay. He explains to Tony that he pays on Monday to keep employees, such as Tony, from blowing their paycheck over the weekend. Told that he should save for the future, Tony snaps back, "The hell with the future." His boss points out that "the future says 'hell with you.' It catches up with you and it says to hell with you, if you ain't planned for it." As the story unfolds, we see Tony think more seriously about his future, heeding the advice of his boss and his second dance partner, Stephanie (Karen Lynn Gourney).

Tony possesses the basic care virtue of attentiveness: observing what people do and listening to what they have to say with an eye to self-improvement. The characteristic further sets Tony apart from his pals and makes us hopeful about his future. The virtue of attentiveness is here at work in a narrowly focused manner. Rather than being attentive to the needs of other individuals (which Tony is in varying degrees), the attentiveness Tony here evinces is to what other people say and do for his own sake. Even as Tony pays attention to the lives of the older workers at the paint store and listens to his boss, so does he observe Stephanie, his friends, and his brother. Attentiveness, then, discloses an indirect social dimension of autonomy. By listening, watching, and mulling over what he perceives in his social relationships, Tony is able to make independent choices for himself.

Entering his home, Tony hears an irritated, "Where you been?"—first from his mother, then his father, then his mother again. We get the impression that this is the usual flak that greets Tony, since he ignores his parents and just runs upstairs and exchanges affectionate greetings with his kid sister. The upbeat disco music resumes as Tony blow-dries his hair and then puts on gold chains in his ritual preparation to go out dancing. The image of Tony primping in front of the bathroom mirror is intercut with shots of people dancing at the local disco club, bathed in a diffuse red light. The camera thereby conveys Tony's eager anticipation of his Saturday night out by suggesting that his thoughts are already dancing ahead to what the club has in store. Warming up in front of the mirror, talking with his father, Tony moves in an abbreviated dance, as if he can hear the revved up music on the soundtrack.

The ensuing scene at the dinner table depicts an emotional family whose interactions are strained because the father is out of work, but too proud to allow his wife to work outside the home. A round-robin of slapping and shouting ends with a glimpse of Tony's wit. When Tony's mother says that she is going back to church that evening to pray that Father Frank (Tony's older brother, played by Martin Shakar) calls her, Tony wryly observes that his mother is "turning God into a telephone operator."

That evening we get our first view of Tony in action on the dance floor, in the same reddish haze that drenched the scenes shown during Tony's earlier coiffing. The music is presented as a unifying and invigorating force in Tony's life, as the songs on the soundtrack merge into the music within the story-time at the dance club.[3] Tony dances energetically, yet smoothly with Annette (Donna Pescow)—an adoring, cute girl who is destined to have her heart broken. The camera conveys the kinetic feel of the dancing by rapidly shooting the dancers at various angles, including top-down and bottom-up, head shots and feet shots. Annette soon approaches Tony about entering the annual contest at the club, one that they had won before. Tony agrees, reminding Annette that they will have to practice. She smiles, delighted at the prospect of spending lots of time with Tony, and says, "Yeah, we'll have to practice." When Annette puts her hand on his shoulder, Tony looks pointedly at it and tells her, "That's practice, Annette. It don't mean datin'. It don't mean socializin'. It means practice."

Tony then hits the dance floor with two girls, obliging one of them who commands him to kiss her. Tony is soon joined by his friends who form a line with the girls, and all the kids on the floor dance in sync, in a disco line-dance. Smoke rises in the soft red light as we watch the dancers do a sprightly little choral number, as if in a reverie or fantasy. When Tony shortly does a breath-taking solo, we will have seen all configurations of dance: partnered, small group, choral, and solo. Together with the varied camera angles with which the dancing is shot, the film seems to be trying to capture every aspect of the disco fever, displaying a love for dance that reflects Tony's passion.

But Tony has more going for him than his flair for dancing. In his work, he is good with people as well as with paint. At the opening of the film, when Tony returns to the store with the can of paint, he has to calm an impatient customer. He tells her that he mixed the paint just for her (when in fact he had gone to another store to pick it up), and that he was also going to reduce the price by a dollar. Later, a professional painter compliments Tony on the quality and price of paint Tony had recently sold to him. As the painter tells Tony that he could come work for him, Tony's boss looks apprehensive and directly offers him a raise. A humorous exchange follows during which Tony is so grateful to receive the $2.50 per week raise that the boss raises the raise, twice, finally settling at $4.00. What should not be lost in the humor is the fact that Tony has ability. He knows how to communicate with customers and he has the ability to learn about paint, people, and the price of each. Tony's abilities and understanding of human nature inform his self-care as well as his efforts to exercise his autonomy in finding his way out of Brooklyn and into a new life.

When the owner of the paint store tells Tony that he has a future here at the paint store, we see him pause to ponder such a life. The employer says that coworker Harold has been

with him 18 years and Mike 15 years. We follow Tony's eyes looking at these two, middle-aged men. The camera returns to Tony's face, which registers rejection of such a future for himself. No scowling or head shaking, no sneering or shoulder shrugging, just a studious assessment of the older men leading lives of "quiet desperation" and then, utter stillness. In just a few seconds the movie crystallizes Tony's contemplation of a paint-store career and his belief that he can do better. Tony may not yet know what he wants to do with his life, but he has begun to figure out what he does not want to do. Unlike his friends, Tony has become self-reflective. The self-governance that characterizes autonomy is impossible without a good dose of self-knowledge. As much as anything else, the story traces the growing self-knowledge that Tony comes to possess. Consonant with care theory, the knowledge is social in origin, emerging from interaction that is sometimes harmonious, sometimes acrimonious, but always latent with meaning that Tony must fathom.

Tony tells his father about his raise. Hearing that it is only $4.00 (a week), Tony's father makes fun of the amount, saying that it "won't even buy $3.00." Tony retorts, "I knew it. Go on, knock it. Just knock it!" Tony points out the meaning of the raise to him, to his self-esteem: "A raise says like you're good, you know. I mean, you know how many times somebody told me I was good? Twice. Two times. A raise today and dancing'. Dancin' at discotheque. You sure as hell never did." We see that Tony has to fight to maintain a sense of his self-worth. The parents have clearly favored Tony's older brother, Frank, who is a Catholic priest. It is no surprise, then, that when Frank leaves the priesthood, the parents try to blame Tony. When they ask Tony what he said to his brother to cause him to stay out all night, he replies that Frank is grown up and can do what he wants. The parents do not realize the foolishness of suggesting that the smarter, more mature brother would be swayed by dance-crazy Tony. Tony correctly, but perhaps foolishly, contradicts his mother when she declares that Frank will soon return to the church. Their shouting match ends in a remorseful Tony tearfully telling his mother that he is sorry and that he loves her.

In fact, Tony has a loving relationship with his older brother, just as he does with his younger sister. The night Frank returns home with the devastating news that he has left the priesthood, he and Tony have a caring, candid heart-to-heart talk. Tony tells Frank that he is sorry and asks, "You got fired, huh?" Frank says that he quit and describes how upset their parents were to learn of his decision. Tony sensitively asks whether the parents asked *why* Frank quit and then says, "Didn't ask why or nuthin'?" Frank says that their parents, with their dream of "pious glory" turned him into what they wished, "You can't defend yourself against their fantasies … . All I really had any belief in was their image of me as a priest."

The film thereby briskly indicates one of the pitfalls of parenthood: projecting what we wish for our children onto them and pushing them in directions that they do not truly wish to go. Such fantasies, the film also suggests, serve the interests of the parents, meeting their needs rather than the needs of their children. In the case of Tony and Frank's parents, priesthood is a tribute to them as good parents and devout Catholics. To keep oneself from this temptation requires virtues of self-restraint and humility that the Manero parents lack. Parents must restrain themselves from imposing their fantasies on their children in order

to let them find out what they want for themselves. Such restraint requires the humility to recognize the limitations of parental authority and keeping their influence in the proper perspective. Parental influence on children is inescapable and often positive. But in order to foster autonomy in children, parents must keep their own narrative of their children's lives from taking over. To avoid trapping children in the parental narrative may require vigilance since the play and influence of such narratives is liable to be both hard to detect and pervasive. We will see another, more fully developed, example of parental restriction of children's autonomy in *The Squid and the Whale*.

Just as Tony listened thoughtfully to his boss painting a future for him at the store, Tony quietly digests what Frank is telling him. And Frank is mistaken about children not being able to defend themselves against the fantasies of their parents. Tony has been fighting off his parents' negative fantasies about him, challenging their image of him as a failure whose $4.00 raise is a joke, as he struggles to discover who he can become. Here, again, the parental projections are in their own interests. If Tony is a loser and to blame for his brother's straying from the church, why, then his parents bear no responsibility for Frank's decision. Even Frank is not to blame. Scapegoating Tony enables the parents to keep all their other fantasies intact.

But Tony is not buying their distorted version of him or the situation. We begin to suspect that perhaps Tony, who is less educated than his brother and who seems to be less intelligent, is actually the stronger of the two. We get another taste of Tony's humor when he jokes, "Guess we're gonna have to take your picture down from the mantel." The shrine to Father Frank is no longer appropriate. Tony also displays insight into the dynamics of the family, pointing out that he has always been the bum in the family while Frank was perfect. The conversation between the brothers concludes with Tony observing, "Maybe if you ain't so good, I ain't so bad." Tony is a diamond in the rough, a late adolescent full of potential, in need of a lot of polishing.

During his brief stay at home, Frank goes with Tony to the disco. It is in this scene, about halfway through the film, that Tony gives a riveting solo dance performance. It begins with Tony taking a girl onto the dance floor to show his brother how he dances. Watching his brother light up the dance floor, Frank is enthralled, seeing a side of Tony he had not realized existed. Tony soon leaves his unaccomplished partner and takes over the floor by himself, confident and at one with the music.

With his platform shoes, flared trousers, and hair just so, Tony twirls and bends, struts and spins, glides and slides as if made of rubber. The camera follows him, again from every conceivable angle, including dizzying diagonal shots (somewhat innovative in 1970s film-making). Tony rotates his hands in a series of captivating rolls, twists, and spirals. His movement is supercharged yet fluid. In one sequence, Tony is hyperkinetic, ready to burst apart at the seams, only to freeze momentarily, for dramatic effect. He is not just a dancer; he is also a performer. As Frank enthusiastically observes, the crowd "can't take their eyes off you." Tony's legs kick, bend, and split apart in a 180-degree angle. His hips gyrate and swivel. He leaps, lands in a split and slides across the floor in a series of splits, only to rise and propel himself up and down on his knees in a disco variation of the traditional Russian dance.

Jumping in the air, Tony executes a mid-air split, touching hands to outstretched toes. In one moment, Tony is a whirling dervish, in the next, a lithe and dapper Fred Astaire.

It is truly an electrifying dance, not so much a single routine as a cluster of numbers, each with a distinctive style, that unfold seamlessly out of one another. Tony moves spontaneously and easily from acrobatic display to softer ballet, with transitions that are inventive, even humorous—including exaggerated pelvic thrusts and flicking imaginary perspiration from his forehead, in apparent parody of himself. His dancing talent gives him the confidence to have aspirations that will take him out of his neighborhood haunts. And his joy in dancing inspires Tony to imagine that he can find similar delight in work during each day of the week, not just on Saturday night.

III. Hello Stephanie, good-bye Annette

Tony ends his partnership with Annette when he sees Stephanie rehearsing at the dance studio. She had exchanged flirtatious glances with him at the discotheque, but rebuffed his earlier overtures at the studio. Stephanie is svelte and moves with a grace that Annette lacks. She also has an air of superiority that Tony finds attractive. Tony goes into her studio and kids her, saying, "Somebody told me you was practicin' to dance with me. Is that true?" He starts dancing around, flashing his winsome smile and suggests that they could be a "dynamite [dance] team." When Stephanie asks him how old he is, he says that he is 20, but his honesty wins out and he corrects himself: "Well, I'm nineteen at the moment, but I'll be twenty very shortly." Stephanie tells Tony that "there's a world of difference [between them], not just chronologically, but emotionally, culturally, physically." Tony's disarming grin gets Stephanie off her high horse and into a coffee shop where they get to know one another.

Stephanie tells Tony of her work and ambitions. Where she works in Manhattan, the people are remarkable, "Brooklyn ain't—isn't—Manhattan." Everything is beautiful, the people and offices, over the bridge and across the water. We notice Stephanie's limitations when she mentions having seen the film *Romeo and Juliet* and Tony says that he read the play in high school, rightly attributing it to Shakespeare. Stephanie "corrects" him, explaining that *Romeo and Juliet* is by Franco Zefferelli (the director of the film version) and not Shakespeare. Tony defers to her, adding that he always wondered why Romeo did not wait longer to take the poison, when waiting would have revealed that Juliet was not, after all, dead. In her know-it-all manner, Stephanie declares "that's the way they took poison in those days." The exchange reveals that Stephanie is a bit pretentious and that Tony thinks more seriously than we might have guessed. Stephanie says that she is ordering tea because it is more "refined," but she says it in her Brooklyn accent, while chewing gum. After telling Tony that she is taking a college course and is going to move to Manhattan, she explains that she is changing, growing: "Nobody has any idea how much I'm growing."

Stephanie agrees to be Tony's dance partner, but nothing more, nothing personal— echoing what Tony had earlier told Annette. When Tony presses her, she gives a painfully

accurate rundown of what she imagines his life to be—living with his parents and splurging on Saturday night. She caps her description off with "you're a cliché. You're nowhere, on your way to no place." Stephanie reinforces the insistence of Tony's boss that he think about his future. And he does. With growing self-awareness, Tony discloses that he would like to get the high he gets from dancing someplace else. Having understood that his dancing cannot last forever, Tony seeks the excitement, self-expression, and creativity that he now finds only on the dance floor. He is beginning to envision the shape his future could take, a narrative sketch of who he might become. When Frank later asks him if he plans to do anything with his dancing, Tony says that he does not know. But we know that Tony will think about Frank's suggestion and take to heart his brother's genuine enthusiasm for Tony's ability.

Stephanie and Tony practice together. The film uses their practicing to offer up more dance numbers and their developing relationship, but also to depict Tony's talent and sensitivity. When Stephanie shows him a new dance routine, Tony immediately picks it up and executes it flawlessly, a fine student of dance. Tony tells Stephanie that he did create a fancy dance step, but adds, "After I saw it on T.V., I made it up." His honesty would not let him take credit for the choreographic creation, but his tentative deception shows that he values such creativity and perhaps wishes he had it. Because Tony does not create his own dances, the jury is out on his choreographic talent, which makes his future less certain and keeps the film from giving us a neat, happy forecast for Tony. Walking together after practice, Tony wonders aloud why they do not talk about how they feel when they are dancing. He is also a student of the psychology of dance, its emotional impact, and the meaning it has for him. We realize that he is more contemplative about dance than Stephanie, more self-reflective about his life than his friends, and sturdier than his brother in the face of parental fantasy. Tony, too, is changing, growing in ways that nobody realizes.

IV. Bridge over troubled waters

Tony helps Stephanie move from Brooklyn to Manhattan, across the Brooklyn Bridge and into a new life. She is moving into an upscale brownstone that is being sublet to her by an older man, who unexpectedly comes down the stairs and gives Stephanie a kiss that is more than platonic. It is clear that he has been mentoring Stephanie, correcting her English, and recommending books. Tony gives Stephanie a knowing, disappointed glance and Stephanie looks abashed. As they are driving back to Brooklyn, Tony confronts Stephanie about her relationship with the man. After admitting that she has had an affair with him, Stephanie defends their relationship on the grounds that without his help, "I'd be walkin' around like an idot goin', 'I don't know, I don't know, I don't know.' And he helps me." Tony asks, "He helps you get in and out of the sack. That what he helps ya do?" Stephanie is ashamed and starts crying, "He helps me. What do you expect me to do, man, what do you expect me to do?" Driving back across the bridge Stephanie sobs, "I'm sorry," presumably for exchanging sex for help at work.

Sex in Tony's relationship with Stephanie and Annette is complicated and conflicted. On the one hand, Tony is a moralist, censoring Stephanie for cheapening herself by having sex with someone she does not love. He also refuses to rehearse with Stephanie because she dances with the dance studio owner, a known letch. In a similar vein, Tony had asked Annette to think about what kind of girl she was going to be (nice or a pig) when she had told Tony that she was ready to "make it" with him. These incidents would seem to indicate that for Tony, sexual intimacy is special and should not be treated lightly.

However, Tony does attempt fumbling sex with Annette when she threatens to lose her virginity with one of his friends, stopping their backseat contortions only when he discovers that Annette has no birth control. When Annette shows up a few days later with a fistful of condoms, the righteous Tony leaves her standing forlornly in the street, telling her that she disgusts him. At the end of the movie, in a brutal scene, Tony forces himself on Stephanie, again in the backseat of Bobby's car. What has happened to his chivalry and lofty conception of sexual intimacy? Tony seems to be an equivocal character, neither here (on the side of sexual propriety) nor there (on the side of sexual license). Actually, the story is realistic in its portrayal of Tony's inconsistent or conflicted behavior. After all, he is not yet out of his teens and is still sorting out his values, ordering his priorities. Tony may well believe that sex is special and still yield to his erotic impulses. Tony is not yet a complete moral person as his beliefs and desires are not fully integrated. He is still in the process of defining who he is and what he expects of himself. The self that Tony is evolving into is shown to be social in that the process by which Tony is coming to know and define himself necessarily includes other people: his responses to them and their reactions to him.

Neither are Tony's desires and emotions truly in sync; he is sorry that his brother has quit being a priest, yet also sees how it serves his desire not to be the "bum" of the family. Working toward the sort of integrity that is found in people whose beliefs and desires, emotions and values are all in harmony may, in fact, be an unending task for all of us. Just as Tony's brother has had to rethink his commitment to the church, so too does Tony have to rethink his attitudes toward sex and the value it really holds for him. His interactions with other people, especially women, will be crucial in Tony's reexamination of himself as a sexual being. We will see how the brothers in *The Squid and the Whale* also move, in fits and starts, toward sexual self-understanding.

Tony tries to calm the distraught Stephanie. He tells her, "Don't worry about nuthin,'" and stops at a park overlooking the river, with a picturesque vista of the Verrazano Bridge unfurling before them from the Brooklyn side. Tony proceeds to share his knowledge of the bridge and his recitation of impressive magnitudes is surprisingly soothing. He tells Stephanie that the tower is 690 feet high and that 40 million cars go across the bridge every year. The bridge is made of 127,000 tons of steel and almost 750,000 yards of concrete. The center span is 4,260 feet long and the entire bridge is 2.5 miles long, if you include the on-ramps. Saying that he knows everything about that bridge, Tony recounts the misadventure

of a construction worker who is buried in the cement, having fallen during work on the bridge. They laugh together at the dark humor. Tony reveals that he comes to the park a lot, to daydream. Stephanie touches the back of his neck and kisses his cheek, friendly with gratitude, but with a ripple of something more. It is an image that is reprised at the conclusion of the movie.

Of course, bridges are pretty obvious metaphors or symbols. What makes the two bridges in the film symbolically effective, however, is their literal function within the story. Tony and his friends go to the Verrazano Bridge to horse around. In one scene, with the strains of Mussorgsky's ominous "Night on Bald Mountain" on the soundtrack (no cheerful disco here), the young men dupe Annette into thinking that they have fallen off the bridge. A screaming Annette runs to the railing only to discover the tricksters safely perched on a platform hidden from view. This fooling around is repeated with tragic effect during the film's finale. Because the ending has been light-heartedly foreshadowed, it has greater dramatic impact. Tony also tells Annette that he often comes to the park to daydream as he looks out at the bridge. The Verrazano Bridge, then, is part of a dreamscape, a place for Tony to fantasize and must be replaced in his life by the Brooklyn Bridge—the way into Manhattan and real possibilities.

For all her pretentiousness, Stephanie is on to something when she speaks glowingly of Manhattan. Life and work there are more interesting and offer more opportunity to young people than the blue-collar neighborhoods of Tony's Brooklyn. By embedding the symbolism of the Brooklyn Bridge as the route to a better life in the everyday experiences of Stephanie and Tony, the film gives it narrative substance. Depicting the Verrazano as a boyish plaything, the film aligns it with Tony's youthful past in contrast to a mature future emblematized by the Brooklyn Bridge. The particular meanings of the bridge in its non-figurative function thereby leaves room for more subtle symbolic interpretations as well. Treating the bridge merely as a plaything indicates that the friends are not capable of seeing or seizing the opportunities it symbolizes, opportunities that Stephanie is realizing and that Tony has dreamed of. Moreover, crossing the Brooklyn Bridge to Manhattan, symbolically, is difficult. It demands vision, courage, and a willingness to break with the comfort afforded by the familiar past. Those who lack these virtues, Tony's friends, are fated to be stuck in the ruts of Brooklyn, or to fall into the cold river below.

The climax of the story takes place at a dance contest at the disco club. The film avoids the clichéd device of ending a story with a competition in which we root for the overmatched hero against devious or despicable enemies. It does so in several ways. First, Tony is not the underdog, and his dance opponents are neither underhanded nor unworthy, except in the eyes of Tony's sad, small-minded pals. Second, the contest is situated on the cusp of Tony's moral development and self-understanding. It is a larger climax for Tony, bringing to an end his old life, including such pastimes as the dance contest itself. Finally, the contest turns out to be a climax with an anti-climactic twist, letting Tony down so that he can rise above it.

V. Save the last dance for me

Tony arrives at the contest with his cohort. Stephanie notices their bruises and bandages, but Tony makes light of their appearance with a joke and a smile. The boys had been in a fight with a Puerto Rican gang, supposedly to avenge the mugging of one of their friends, Gus, who is in the hospital with contusions and broken bones. But the brawl was in vain, as Gus admits that now he is not sure that the gang the boys fought was actually the one that attacked him. Tony and his battered mates are furious that they incurred so many injuries, and might have suffered still more, for nothing. The mistake has greater significance for Tony. The wasted violence of the group of friends adds to Tony's growing dissatisfaction with his life. The injuries seem to epitomize the bruising futility of his relationship with his peers and parents. Together with the outcome of the dance contest and the second trip to the Verrazzano Bridge, the futility of the gang brawl will prove decisive for Tony.

The finale of the dance contest presents a cross section of Brooklyn, featuring couples who are black, Italian, and Puerto Rican. After the black couple finish, Tony and Stephanie begin their dance with a still moment, looking soulfully at one another. The music is the Bee Gees' song, "More Than a Woman," appropriate for the role that Stephanie plays in Tony's life. Their routine is elegant and cool, unlike the jerky and overwrought dance of the black couple that preceded them. Tony and Stephanie separate, then come together in smooth turns and fluid entwinement. Tony is dressed in a white suit, Stephanie in a light, pink-white dress. Their clothing, the gauzily soft lighting, and their romantic dance number conspire to create an enchanted, heavenly image. As they turn, with Stephanie embraced in Tony's arms, they kiss languorously and stare into each other's eyes. They end their dance smiling, strutting single file off the dance floor, with Stephanie's arms resting on Tony's shoulders. The youthful crowd applauds and cheers the neighborhood favorites.

The Hispanic couple then brings the contest to its conclusion. Dancing to Latin rhythms with verve and élan, the female partner's red dress flares and her exposed legs strike the air, as if to announce from the onset that the pair is full of life and are kicking up their heels to show it. As his friends mock the couple as "Spics," Tony admires their style and praises their performance. The male spins his partner, her legs fly out and down with controlled abandon. Where Tony and Stephanie were cool, as if descended from the stars in clothing spun of moonbeams, the Puerto Rican pair is hot, filling their routine with hitches, leaps, and swirling twirls. Stephanie looks on nervously; Tony seems entranced. As the dance draws to a close, the Italian boys bleat, "No contest, man, no contest." Tony objects, "I don't wanna hear that. Dey, dey wuz better 'n us." Stephanie tempers the disagreement, declaring that the Hispanic duo were not better, just different. Tony is remarkably able to see things clearly, without illusion: whether it is his brother's defection from the clergy, his own self-worth under his father's derisive criticism, or here, his performance in comparison to the superb dancing of the Puerto Rican couple.

When the DJ announces Tony and Stephanie as the winners, Tony shakes his head and looks sorrowfully at his cheering friends, believing that the judging reflected a bias for the home turf contestants. To the strains of "Stayin' Alive," Tony receives the trophy. He is mortified at being party to a deception, as if the falseness of the prize has cheapened the art of dance itself. Tony's clear-sighted appreciation of the Hispanic dance number overrides the easy satisfaction that self-deception about one's worth can provide. He tells his pals, "You phony idiots. You know who shoulda won that contest. My own friends can't even be straight with me. You gotta lie right through your teeth." Of course, their affection for Tony and prejudice may have led the friends actually to see Tony and Stephanie as the better dance team. But Tony is disgusted with his pals, banged up in a meaningless fight and blinded by their delusions. Telling Stephanie that the contest was rigged, Tony walks her over to the Spanish couple, hands them the trophy along with the first-place prize money, and tells the surprised pair that they deserve it.

Tony rejects the image his friends have of him as the king of disco. It is a fantasy that serves the friends' needs by elevating the image they have of themselves—they are, after all, buddies with this local dance star. Here we see Tony's virtues of honesty and integrity. We would expect people to be most prone to indulge in self-deception in areas of their lives that are basic to their identities and self-esteem. Refusing to fool himself about the art he loves and that gives him the greatest sense of self-worth, Tony appears ennobled in handing the trophy over to its rightful owners. But keeping the story realistic and Tony's character in perspective, the film immediately knocks him off his pedestal. First he manhandles Stephanie, forcing himself sexually on her, and then he hypocritically objects to Annette having sex with his friends. They push him away and accurately point out that Tony "doesn't give a damn about her." Clearly, Tony's integrity and sense of honor are flawed, which is to be expected in someone whose personal narrative, including its moral bearings, is still developing.

The friends drive to the Verrazzano Bridge to engage in their usual hijinks. This time, however, Bobby (Barry Miller) uncharacteristically joins in, performing crazy stunts, like walking on his hands on the railing. He is trying to prove that he is no coward. Because he avoided the gang fight that bloodied the others, Bobby had been criticized as a punk. Trying to show off, Bobby stumbles and dances precariously on the railing of the bridge. Tony urges Bobby to get down and reaches out to get his wobbly friend out of danger. Tony cajoles the crying Bobby, saying, "Don't get upset. Come on. We'll talk," but Bobby reminds Tony that he did not call to talk when he said he would. Tony let Bobby down because he was preoccupied with helping Stephanie move and had forgotten his friend. Tony again reaches for Bobby, but his distraught pal turns awkwardly away, teeters, and tumbles off the bridge to his death. The friends look on in horror as Annette shrieks and cries hysterically.

The police ask the group if they think Bobby killed himself. Tony observes, perhaps a bit too profoundly, "There are ways of killing yourself without killing yourself." Bobby was trapped. His girlfriend, Pauline, was pregnant and he was being pressured to marry

her by priest, parents, and high school guidance counselor. Throughout the movie, Bobby has been seeking help, especially from Tony. Bobby does not want to marry Pauline but feels boxed in because she will not get an abortion. On the day he had begged Tony to call him, Bobby described himself as paralyzed, saying, "I've got no more control."

It is not clear that Tony could have saved Bobby had he answered his call for help; however, it is painfully true that Tony has been neither attentive nor responsive to his desperate friend. Tony has not been caring. The attention and responsiveness he lavishes on Stephanie seem to exhaust Tony's emotional resources. When he did acknowledge Bobby's distress earlier, Tony did not take the time to really listen to what was going on with his friend or to give the support he desperately needed. Although Bobby's neediness is shown repeatedly to be annoying, a truly caring friend would take the time and energy to listen and try to provide a helpful response. The question of how to help friends in need is explored with particular sensitivity to disparities between the friends in *Friends with Money*.

Bobby personifies the difficulty of getting across that other bridge, the one that leads out of Brooklyn into a world of possibility. He lacks the courage to follow his own lights, to do what Tony's brother advised him to do, "what he thinks is right [for himself]," rather than what other people tell him to do. Bobby cannot cross the bridge but he also does not want to stay on the other side, the side that represents marrying Pauline, having a child, and being trapped for life. The only way out of this no-man's-land, the middle of the bridge, is to give up. Bobby kills himself without killing himself in the sense that he is purposely careless, perhaps not intentionally jumping off the bridge, but allowing himself to lose his balance and fall off. He has an underlying death wish. Taking Tony's psychological observation one step further, as referring to himself, there are also ways of killing ourselves without giving up our lives. Staying at the paint store for the rest of his life, as Harold and Mike have done, probably seems to Tony to be another form of suicide.

As a metaphor, then, the bridge offers three possibilities. We can cross it to the uncertain chance of a more rewarding life and this takes courage. Stephanie has chosen this option with her move into Manhattan. Another possibility is to stay in Brooklyn—dull, but safe and reassuring in its childhood resonances of family and friends. This is the fate of Tony's chums. The third possibility is Bobby's. Too weak to cross the bridge but repulsed by the prospect of staying on the suffocating safe side, Bobby finds himself stranded in the middle. But there is no viable option between staying and leaving. It is not a choice so much as an inability to choose, and anyone who winds up there must lose his balance. Life presents irrevocable choices with no middle ground: priesthood or no priesthood; pregnancy or abortion; marriage or no marriage; Brooklyn or Manhattan.

Tony turns away from his departing friends and walks off by himself. He rides the trains (taking us back to the second shot in the film), standing and sitting, tortured and tired. Gone is the upbeat or dreamy disco music on the soundtrack; it is replaced by a jangly, edgy jazz-like score. Tony rides until dawn, winding up at Stephanie's brownstone, now

accompanied once more by the Bee Gees singing, "How Deep is Your Love." Stephanie opens the door to a contrite Tony. He apologizes for his rough treatment of her after the dance contest and then talks of getting his own place and working in Manhattan.

When Stephanie asks what kind of job he is planning to get, Tony admits that he is not sure, but asserts, "I'm an able person. I can do these things." He tells Stephanie that he would like to be friends with her, nothing romantic, and that they can help one another. When she teases him, asking whether he could really be friends with a *girl*, Tony smiles and honestly confesses, "The truth? I dunno. But I'll try. That's all I can promise. I'll try." Stephanie says softly, "OK. We'll be friends. Just be friends." She clasps his hand, leans over him, and kisses his forehead. Stephanie puts her head next to his in a manner at once solicitous and sensuous. As the credits roll, the couple is frozen, framed by the dawn-filled window, Tony sitting on the window-seat, a standing Stephanie leaning into him. Their relationship is as open-ended as Tony's future, but Tony is in Manhattan.

True enough, Tony does not enter Manhattan triumphantly, gliding across the Brooklyn Bridge, over the sparkling waters, with a job full of promise in hand. Disheveled and somewhat forlorn, he rides under the river by public train. Tony will have to work his way up, as Stephanie has. But we have reason to think he has a fighting chance. Tony is smart and funny, good with people and able to learn. He also has moral virtues essential to success: determination, honesty, self-awareness, and integrity. Tony's integrity and honesty are demonstrated in his refusal of the prize to be given to the winner of the dance contest. His self-awareness and determination are expressed in his denial of the restrictive narratives projected for him by family, friends, and paint store owner. Tony would not go back—to the teenage pastimes of his friends, to living with his parents, to the dead-end job at the paint store. The anti-climactic culmination of the dance contest suggests that even disco no longer has the allure for Tony it once did. He is cured of his Saturday night fever, ready to move on with his life. As with his moral personality, his narrative is incomplete. But Tony has begun to fill in the outline of the story through which he is defining himself. He complements his earlier rejection of a career in the paint store with a venture into life and work in Manhattan. He may not be sure what exactly he is going to do, but he knows where he will do it and he is not too proud to ask for Stephanie's help in doing it.

Throughout the story Tony's autonomy grows because he is able to digest the lessons that emerge from his varied social interactions. He exercises his autonomy in breaking with the safety of the familiar ways of Brooklyn toward an uncertain narrative in Manhattan. Tony's attentiveness combines with his intelligence to enable him to care for himself as his friends, especially Bobby, cannot. Our next two chapters take up the major strands of family and friendship with which Tony has had to deal. As with Tony, there is much that is dysfunctional and uncaring in the family of *The Squid and the Whale*, and *Friends with Money* explores in greater depth the difficulties and possibilities of care in friendship.

Notes

1. Alisdair MacIntyre, *After Virtue* (Notre Dame, IN: University of Notre Dame Press, 1981), p. 197.
2. MacIntyre's viewpoint is largely retrospective, focusing on the narrative of what has already occurred in the individual's life. The emphasis on the past seems to stem from the weight MacIntyre places on accountability for one's actions, and we can only be held accountable for what we have already done. He does, however, mention the future: "We live out our lives … in the light of certain conceptions of a possible … future" (p. 200). However, MacIntyre does not explore the role of the individual in shaping the narrative of his future and then having that narrative guide his actions. Rather, the life of the individual itself possesses this future orientation: "Our lives have a certain form which projects itself towards our future" (p. 201).
3. Although bursting with song and dance, *Saturday Night Fever* is not a musical in the traditional mode. None of the characters sing, and the dance numbers are more embedded in the story than is typical of most standard musicals such as *Oklahoma* or *West Side Story*.

Chapter 2

Sea Changes: Failure to Care in *The Squid and the Whale*

I. Divorce and the requirements of care

The Squid and the Whale (Noah Baumbach, 2006) would make a great instructional video for parents on how not to split up, at least if their children's welfare matters to them. In the film, four family members going through the domestic upheaval suffer and struggle in their own way, with the tribulations of the two boys being depicted as especially poignant. Although Bernard (Jeff Daniels), the father, seems to dominate the on-screen interaction, by the end it is Walt (Jesse Eisenberg), the older son, who has become the main protagonist. Walt must work through his dysfunctional identification with Bernard in order to begin to discover what he wants and who he is. Walt's struggle for autonomy, then, is a central theme of the story. During this struggle, Walt becomes disillusioned about his father and learns to face primal fears, fears emblematized by the Natural History museum's recreation of an epic sea battle between a giant squid and whale. But before Walt can understand the dynamic of his family, the story tracks the group's stumbling efforts to cope with the sea changes that divorce entails. In the process, the film reveals a great deal about the ethics of care, while eloquently depicting the major obstacles to its realization within family.

The opening scene intimates the strife to come. The family is still intact, playing doubles tennis: Bernard and Walt are teamed against the younger son, Frank (Owen Kline), and his mother, Joan (Laura Linney). Instead of teaching his son to enjoy the game or perfect his stroke, Bernard instructs Walt to hit the ball at his mother's backhand since that is her weakness. Bernard soon hits a hard forehand directly at Joan, falsely claiming that the violence was an accident. The hostility between husband and wife is only part of what the tennis game reveals. It also shows the ugliness of Bernard's competitiveness, misplaced because it springs from a life centered upon his fragile ego. His serious character flaws go unchecked throughout the film and keep him from exercising the care characteristic of a good parent.

In telling the story of the disintegration of the Berkman family, the film returns us to the *locus classicus* of feminist theorizing about the care ethics—the parent–child relationship.

I will argue in what follows that *The Squid and the Whale* enriches our understanding of the ethics of care, primarily by embodying the *failure* to care and its consequences (as negative space in sculpture discloses meaning latent in the sculpted mass). The movie prompts us to reconsider core elements of the care ethics: the social self; attentiveness and responsiveness; the relational aspects of autonomy; the sympathetic imagination; and the place of generosity.

Within care theory, the conception of the self as social has meant several things. Among them is the notion that our identities are the result of relationships with other people. The ability to use language and understand ourselves as individuals, for example, presupposes human relationships, as well as a minimal level of care within them. Construing our identities as social can also mean that we view personal identity as significantly defined by our relationships with other people: "Our relations are part of what constitute our identity."[1] As Virginia Held notes, "Every person starts out as a child dependent on those providing us care, and we remain interdependent with others in thoroughly fundamental ways throughout our lives."[2] Crucial to this identity are the ends and values that direct our thought and govern our action. These goals and values are socially shared and not merely socially derived.[3]

We often adopt ends unreflectively because we identify with people who have them. While identification can be a conscious choice, most identification for children occurs in their unreflective give and take with parents. Here the film discloses a little noted liability or danger: taken to an extreme, identification can hobble children in their attempts to understand and define themselves. In order for Walt to begin to know who he is and what he wants, he must distance himself from the purposes and opinions of his father, which he has heretofore uncritically adopted. Unless Walt deliberately stops identifying with Bernard, he will remain a youthful imitation of him.

The film's inquiry into the interplay between autonomy and care is undertaken with sensitivity to social undercurrents both hazardous and salvific. In interrogating the conditions that further autonomy as well as those that limit it, *The Squid and the Whale* extends our understanding of the social aspect of autonomy. In recent theorizing, many proponents of care have ceased to regard autonomy as necessarily hostile to a concern for the social. Associating autonomy with the liberal tradition and its emphasis on the isolated, contracting individual, care ethicists initially opposed care to autonomy (as well as to concerns of justice and rights).[4] However, the importance of autonomy to actual caring relationships called for a reconceptualization of the notion. Adopting this social conception of the self, then, care theorists began to articulate the relational features of autonomy. Grace Clement, for example, notes the importance of autonomy to healthy caring relationships.[5] In the relationship between parents and adolescent children, parents should fulfill their responsibility to further the child's self-understanding and independence of thought and choice.

Although theorists have uncovered complexities and controversies in the relational conception of autonomy, most agree that achieving autonomy requires the acquisition of a complex set of competencies. Diana Meyers argues that the autonomous person will

have developed "a repertory of skills through which self-discovery, self-definition, and self-direction are achieved."[6] The competencies of autonomy, according to Marilyn Friedman, are particularly expressed in choice and evaluation: "Autonomy involves choosing and living according to values that are one's own."[7]

Following Meyers, we will construe that portion of autonomy that involves self-definition and self-understanding as authenticity. Authentic self-creation is an ongoing process for all of us, but is especially critical for adolescents, as they try out a range of possibilities for themselves. One important phase of exploration involves envisioning scenarios or narratives by which they might wish to define themselves. Narrative is a natural constituent of care ethics, given its emphasis on the particular contexts and histories of the individuals in relationships. Grounding caring behavior in the concrete configuration of particular lives is contrasted with applying abstract, universal principles—of justice and rights, for example. For the emergent autonomy that marks adolescence, narrative takes on added significance in the care ethics.

The film elaborates upon the importance of narrative by depicting its specific role in defining authenticity. *The Squid and the Whale* portrays the uncertain experimentation through which teenagers try to figure out who they are, with sexuality a central area of concern for both Walt and Frank. Among the competencies of authenticity that are crucial for the brothers to acquire are skills of introspection—especially a sensitivity to one's own feelings and desires—and powers of volition, which are needed to resist social pressures.[8] Where Walt is virtually unaware of his own true feelings throughout much of the story (because he never thinks to resist his father's tastes), Frank is more in tune with his impulses and emotions (however tangled they may be), precisely because Frank has escaped Bernard's overbearing influence.

Inter-subjectivity is relevant even at this basic level of competencies or skills because our relations with other people (personal and economic, familial and political) can be decisive to our range of choices. Caring relationships further our autonomy, and oppressive relationships obstruct it. The dependence of autonomy on relationships with others includes the processes by which we reflect on our selves and make our decisions. Our capacity for serious self-reflection and authentic decision-making requires caring relationships that support us with trust, sympathy, and an unselfish interest in our lives. As Linda Barclay observes, "Our ongoing success as an autonomous agent is affected by our ability to share our ideas, our aspirations, and our beliefs in conversation with others."[9] We need people we trust to help us examine our values, order our priorities, and make important decisions. Although I do not believe that autonomy is simply "the capacity for a distinctive form of social and, in particular, dialogical engagement," I agree that such a capacity certainly enhances one's autonomy.[10]

In order to nurture authentic self-knowledge and self-definition in our children, we must be attentive to them, and caringly notice what they are going through. More than simple observation may be required; parents often need to ask their children about themselves in order to discover what they feel or desire. Finally, parents may have to encourage children

to try things that will help them achieve authenticity. Joan at least *tries* to prompt self-exploration in Walt, while the thought never even occurs to Bernard.

By returning us to the relationship between parents and children, the story also sheds light on sympathetic imagination. We see that parents need to make an imaginative effort to enter into their children's inner lives. Adolescents in particular do not readily reveal what they are feeling. The attentiveness and responsiveness that are central to the care ethics typically require that parents engage their children's inner lives. It seems reasonable, therefore, to see the work of imaginative sympathy as a preliminary phase of attentiveness, one that is often essential to active engagement with the needs and problems of one's children.

The film develops our understanding of care by showing how generosity is embedded in it. Through Bernard's stinginess, we see how vital giving of oneself is to the care of parenthood. The generosity required of parents includes generous-heartedness: a giving that is itself emotional (or at least based on emotion). We can give our sympathy and compassion, which often requires that we sacrifice the emotional satisfaction to which, in fact, we have a claim. James Wallace argues that generosity of heart is most profoundly expressed when we forgive harms done against us.[11] In such cases, we give up our claims against the offender and thereby bestow upon him relief of the burden of indebtedness. Allowing a friend to give the gift or tribute we wished to bestow, for another example, is being generous with regard to the joy of giving itself.

In Bernard, the film portrays a parent who is incapable of being generous with his time, money, or heart. He painfully demonstrates the various ways in which parents can fail to give of themselves freely and for the sake of their children. We see Bernard unable, for instance, to allow his son a small victory in a game of ping-pong because winning is too important to him. *The Squid and the Whale* reveals in chilling detail how self-centeredness prevents parents from taking the time and effort to nurture the self-creation that defines their children's authenticity.

II. Father knows best

From the outset, it is clear that Walt idolizes and idealizes his father. Imitating the pompous, know-it-all attitude of Bernard, Walt repeats his pronouncements without really understanding them. We soon learn that Walt does not even read the books about which he spouts Bernard's commentary. He cares only about appearances—showing that he has a sophisticated view about literature, not bothering with why it may be the view worth holding. Unlike his father, who has done the work to earn his snobbery, Walt seems to think that reading is a waste of time. Bernard's domineering behavior thereby ironically short-circuits for his son the very love of literature and learning that (we surmise) motivates him so strongly.

Bernard claims, for example, that the best of Dickens is not typically taught in high schools. Although this may be insightful, it effectively preempts Walt's own investigation

of his assigned reading. To her credit, Joan suggests that Walt read the book himself. "See what you think of it," she urges. Parents (or teachers) who truly care encourage children to uncover meaning for themselves. In so doing, young persons will discover things about themselves, including the values that will define who they will become.

The link between reading fiction and self-reflection is captured incisively in this passage from a contemporary novel: "Reading about imaginary others made me intensely curious about my real self ... Once I started reading I entered a period of introspection and self-examination; fiction referred to me questions I had not even known how to formulate."[12] Bernard's inability to recognize how his behavior is harming Frank and Walt is symptomatic of his failure to think about what his boys are going through in the first place. Bernard cannot be attentive to his children because he seems to care only about himself—his own needs, desires, and views. It is no wonder that by the time the film takes up the story of the Berkmans, Joan has drifted away from Bernard.

The film prepares us for the marital collapse. Bernard sleeps on the fold-out bed; Joan eagerly jumps up to answer the telephone; and we watch Bernard's suspicion as he notices she is talking with another man in the neighborhood (just prior to the argument that signals their separation). Although both parents are inappropriately candid in discussing their sexual lives with their sons, Joan seems to make more of an effort to comfort them and to imagine what they are experiencing. When Frank cries upon learning of the separation, Joan hugs him and later tells Walt that the marital breakup has nothing to do with him. We then watch the brothers try to make sense of the separation. Walt emphasizes their father's recent lack of literary success, thinking that what matters to Joan is professional achievement rather than a loving relationship. Thanks to Bernard's example, Walt is overly concerned with the realm of appearances and status. Following his father's lead, for instance, he will later ask the school psychologist whether he has a PhD.

Joan does seem to have a sympathetic imagination, crucial to the responsiveness required in meeting the needs of those with whom we have a caring relationship. We see no evidence of this imaginative capacity in Bernard. While he may be able to enter into the lives of fictional characters in literature, he makes no attempt to fathom the inner lives of Walt and Frank. Bernard is oblivious to the impact and repercussions of the parental separation and divorce on anyone but himself.

Bernard takes the boys to his new house. Although it seems a bit shabby, he compares it favorably to the family home now enjoyed by Joan. Bernard trots out his pet phrase of praise, calling the house "the filet of" the neighborhood. For all his confusion and imminent acting-out, Frank is genuine and expresses how he feels, saying that he likes being at the old house more. It is apparent that Bernard would need to spruce up his new domicile to turn it into a welcoming second home for the boys. The house needs more comfortable furniture and its walls are sorely in need of patching and painting. As the story moves along, Bernard will neglect these details of domesticity, just as he neglects the deeper needs of his sons.

Bernard tells Walt that the divorce is pretty much his mother's idea and informs him of Joan's long-term affair with a man Walt knows, the father of a school friend. Winning

Walt's allegiance by appearing innocent and aggrieved is more important to Bernard than considering Walt's tender sensibilities. In what appears to be a disingenuous maneuver to protect himself from just this sort of censure, Bernard tells the boy that he thought Walt knew about the four-year affair.

Walt soon takes up his father's cause with Joan, telling her that he is not going to spend time with her at the family home. He accuses her of betraying them all, melodramatically proclaiming that she had turned their house into a "brothel." Walt continues his parental denunciation by telling Joan that she disgusts him. Lest we sympathize too easily with Joan, we soon learn that she has confessed to Frank to having had other affairs as well. Inundated with sexual information, the boys' imaginations run rampant. And Frank begins to act out, drinking alcohol, and masturbating in the school library. He seems to equate adulthood (and his own desire to grow up) with alcohol and his emerging sexual urges. Of course it is natural for both boys to be interested in sex at their ages; however, the hyper-sexualization of their lives by Joan and Bernard promotes an exaggeration and distortion of sexuality, most markedly in Frank.

The self-discovery and self-definition that comprise authenticity require that we construct narratives for ourselves. Sometimes narrative projections are sweeping, for example, envisioning potential careers; sometimes they are narrower, and concern such things as whom to date or how to drink beer. We watch Walt think about dating (and then do some of it), and we see Frank experiment with alcohol. The boys also try to make sense of their parents through storytelling. Frank is open to seeing their mother as a gifted writer, but Walt's world centers around Bernard as the eminent novelist. As the story unfolds, we realize that Bernard's own self-narrative of success is crumbling and that this leaves him with little self-respect. Just as the boys are looking for narratives that confer understanding and control of their lives, Bernard is clinging to the outworn story of himself as a literary *wunderkind*. Buffeted by rejection, he takes solace in past success, reliving it by giving a sparsely attended public reading and retelling stories of happier days.

During a tennis lesson with Ivan (William Baldwin), Frank lets loose a string of expletives, imitating Bernard after his own fashion. Yet Frank's outburst is more truly his own than Walt's more affected renditions of Bernard. Frank's behavior more honestly expresses his will and desire than does Walt's. Because Frank is not in his father's thrall, he is freer to function autonomously and authentically. When he yells his curses, Frank gives vent to genuine feelings of frustration. On the other hand, Walt's high-sounding judgments about books he has not read are detached from his inner life. Walt's literary affectations come out most pointedly and humorously in conversations with a cute girl who obviously likes him.

III. Lack of generosity and over-identification

During their first conversation, Walt echoes Bernard in calling F. Scott Fitzgerald's *This Side of Paradise* "minor Fitzgerald." It may well be, but Walt certainly does not know why. In contrast, Sophie's enthusiasm for the novel's romance comes out of her personal

experience of reading the book. It speaks to her teenage desires and fantasies. Walt proceeds to pronounce Kafka's *Metamorphosis* a masterpiece, but we suspect he has not read *it* either. When we later hear Sophie discuss the book with Walt, we wince as he fakes it. Walt says seriously (and therefore in a self-parody) that the book is "very Kafkaesque." Just as we are thinking that a book by Kafka cannot itself be "Kafkaesque," Sophie gently indicates Walt's faux pas by noting that Kafka did, after all, write *Metamorphosis*. Walt does not seem to recognize his misstep, but no matter, Sophie finds him adorable.

Walt's imitation of Bernard extends to the need to feel superior in general, not simply in literary matters. As Walt kisses her, Sophie offers instruction in the art of smooching, but Walt criticizes her for having too many freckles. Walt is so concerned with status that he cannot let himself feel genuine emotions or take advice without defending his position, even if it means hurting Sophie's feelings in the process. Like his father, Walt is cut off from the sympathetic imagination, which allows us to perceive what other individuals are experiencing and respond accordingly. Neither Walt nor Frank has a father figure who consistently demonstrates sympathy and caring responsiveness to the needs of others. It is no wonder that they both flail about, at sea, in the midst of their domestic turmoil.

At the new house, the walls continue to have patches of paint and plaster conspicuously missing. Bernard's obvious lack of concern about making an attractive home for the boys is compounded by his stinginess. He seems indifferent to Frank's complaint of a fever, and when he finally gives him money to buy Tylenol, it is not enough. Bernard gives grudgingly, in dribs and drabs. Later, Bernard lets Sophie pay for a shared meal in a restaurant, after suggesting that the teenagers order half-portions. Bernard's failure to fix the walls of his new home can also be viewed as stinginess, either monetarily or in terms of an unwillingness to invest the time and effort needed to do the work himself.

Divorce puts a strain on the finances of most people. Bernard's concern for money could be seen as simply being realistic, but the film does not depict him sympathetically and he comes across as niggardly. We are thereby invited to see the money as a motif or metaphor. Bernard's economic tightfistedness symbolizes his stinginess with attention, effort, and heart. He is cheap with his emotional resources as well as his economic ones. Bernard puts his own needs ahead of the needs of his children (and, we can readily infer, of Joan, when she lived with him).

We soon see a repeat of Bernard's intra-familial competitiveness as he drubs Frank at ping-pong. Bernard's ego is so delicate that beating his son is more important than having a good time or letting Frank have an edge. Letting the other person experience the joy of victory, even when we could have won, exhibits generous-heartedness by freely giving another person the delight that could have been ours, rather than something of material benefit. When they play next, we hear Bernard curse his own mistakes, conveying his destructive attitude that error and failure are intolerable. Flubbing a serve from Frank, Bernard even goes so far as to say that he was not ready—that old refuge of the child who cannot bear to be beaten. After finally losing the game, Frank throws his racquet in Bernard's direction and sneers, "Suck my dick, assman!" Frank has picked

up his father's explosive language, but his frustration is genuine and he adds his own linguistic embellishments, such as "assman."

The correlative of Bernard's insufferable competitiveness is his absolute authoritarianism. When Frank says that he would like to be a tennis pro at a club, like Ivan, Bernard does not seize the opportunity to explore alternative narratives with his son. Instead of asking what Frank finds attractive about this career, Bernard belittles it as lacking in seriousness, and proceeds to call Ivan a philistine. Unlike Walt, Frank is true to himself and resists his father's attempt to denigrate Ivan, whom he obviously likes very much. Frank characterizes himself as a philistine as well, because of his indifference to good books or films. Frank challenges Bernard's authority over him. As he does with Walt, Bernard simply reasserts his cultural standards, but offers no reasons why someone like Frank should not settle for being a philistine.

Frank's profanity-laced outbursts seem more of an indication that Bernard's tantrums give Frank permission to be vulgar than that he is emulating his father out of admiration. Frank will later also disagree with his father about whether Ivan is a "serious possibility" for Joan, after Frank discovers their romantic relationship. We have to laugh at Bernard's disclaimer that he "didn't want to badmouth Ivan," when in fact that is what he does most of the time with regard to most people.

The difference between Frank and Walt points to a complicating social aspect of self-definition and personhood. Walt has thoroughly identified with his father, internalizing Bernard's values and attitudes. We see that the social impact of such identifications on selfhood can sometimes actually impair authentic personal development—when the values and habits that are adopted are suffocating and inauthentic. We might consider this to be a form of over-identification, leaving aside the question of whether the attitudes and values in question are flawed in the first place. Over-identification occurs when the authenticity of the child is jeopardized, no matter what values are being foisted upon him. *The Squid and the Whale* portrays Walt's identification with Bernard as obstructing his exploration and understanding of himself.

Because Walt has nothing to call his own, he is (both literally and figuratively) pretentious. He literally pretends to have read books and written songs that he has neither read nor written. And he pretentiously expresses opinions that he has not arrived at through his own thinking, assuming a superior attitude that is ungrounded in his own experience or thought. Bernard must bear some responsibility for Walt's lack of a true self because he fails to encourage Walt to think or do things for himself. For example, he never asks Walt what *he* thinks of *The Great Gatsby*, or what *he* likes about the story. The difference between the reactions of Frank and Walt to Bernard's behavior is that Walt's response is mediated by an over-identification with his father that Frank does not share. Walt even needs Bernard's advice about his new girlfriend, Sophie.

As noted, Bernard exhibits a failure of sympathetic imagination. He never tries to imagine what his children are going through—where *their* imaginations are taking them or how they interpret their parents' behavior. Care dictates that we imaginatively engage the inner lives

of other individuals because such sympathetic resonance better positions us to respond to their needs—a cornerstone of the care ethics. Bernard seems incapable of such imaginative sympathy, not only with his children but with adults as well. Bernard may be a good reader of literature, but not of human nature.

IV. Inauthenticity and pretense

A turning point in the movie occurs when Bernard and Joan are chatting at the door of the family home occupied now by Joan. Joan looks sad, as if sorry for the separation, and perhaps wishing that things were different. Bernard reports that in a recent conversation, his father had expressed the opinion (reached after talking with Joan) that he could save his marriage. Joan's vulnerable appearance indicates that she may be open to discussing the relationship, if not to an immediate reconciliation. Bernard declares that he has tried everything: a dubious proposition, given what we have seen of him and his familial intercourse. In any event, why not take this opening to ask Joan what he could do to make their life together more fulfilling? Bernard does not accurately perceive Joan's expression, nor does he appreciate the fact that his father heard something hopeful or wistful in her voice.

Joan looks tearful and in need of comfort. When Bernard walks away, Joan is downcast, and, indeed, starts to cry. Bernard cannot enter into Joan's experience because he does not really see how she is behaving; he simply does not pay attention. The film suggests that Bernard cannot pick up on the cues Joan is dropping because he is so focused on himself—*his* opinions, *his* needs, and *his* current literary setbacks. He is so wrapped up in himself and his attempt to salvage his literary image that Bernard forgets that Frank is home alone even as he drives Walt and Lili (Anna Paquin) to a college to read excerpts from an earlier, successful novel.

Meanwhile, the brothers are getting into trouble: Walt for plagiarism and Frank for untoward sexual behavior at school. Walt performs a song by Pink Floyd that he passes off as his own. He wins first prize in the school talent contest and praise from his parents and Sophie. The attractive female college student, Lili, who is now living in Bernard's house tells Walt that she will keep his secret. But Bernard and Joan are soon called to his school and confronted with Walt's deception. Bernard foolishly defends his son as "giving his own interpretation." The teacher persists, saying that Walt is not doing his homework and that he does not think Walt read *The Great Gatsby*, even though he wrote a paper on it. The teacher's suspicions are corroborated by Walt's empty literary posturing.

Why does Walt lie about writing the song instead of simply playing and singing it well? Seeking to emulate Bernard, Walt wants the status of being considered creative, but without actually doing any creating, just as he wants to be thought lettered without actually reading the books about which he holds forth. Walt manufactures an image of himself according to what he thinks his father is and wants him to be. Walt spends so

much time maintaining the appearance of a cultured and creative young man that he has no idea who he is or what he actually likes.

The story positions Sophie as Walt's foil. She actually reads the books and forms her own opinions about them, with no regard to their reputation or lack of cache. As her name implies, Sophie is wise enough to be truthful with herself about her feelings and desires. She is her own person. Sophie likes the romance in Fitzgerald, finds Kafka weird, and knows that she really likes Walt. Because of his father's undue influence, and his resultant inability to cultivate his own taste, Walt is inauthentic. Walt does not understand who he is and has not defined himself having uncritically adopted the outward mannerisms of his father.

Frank's problems at school are healthier, because they stem from his confused feelings and genuine struggle to find out who he is. We watch Frank playacting in front of a mirror while he drinks, first, beer and later hard stuff. Bernard and Joan are called to school because Frank has smeared his semen on school lockers after masturbating. The parents blame each other for Frank's inappropriate sexual behavior, but only after Bernard has questioned the accuracy of the account of Frank's behavior. Joan privately and correctly points out that having the 20-year-old student living with the boys is confusing for them. And Lili has flirted with Walt, who appears awestruck.

Besides hearing Lili's overtly (and overly) sexual poetry in Bernard's class, Walt is exposed to the sexually tumultuous film *Blue Velvet* by his father in Lili's presence. Awkwardly investigating their own sexuality, the brothers are also subjected to stories of parental infidelity and images of parental sexual relations that are further distorted by the interpretations offered by Joan and Bernard. In fact, a breakthrough occurs for Walt after he happens upon his father groping Lili, who is resisting his sexual entreaties, in Bernard's new home.

V. Seeing the truth and facing fears

Walt flees his father's house and finally reconciles with his mother. After walking to the park and dousing his head in the pond to clear it (or perhaps to cleanse himself of his father's influence), Walt shows up at his mother's door. He had thus far been making her pay dearly for the divorce and his pain, but even that had been shaped by Bernard. Recall that Bernard had turned Walt against his mother by sharing her infidelities with the boy. Walt confides in Joan that he feels he should not have broken up with Sophie and Joan asks him about his reasons for doing so.

Where Bernard never asks Frank why he wants to be a tennis pro, like Ivan, or what Walt likes about Sophie, Joan encourages her son to share his feelings. But Walt's answer reveals that he is living outside himself, as if looking in on someone else's life. He tells Joan that he thought he could do better, but he cannot say how. We sense that the image he had of himself included being with a more seductive and sophisticated girl, maybe someone like

Lili. Joan tells him that it is good that he misses Sophie, presumably because he is finally in touch with how he really feels and not how he thinks he should appear.

Walt makes his external viewpoint explicit: "I just don't see myself as a person who is in this situation." To which Joan replies, "[But] this is how it is," indicating the reality of Walt's situation. The discrepancy between Walt's image of himself and his actual condition parallels the disparity between Walt's claim of composing the Pink Floyd song and the reality of the situation. When discussing his lie with the school psychologist, Walt protests that he "could have written the song," an echo of Bernard's feeble defense that Walt was rendering his own interpretation. When Walt says that he does not see himself as someone in this situation, it is as if he has seen himself looking longingly through the restaurant window at Sophie and her family. Before going to the park and then to his mother's house, Walt had stopped to watch Sophie eating a meal with her family, similar to one that Walt had once shared with them. Walt alienated someone who had great affection for him because he turned to Bernard for advice. Instead of helping Walt figure out what he truly felt about Sophie, Bernard comments that Sophie seems fine for now, but that Walt should not limit himself. Walt cannot enjoy the romantic feelings of attraction and affection without soliciting his father's opinion.

The film deftly juxtaposes Joan's inquiry into Walt's feelings for Sophie and affirmation of his pain with Walt's recollection of Joan's attentiveness in his earlier childhood. Talking with the psychologist about a fond memory, Walt recounts afternoons he had spent with his mother visiting the Museum of Natural History. But the exhibit of the battle between the squid and the whale terrified Walt and he could not look at it. Later that night, Joan talked with Walt about his experience and described the tableau for him. He tells the psychologist that his mother's description made it less frightening; she had enabled him to face an unpleasant reality. The sea battle is a staged representation of a remote event, whereas Walt's romantic anguish is the painful residue of his distorted self-representation. But Joan's caring helps him deal with the turmoil of both.

The story situates narrative firmly in the fabric of parental care. By providing a narrative of the sea-struggle within the safety of Walt's childhood bedroom, Joan helps her son gradually learn to cope with the disconcerting realities that we all face. Now, in dealing with the conflicts in his personal life, Joan's responsiveness to Walt's misguided self-narrative prepares him for self-understanding and authenticity. As we will see at the film's conclusion, Joan's expression of care also prepares Walt to face the violent diorama head-on, with all the symbolic freight that it carries.

Toward story's end, the boys witness one last parental conflict. Arriving at the family home looking for Walt, with Frank in tow, Bernard belatedly tries to reconcile with Joan. He now asks her whether he could have done more—something he should have asked her during their earlier dialogue in the doorway, when referring to his conversation with his father. He blathers on about cooking more and trying again. In contrast to her earlier teary response to Bernard's obtuseness, Joan now laughs at him. The boys watch as Bernard threatens to sue Joan for custody while Joan rejoins that he would do so only to save money in child support.

We then see the brothers show sympathy and care for one another for the first time. Bernard demands that both boys get in the car, but Frank, ever honest about his emotions and desires, refuses. Walt intervenes on Frank's behalf, saying that he will go home with their father. Frank in turn responds with kindness, offering the cat to Walt for the night. Seeing the parental conflict with open eyes has finally disclosed his father's true nature to Walt, and the filial generosity of heart is a resultant breakthrough in Walt's relationship with his brother. He is being generous-hearted in giving up his own comfort, in avoiding the company of their father, for the sake of Frank. It is as though Walt's best feelings can emerge now since he has seen Bernard for the stingy-hearted man he is. Bernard suffers an apparent heart attack in trying to retrieve the cat, who has symbolically run away from the prospect of going to Bernard's unwelcoming home (mirroring the aversion felt by the brothers).

Walt's visit to his father in the hospital recapitulates much of their relationship, except that now Walt is disillusioned with Bernard. The pain of losing Sophie, coupled with the argument between his parents, has awakened him to Bernard's unrelenting self-absorption. The scene plays out as a crystallization of Bernard's repeated failures to extend himself beyond the boundaries of his self in caring behavior. He tells Walt that the doctors think that he is just exhausted and that he has not suffered a heart attack after all. When he tells Walt to stay the day at the hospital, it is because he needs the company, not because he would like Walt's companionship in particular nor because he had truly missed his son. Having provoked Sophie to break off their relationship, spoken with Joan about his feelings, and digested Bernard's economic reasons for seeking custody, the scales have fallen from Walt's eyes, and he sees his father clearly, perhaps for the first time.

Walt broaches the idea of spending time at his mother's place. Bernard rejects the suggestion on the purely selfish grounds that he will need Walt's help, yet Walt defies him. Bernard finally asks why Walt does not want to come to his house. But before Walt can answer, he tells him that Walt has hurt his feelings and that he shouldn't "be difficult." It takes the entire film for Bernard to inquire into his son's motivations, and even then his self-absorption prompts him to preempt Walt's answer with a declaration of his own emotional condition. Walt cries. Is it for his father, himself, or does it simply express his realization that Bernard cannot care about anything but himself? Expressing his stinginess one last time, Bernard offers to *lend* Walt his first edition of Norman Mailer's *The Naked and the Dead* as a "present." Bernard does not seem to understand what giving is and that lending is not giving. Just as Kafka's *Metamorphosis* cannot itself be "Kafkaesque," lending something as a present is an oxymoron—unintentional and ironic.

Walt gets Bernard a pillow, and Bernard takes his hand. Instead of expressing gratitude or affection, Bernard asks Walt to see about getting him some breakfast. Out in the hall, Walt tells a nurse, "The man in that room wants to order some breakfast." By not referring to Bernard as his father, Walt explicitly distances himself from him. Walt leaves the hospital and runs through the park as the soundtrack plays urgent, slightly upbeat strings in a low register. Walt's two journeys through the park seem to represent a flight from Bernard's

influence, first taking him to his mother and now to the museum. Walt stands before the squid and the whale exhibit; the squid is under the whale, clutching it, even as part of the squid is in the whale's mouth. As we watch Walt confront the battle and come to grips with his fears, we appreciate how frightening the tableau would be to a young boy.

VI. The high cost of stinginess

The film offers two running motifs to capture the cramped nature of Bernard's character. Besides his stinginess with money, Bernard's concern with space, especially parking space, is also symbolic. He bemoans losing parking spaces or having to search for them. Bernard has lost his space or place, both in the literary world and in the family. Sleeping on the pull-out sofa, Bernard no longer has an intimate place with his wife. Indeed, he is replaced by a series of lovers that culminates with Ivan. Joan has also assumed Bernard's shining literary place within the family and the community, as her novel is excerpted in the prestigious *New Yorker* magazine even as Bernard's current writing is rejected.

The space that he has fashioned in his new house for himself and his boys is meager and shabby. During her sojourn there, Lili complains that the refrigerator is always empty. Bernard's emotional cupboard is just as barren; he has no emotional reserves upon which to draw to help his sons through the marital breakup, or their own maturation process. The walls of his house, bare and in disrepair, reveal nothing of him, neither his labor nor his taste. In contrast, Joan immediately personalizes her space after Bernard leaves.

As we have seen, Bernard is tight-fisted with money, reluctantly giving Frank the few dollars he needs to buy Tylenol for his fever (and then shortchanging him), stinting on food in the house, and letting Sophie pay for her dinner out. The two metaphors of money and space converge when Bernard complains about having to pay 15 dollars to park his car at the restaurant. Space, or a place, costs money, and our place in the lives of other people, such as our children, also exacts a price from us. We have to recognize and respond to the needs of those with whom we are in close relationships. And sometimes we have to put their needs ahead of our own, something we never see Bernard do. In the end, Bernard is displaced from his sons' lives, as he had been from Joan's, because he cannot give of himself. The film is insightful about the importance of giving to care. What we value must be given open-handedly for the sake of the other person: energy, thought, emotion, attention, and yes, sometimes money itself. The empty refrigerator understatedly symbolizes the fact that Bernard cannot provide sustenance for his boys; what he has to give cannot sustain them.

Just how empty Bernard is comes through with the books he offers to Walt. When he gives his own book to Walt, he inscribes it "Best wishes," as if to a stranger. Bernard gives no thought to what the book might hold in store for Walt or what giving his own writing could mean to his son. He spends no time on his inscription to Walt. When he attempts to make his Mailer first-edition a present, Bernard loans it to Walt. The humor is painful to watch. Walt really is a stranger to his father because Bernard never attends to what his son may be thinking or feeling on his own terms, without reference to Bernard. Nor does it ever occur

to Bernard to inquire into his son's life. And lending is as close to a gift as Bernard can come because he cannot really let go of anything he values. Bernard's inability to give up what he prizes even extends to victory in tennis or ping-pong. He cannot give Frank the satisfaction of victory, but has to stoop to the dissembling formula of claiming not to have been ready in order to protect himself from defeat.

Books have special significance in the story. Bernard displays his love of reading and writing as a teacher, is a published author, and derives his self-worth from the success of his writing. Moreover, his self-esteem is dealt a heavy blow when he learns that Joan's writing is eclipsing his own. Bernard makes informed judgments about literature, but does so with Walt as an authority figure, not as a caring father who seeks to nourish Walt's appreciative or critical acumen. When he gives books to Walt, he does so impersonally, as a loan or with "Best wishes."

We may wonder why Walt does not read even the good books his father recommends. Walt might be afraid that he will not be able to see the deeper, underlying meaning or he might think that they are a waste of time. All that matters is having the right opinion of them—Bernard's. Bernard has so pressed his views upon Walt that he deprives his son of the very thing for which his opinions count, the varied pleasures of reading. Missing out on the delights of self-discovery, the intimate connection between books and authentic selfhood bypasses Walt. He does not discover things about books for himself, and he does not discover things about himself through books. The potential for self-definition, awaiting us in the fictional worlds of novels, is lost on Walt, as it is not on Sophie. This is why Joan's suggestion that Walt try reading the books himself is so important.

In ways that are philosophically interesting, the film emphasizes the obstacles children face in developing their authentic selves. Parents cannot stop their offspring from identifying with them and it is likely that some amount of identification is even healthy for children. Important values and virtues are typically inculcated in the unremarkable exchanges of everyday life. But parents can keep their children from over-identifying with them and thereby stunting the youngsters' individuality. By encouraging our children to think and experience life, as well as books, for themselves, we help them to understand and define themselves. Although her interaction with Walt is limited, Joan does try to get him to read, think, and experience for himself. Just as she did with the diorama of the squid and the whale, Joan helps Walt cope with the painful emotions that arise in his personal life. We take heart in the fact that by the story's end, Walt has separated himself from his father and may finally begin to create an authentic identity for himself. As for Bernard, he is alone. Lili has moved out of his house and his sons have moved out of his life.

Notes

1. Virginia Held, *The Ethics of Care: Personal, Political, and Global* (Oxford: Oxford University Press, 2006), p. 14.
2. Ibid.

3. Linda Barclay, "Autonomy and the Social Self," in *Relational Autonomy*, eds. Catriona Mackenzie and Natalie Stoljar (Oxford: Oxford University Press, 2000), pp. 52–71, 62–63.

4. Among familiar care ethicists who opposed care to theories centered upon autonomy or justice are: Nel Noddings, *Caring: A Feminine Approach to Ethics and Moral Education* (Berkeley: University of California Press, 1984); Lorraine Code, *What Can She Know: Feminist Theory and the Construction of Knowledge* (Ithaca, NY: Cornell University Press, 1991); and Virginia Held, *Feminist Morality: Transforming Culture, Society, and Politics* (Chicago: University of Chicago Press, 1993).

5. Grace Clement, *Care, Autonomy, and Justice* (Boulder, CO: Westview Press, 1996), pp. 35–36.

6. Diana Meyers, "Intersectional Identity and the Authentic Self?" in *Relational Autonomy*, pp. 151–180, 174–175.

7. Friedman makes the useful distinction between moral and personal autonomy: "Moral autonomy ... involves choosing and living according to rules that one considers morally binding. Personal autonomy involves acting and living according to one's own choices, values, and identity within the constraints of what one regards as morally permissible," "Autonomy, Social Disruption, and Women," in *Relational Autonomy*, pp. 35–51, 37. The sense of autonomy that is meant in this discussion is by and large of the personal variety.

8. Other competencies of authenticity are less relevant to the growth of Walt and Frank, those that are geared to navigating group membership and interpreting the meaning of group participation. Meyers, "Intersectional Identity and the Authentic Self?," pp. 154, 166.

9. Linda Barclay, "Autonomy and the Social Self," p. 57.

10. Marilyn Friedman, "Autonomy, Social Disruption, and Women," pp. 40–41. In a similar vein, Virginia Held makes the (perhaps overly narrow) claim that "the autonomy sought within the ethics of care is a capacity to reshape and cultivate new relations," *The Ethics of Care*, p. 14.

11. James Wallace, *Virtues and Vices* (Ithaca, NY: Cornell Univ. Press, 1978), p. 182.

12. Ronan Bennett, *The Catastrophist* (New York: Bloomsbury, 1997), p. 214.

Chapter 3

The Bonds and Boundaries of Friendship in *Friends with Money*

I. Caring friendship

Although interaction among friends is found in many popular movies, few of them actually elicit serious reflection about the ties and limits that characterize friendship. Besides being an entertaining film, Nicole Holofcener's *Friends with Money* (2006) does deepen our appreciation for the way friends, including spouses, care for one another or fail to be caring. General claims about what friendship requires of us are all well and good, but we see just how complex the nature of friendship is when it is individualized through the lives of actual, or fictional, people. The film interrogates the obligations and boundaries of friendship by examining relationships that are shaped in different ways by the people in them and by their history together. The story is especially good at grounding its meditation on friendship in the daily give and take of fairly unexceptional people whose interests and problems speak to all of us.

The film invites scrutiny of the following aspects of caring friendship: giving help or criticism; inequality in friendship; overcoming disagreement; and the importance of expressing care. These basic features of friendship are not dealt with serially, but are interwoven throughout the fabric of the story. The characters illustrate, in a variety of ways, strengths and shortcomings in these aspects of friendship, often as not involving money.

Much of the incident of the story is given over to the physical: bumps and bruises, creams for skin, bad hair and bad breath, cleaning homes and adding rooms to homes. Then, too, there is clothing: shoes for children, dresses for friends, socks and sweaters and jackets of cashmere. There is also the matter of sex—good, indifferent, or non-existent. So much attention is paid to bodies, appearances, and physical needs that the film's insights into the demands and joys of friendship can be overlooked. The story revolves around the lives of four friends, but it soon becomes apparent that Olivia is central; for instance, the opening and closing shots of the film are hers. The friends with money are, after all, Olivia's friends—Jane, Franny, and Christine also have husbands, children, and apparently more settled lives than Olivia. A former school teacher, Olivia works as a cleaning woman, or

maid, and seems at loose ends with regard to work and male companionship. For most of the movie, we see her struggle with a skewed new romantic relationship even as she tries to revive a moribund affair with a married man.

Olivia's need for help and some criticism or advice is most obvious, but all the friends in the film, at one time or another, need their friends to bail them out or set them straight. Among various theories of friendship are those that distinguish it from the reciprocity of favor-giving, in which parties are obliged (and expected) to repay favors with benefits of approximately equal worth. The dictum made famous by Karl Marx (coined by French Socialist Louis Blanc) is thought to apply to friends: from each according to his ability, to each according to his need. As a general principle this may have merit; however, its implementation is complicated by the specifics of the relationships and the people in them.

The film illustrates the unanticipated difficulties of helping friends by raising questions about money, that most ticklish of subjects among friends. (Recall in *Seinfeld* the turbulence generated by Elaine discovering how much money Jerry has.) For example, how much money does friendship require or commend a wealthy individual to give or lend to a struggling friend? When Olivia asks Franny for a loan, it seems obvious at first that Franny should give unstintingly to her friend who is just scraping by. After all, the principle of giving according to ability would seem to suggest that the wealthy friend give as much as possible to help the friend in need. But considerations of dignity or dependence indicate that we must take into account the impact of the bequest on the relationship itself. Might not the beneficiary of the gift feel beholden and might not the inequality of indebtedness erode the friendship? *Friends with Money* shows in an understated way that coming to the aid of friends is often a more nuanced matter than it may at first appear to be.

Consider next the help that is given when we provide needed questioning, criticism, or advice. Once we leave the precinct of bromides that call for being constructive or non-judgmental, we need to delve more deeply into the prerogatives and limits of friendship. By probing the details of particular friendships, the film unearths important insights. We watch Aaron criticize his wife, Jane, for her sour attitude in general and unwillingness to wash her hair, in particular. Aaron confronts Jane only after milder pleas for a brighter outlook and shampooing go unheeded. And he confronts her by really listening to her complaint and then asking her such a direct question that she must at last confront herself. Aaron does not transform Jane's problem into something about himself; that is, he does not criticize her negativity and enervation by talking about how it hurts him. Even though living with her has become burdensome, Aaron keeps the conversational focus on Jane and as a result she has to focus for the first time on what exactly chronically plagues her.

Although the film stresses disparity in wealth, it points to the more general problem of inequality and how friendship must navigate it. Because Aristotle viewed moral virtues, such as honesty and generosity, as the crux of friendship, he worried about inequality in virtue or character. Can people of seriously different levels of moral development enjoy the strongest of friendships? While moral inequality certainly jeopardizes friendship, the film addresses other sorts of inequalities. Financial inequality is portrayed as a cause of or

ingredient in inequality in autonomy: the freedom to make one's own choices according to what one truly values. In addition, there are inequalities in confidence, attractiveness, and career success. The story shows how friendships have to weather disparities in securing the things that make for a happy life. For example, we do not see any of the women feel envious of a friend's rosier marriage, better job, or more money. It is likely that this lack of envy is part of what makes Olivia an appealing character, since she has the least of all these good things.

The film also plunges into the murky waters of disagreement and the conditions that encourage its amicable resolution. Time after time we see Jane simply bark at people with whom she comes into conflict, while David and Christine dwell in discord, whether it is due to differences in their work together or friction aroused by personal comments. As the story unfolds, we see that the ability of friends to resolve conflict or iron out differences rests heavily on a foundation of sharing. We see that Franny and Matt share everything in their lives, from shopping and money, to decisions about child-rearing and gift-giving. The sharing carries over into resolving disagreements. When friends are involved in one another's lives and purposes, they have the further goal of finding common ground rather than arguing to hurt or vanquish the other person.

The film indicates that Franny and Matt are able to reach accord because their sharing includes doing lots of things together and enjoying doing them. The entwinement of their lives provides a reservoir of mutuality that can be drawn upon to reach agreement without anger or abuse. In contrast, Christine and David cannot overcome their differences because they cannot even shop together without bickering.

Finally, the story shows why expressing care in the casual transactions of everyday life is crucial to a friendship. Expressing care presupposes attention—noticing what is going on in the other person's life. Only then can we inquire whether something is amiss or whether we are needed. Sometimes we express care by the small gesture of massaging a spouse's feet, as Matt does for Franny. Sometimes we show concern by just asking if the friend is hurt. It drives Christine crazy, for instance, that David is never moved by her frequent domestic missteps to see if she is alright or needs looking after. She rightly wonders whether he cares or even notices her cries of pain. Through the interactions of the friends, we see that expressing care by itself is a form of caring for one another and that sometimes it is enough to buoy the friend.

II. Different lives, different problems

The film is structured as myriads of short scenes that cut back and forth among the four female friends, often in the company of one another, their male companions, or families. In this fashion, mini-episodes in the lives of the characters are diced into portions of interwoven, smaller scenes. Interspersed with this predominant focus on the individual characters are several events at which all the friends are gathered, as when they try on

dresses or meet to dine. The quick-cuts introduce us to the four friends within the first few minutes of the movie and the movement from character to character energizes the narrative rather than fragmenting the story. But for purposes of exposition, it will usually be more helpful to examine a character's particular episode *in toto* as it transpires in her life, not as it is presented, in interrupted fashion, in the movie.

The story is book-ended by two meals. During the first dinner at a restaurant, the very wealthy couple of Franny (Joan Cusack) and Matt (Greg Germann) invites the friends and respective spouses to a posh fundraiser for research on ALS (Lou Gehrig's Disease) for which they have purchased a table. When asked about another donation, the couple discloses that they have contributed two million dollars to their daughter's school. The friends are flabbergasted, from which we surmise that they were not aware of just how affluent Franny and Matt are. And perhaps people should not disclose their full wealth when their bank account so exceeds those of their friends. Awareness of great financial inequality can be a barrier to intimacy or create unrealistic expectations.

Jane (Frances McDormand) says that Franny and Matt should give the money instead to Olivia (Jennifer Aniston) since she works as a maid. Early on, then, the film raises the question of helping friends and how money should figure in such help. Should we not help those we love at least as much as individuals who are strangers to us? Franny shortly asks her husband privately whether they should give Olivia money and he says, "No, no, not again." Matt points out that Olivia could be doing something other than cleaning houses and that hiring her to clean their house would be even worse than giving her money. The question of lending or giving money to friends resurfaces midway in the story.

When Christine (Catherine Keener) toasts Jane on her birthday during the meal, Jane is moved and says that she would want to die if she did not have her friends. But she feels deadened even with these friends. For much of the film, we watch Jane gripe and snipe and refuse to wash her hair. The neglect of her appearance is especially significant as she designs her own line of stylish, expensive dresses. Motifs for the major characters are thereby established early on. Besides Franny's wealth and Jane's malaise, we know that Olivia is underemployed, smokes pot, and is not doing well with men. We also know that Christine and David (Jason Isaac) are having marital problems when Jane tells her husband, Aaron (Simon McBurney), that they have not had sex in almost a year. The tension in their relationship is heightened by the second-story addition they are putting on their house. It will be the crux of yet another bone of contention, as if adding externally to their domestic life has the untoward effect of subtracting from its emotional foundation.

The pair collaborates in scriptwriting, working on their computers at desks that face each other. Here, too, discord marks their relationship. Jointly composing dialogue, Christine protests that David is bullying her to get his way. She then asks why there is so much noise. David points out, "Maybe because we're building a second story." Christine seems oblivious to the ramifications of their earlier architectural decision, including how it obstructs their neighbors' views.

We soon witness Olivia scoring a free sample of a very fine skin cream at a department store. She pretends not to recall the name of the cream, implying that acquiring the sample is more an afterthought rather than the purpose of her errand. She repeats the charade at the cosmetic counter of a second store, expressing mild surprise when she sees the product, as if not sure that is what she was looking for. The salesman officiously rejects her request for an additional sample for a friend, but Christine shows up early ("to get away from my stupid husband") and Olivia directs the clerk to give her the cream. One of the few and small triumphs in Olivia's tight little world. She happily stacks up this and other beauty product freebies once home.

In sharp contrast to the cutting exchanges between Christine and David are the calm, measured discussions that take place between the wealthy spouses, Franny and Matt. As Matt massages her feet, Franny worries that their son does not play with balls. She wonders whether their son is gay. "Would it bother you if he was gay?" asks Matt. Their conversation is easy, leavened with gentle humor. Even when they disagree, there is no acrimony. Matt insists that expensive shoes are good for their daughter because her feet are growing. When Franny challenges him as to how he knows this, Matt says that he just does.

Theirs is an example of a relationship in which doing things together and sharing interests maintain their harmony. It is no wonder that Franny and Matt are the only couple whose sex life seems fulfilling. In obvious contrast to Jane, who is letting her hair go unwashed for days if not weeks, Franny is complimented by Matt on how good her hair smells. Although the compliment is in the realm of the physical, it indicates a deeper level of mutual regard and appreciation. We come across another telling example during the ALS benefit dinner at the film's conclusion.

Aaron's sexual orientation is both a topic of conjecture among the friends and a theme or thread of the story. He is gentle, supportive, keen on attire, and attractive to men, fitting snugly into the cultural image of the gay man. Of the male spouses, Aaron is also the most completely realized and morally engaging. In fact, he is arguably the most likable character in the story. Aaron confronts his wife, Jane, constructively and intelligently, and puts his son to bed with such a soothing voice and peaceful imagery that we take his side when he tells Jane that he wants another child. Although Jane rebuffs him, she is funny, saying that she cannot have another child because she is "a hundred years old."

When Jane and Aaron go out for lunch, Jane harps on the lack of service and notes that the waiter was nice to Aaron only because he thinks Aaron is cute. She was ignored. When the waiter does show up, he smiles at Aaron and addresses only him, bearing out Jane's observations and disgruntlement. Aaron points out one of Jane's dress designs, worn by a woman at a nearby table. Although Jane groans that the woman does not look very good in the dress, Aaron is undaunted and invites her to revel in the public display of her creation.

Like Matt with Franny, Aaron is appreciative of his spouse and encourages her to take pleasure in her success. *Friends with Money* deftly illustrates that a pivotal ingredient in friendship is just this: helping friends see what is positive in their lives and encouraging joy in life itself. Too often discussions of friendship overlook this most commonplace yet basic

dimension of personal relationships. Delight in the everyday is ingredient to a good life and who better to remind us to savor these mundane moments than friends, the very people embedded in the merry moments themselves?

III. Marital discord: Confrontation vs. constructive criticism

A major storyline is Olivia's relationship with Franny's personal trainer, Mike (Scott Caan), which Franny has initiated as a blind date. From the outset the relationship is skewed, as Olivia allows herself to be exploited and taken for granted. We realize early on that she lacks self-respect and that the deficiency informs her enduring relationships, and even relationships that do not endure. Unless we expect and insist on the respect that is our due, the relationship is liable to lack the equality necessary to genuine friendship. Caring friendships require approximate equality in respect and autonomy. *Friends with Money* explores equality and its absence in regard to the independence of thought and action that comprise autonomy. The greatest impact of imbalance in wealth may be its contribution to inequality in autonomy. Yet even where money is not pivotal, Olivia is at a disadvantage. Just as she is on the short-end of the now-defunct relationship with her married love-interest, so does she take a subordinate role in her interaction with the trainer Mike.

During their initial lunch date, for example, Mike keeps gawking at a woman at another table. When he asks Olivia how he looks, she replies wittily, "Compared to what? We just met." Mike half-heartedly apologizes to Olivia, telling her that he had been in love with this woman of his gaze in his adolescent days and that she ruined his life by dumping him after a few hours of romance. We soon see Mike sitting next to this old flame, laughing and waving over to an annoyed, abandoned Olivia who turns away and reads a newspaper. As she pays the bill, Mike runs up to the counter and says that he is sorry for deserting her. Outside, Mike asks Olivia for another date. When he prattles on about the girl and his youthful crush, Olivia asks him, "Are you stupid?" We think that she is finally going to wash her hands of the boor, but instead she accedes to his request to accompany her on the cleaning job to which she is heading.

At the home where Olivia works, Mike examines the unhealthy contents of the client's refrigerator, and does not clean it as Olivia instructs. He presently asks her for a slice of her pay, claiming (falsely) that he helped. Olivia stares at him. When she gives Mike some of her cash, we in the audience cannot believe that she would let herself be so used. Mike has the nerve to tell her that she could make a lot more money as a personal trainer, as he does! Later in the story, we will see Olivia entertain the idea of becoming a trainer, even though she dislikes exercise, in order to better herself financially. Money weighs on her, and when she asks the fabulously rich Franny for a loan, an important dimension of friendship is laid bare.

Christine and David have trouble working on their current script. And while disputes about writing, as well as conflict over the addition to their house, are real, they are more a symptom of what truly ails the marital friendship. The overt disagreement concerns

maintaining consistency in the dialogue and behavior of the characters they are creating. When they discuss whether characters would actually say or do certain things, we cannot help but wonder about the speech and actions of Christine and David themselves: whether how they speak and act toward one another is consistent with a loving marriage.

Christine starts to eat a snack as she argues with David about their writing. David voices disapproval and tells her that he "can see it on your ass," referring to the weight she has gained from all her snacking. Christine is nonplussed. David defends his observation by saying that he thought she would want to know. Christine retorts, "What made you think I'd want you to tell me if I were gaining weight?" She presses on, "Would you want me to tell you, for instance, that you always have bad breath?" David answers that he guesses he would want to be told. Christine transmutes the hypothetical into a hurtful assertion, saying, "So now you know." As if that were not enough, she elaborates, "Your breath smells like a dead man."

When David asks Christine why she did not tell him before, she says that she did not want to hurt his feelings. David denies that his feelings are hurt since the bad breath is not his fault "per se." Christine chides David on his lack of sensitivity, to which he responds, "So I'm a dick because I don't take the criticism personally!" When Christine goes outside, past the Hispanic construction workers who are doing the expansion of their home, she is glared at by a neighbor. The film thereby foreshadows another conflict between Christine and David: how their second-story addition is impinging on the visual prospects of their neighbors.

The tension between Christine and David raises the delicate issue of the expression of care in friendship: how can or should we help friends who are struggling with marital conflict or crisis? Christine and David's friends are keenly aware of the couple's marital problems. We hear different women talk of the infrequent sex, public squabbling, and the need for marriage counseling. Yet none of them really does anything to help the couple deal with their difficulties. Jane does listen to Christine complain about David and her support certainly gives some comfort. All well and good, but Jane does not address the substantive issues that chronically plague her friend's marriage. Aaron, on the other hand, actually pays attention to the details of the problems. *Friends with Money* uses Aaron's attentiveness and responsiveness to suggest the kind of help individuals can give to friends when their marriage is falling apart. He makes the effort to listen, processes what he hears, and then offers his opinion.

As Christine rehashes for Jane her most recent altercation with David, Aaron offers a judicious appraisal of the spousal brouhaha. He tells Christine that he does not understand why David is a jerk for not being upset, "It sounds like he's just more confident than you." They are two different people, with different strengths and levels of sensitivity. Aaron points out that Jane does in fact tell *him* when he has bad breath, but he just brushes his teeth. He gently observes that maybe the conflict is not all David's fault and that Christine bears some responsibility for the marital discord. The look on her face indicates that the possibility that she plays a part in the strife that besets their marriage had not occurred to Christine. Although Aaron's responses to Christine's complaints do not in fact prompt her to reevaluate

her relationship with David or her role in their conflicts, they do indicate in a matter-of-fact way how friends can help. Friends can say what they see, recount their own experience (such as dealing with criticism from their own spouses), and encourage us to take responsibility for our marriage and its flaws.

Neither the arguments over construction, whether of home or of script, nor the criticisms leveled at one another are quite at the heart of the problem that Christine and David face. They do not know how to discuss their differences in a non-destructive manner. Despite working together (or maybe because of it), Christine and David do not really share their lives, enjoy, or appreciate one another. They certainly never express mutual appreciation. Discussing the lively sex life of Franny and Matt, Christine and Aaron note that they also do not fight much. Aaron attributes their lack of conflict to the security provided by wealth. But lots of cash is not enough to vouchsafe a relationship. Many couples who are well off argue, tear at each other, and divorce. Franny and Matt are the antithesis of Christine and David because they enter into and dwell in one another's personalities. Mutuality informs their relationship at its core. Franny and Matt are the least interesting because the least at war; however, their relationship provides respite from and needed counterpoint to the battles between Christine and David, Jane's despair, and Olivia's empty, ersatz relationship with Mike.

Two incidents involving space or place put Jane's discontent in perspective and disclose her own lack of perspective. Jane confronts a woman over taking a parking space she thinks is rightfully hers. She proceeds to inform the woman that her son had had a play date the previous week with Jane's boy and that Jane had in fact fed him *two* meals. Having heard this complaint before, we know that Jane had been bothered by the lack of acknowledgment from this woman. Appalled at Jane's verbal onslaught, the mother of the boy (seated in the back of the car) drives off rather than discuss the space or the play date with the frothing Jane.

Aggrieved throughout the story, Jane may in fact be right that the mother should have thanked her for taking good care of her son. But Jane seems to be overreacting. Should the mother's ingratitude send Jane over the edge or prompt her to antagonize someone with whom she might have future dealings? Then, too, Jane gives no thought to the way her churlish behavior might compromise her son's relationship with his little friend. Jane's sense of being slighted is consuming her, as we soon witness another outburst in a department store. This time Jane is outraged that two people have ostensibly cut in front of her in the checkout line. After she lashes out with profanity, the store manager asks her to leave. Jane is shocked to find herself being escorted out of the store and throws her would-be purchases on the floor. Beside herself with anger and humiliation, she blindly storms out of the store, smashing into a door, knocking herself out, and breaking her nose.

Jane may have been in the right both with the parking space and with her place on line. However, she allows these petty incidents to get the better of her, working herself up into an anger that is out of all proportion to the events. Why? Clearly Jane feels ignored, overlooked. Recall her similar complaint about the waiter in the restaurant, a scene and irritation that is to be repeated at a luncheon with her husband and a new couple. Jane will later tell Aaron that she feels as though she is just waiting to die (echoing Christine's accusation that David's

breath smells like a dead man). The film uses Jane's refusal to wash her hair to symbolize her sense of futility and giving up. She claims that washing her hair makes her arms tired and that she is tired in general. What is the point of washing one's hair when it will just get dirty again?

By connecting Jane's personal discontent with the subject of friendship, the film develops a central theme. We ask ourselves how we can help a friend when she feels overlooked, tired with the upkeep of the everyday, as though the joy of life has leaked out. Aaron's response later, in the car, gives us one viable possibility. He confronts his wife about her hair, her anger, and her ennui. Having just had lunch with some new friends, Aaron asks Jane why not getting waited on promptly and not getting another cup of coffee is so important. During the meal, he had asked Jane not to get in a tizzy over the lack of service because they were "having a really lovely time." In other words, we have some control over whether we let minor disturbances spoil our delight in the experiences that make life worthwhile. By confronting us about our debilitating negativity, friends can evoke self-reflection in us and perhaps subsequent reorientation toward the "slings and arrows of outrageous fortune."

Aaron demands of Jane, "What horrible injustice was done to you?" He continues by asking why she is neglecting her hair, and she utters her refrain that she's tired. Aaron presses on, "Of what?" Jane candidly reveals, "There's no more wondering what it's gonna be like." She seems enervated by the fatigue of boredom, not just periodic boredom with this or that, but boredom with everything—with her lot. Aaron probes further, "You don't like your life?" Somewhat chastened, Jane replies, that she does like her life. Aaron's response to his wife's unhappiness might be characterized as solicitous confrontation. As indicated, Aaron does not cast Jane's unhappiness as something that weighs on him, sabotaging his happiness. He keeps the focus of conversation on Jane and what exactly ails her. Its thrust is to force Jane to needed introspection and away from her peevishness at outward events that reinforce her sense of being overlooked. Feeling neglected by others, waiters and shoppers and mothers, Jane neglects herself. At the core, she feels a lack of significance, issuing in a loss of vitality.

Unlike her female friends, who fail to push Jane to examine the cause of her discontent, Aaron rouses Jane to face the value of her life—though a little late in the day, after the self-destruction of the broken nose. The film indicates that friends can help us out of our funk by paying attention to the cues we give and then responding in a forthright, but caring manner. Of course, the exact form of that response depends on the relationship and the nature of the unhappiness. The fundamental question of helping those about whom we care takes another variation in Olivia's decision to pursue a career as a trainer.

IV. Money, helping and expressing care

Intrigued by the possibility of earning much more as a personal trainer than as a maid, Olivia approaches Franny about borrowing 1800 dollars for the course that would certify her in the field. Franny responds by saying that this is a lot of money. In one sense, this is

simply not true. Recall that Franny and Matt not only paid thousands of dollars for the table at the ALS benefit to which the friends had been invited, but that they gave two million dollars to their daughter's school; 1800 dollars is small change to this opulent couple. If they can give so much money for the benefit of people they do not even know, surely a couple of thousand for a friend goes without saying.

Nevertheless, the money Olivia is asking for is a lot between friends, especially when one is just getting by. Giving money can alter a friendship, exacerbating an already existing inequality and perhaps, as Matt has implied, fostering dependence. Under some circumstances, the needy friend can actually come to feel resentment at being in the debt of the wealthier party. Although much is often made of friends responding freely and fully to the needs of each other, the story dramatizes the powerful line from Cindy Lauper's song, "Money Changes Everything." What is the most helpful or appropriate way for friends to help one another out: loans, gifts, some combination, or sage advice instead of cash? The exchange between Olivia and Franny shows that there are no good general answers because friendships are determined by the particulars of the relationship. Consequently, the best course of action must reflect the concrete configuration of the friendship, and Franny's response to Olivia does not.

Franny suggests that Olivia go back to teaching and points out that of all the friends, she is the only one who does not even like to exercise. So how exactly does becoming a professional physical trainer make sense? We have heard Franny explain what a wonderful teacher Olivia was, but that the disproportionate wealth of her students dispirited her. Franny then makes the loan contingent on Olivia going to therapy to figure out what she wants to do with her life. Here *Friends with Money* deftly discloses a subtle facet of friendship and advice. Franny's questioning and advice have much to recommend them. Olivia really should think through how becoming a fitness guru involves exercise and a commitment to physical regimen that she herself seems to lack. And perhaps Olivia would do well to get professional counsel in deliberating over her options among future careers.

Nevertheless, Franny is not in a position to offer these observations or advice. Because Franny is the person to whom Olivia is applying for help, and because she is swimming in money, she comes off as carping or tight-fisted by raising objections to Olivia's plan. An important truth is thereby slipped undramatically into what appears to be the most ordinary of interactions: some things need to be said, but *which* friend does the saying can make all the difference. The freedom of friends to comment or question is dependent on context, history, and relative positions—with regard to children or parents, for example, and not just money. We can easily imagine someone asking tough questions of a friend or giving good advice to her, and being the right one to do so because she has struggled with wayward children or infirm parents. In this case, Franny is not the right person to question Olivia about her career choices even though one of the friends certainly should. Franny's hands are tied because she is extremely wealthy and because Olivia has appealed to her for financial help.

We might recall that Franny also tried to improve Olivia's love life by setting her up with Mike. Not such a good idea, as it turns out. From these two incidents, we can conclude

that Franny's weakness is that she is not very perceptive in judging how to help friends, or Olivia at any rate. Franny lacks judgment in responding to need, but then again, such judgment is not that easy to come by. As we (and Franny) might anticipate, Olivia is annoyed when Franny says that she has to check with husband Matt before making the loan. Olivia notes how much money the couple spends on their children's shoes and goes on to say that the money is, after all, Franny's not Matt's. But Franny disagrees. She explains, as if it is obvious, that the money belongs to Matt as well because they are married. It would never occur to Franny to take greater control of the wealth just because she brought it into the relationship. It is "our money," just as everything else is shared in their lives.

As noted, the bedrock of their harmonious marriage is the sharing and mutual enjoyment of one another. We see them shop together, rear their children together, discuss their decisions amicably. In fact, it is because they share so much that they can resolve disagreements swiftly and without rancor. Among the purposes and values that they share is the desire to reach agreement, to share one another's viewpoint when all is said and done. In the fundraising finale, it is telling that Matt is drawn to the tandem bicycle among the items to be auctioned. He sees how he and Franny could ride it together. More than wealth, their shared lives is what keeps their marriage free of acrimony.

The big blowup between Christine and David begins with Christine finally realizing that their second-story addition is infuriating the neighbors whose views are severely obstructed. Perhaps the impact of the addition on vision is a metaphor for the lack of perception in the interactions between Christine and David. They do not really see each other very well, and they miss what is best in each other. David is remiss in not paying attention to Christine's repeated mishaps around the house, but for three weeks Christine has herself failed to notice that David had shaved his beard. Inability to perceive the physical condition of one another bespeaks blindness to their spouse's less obvious emotional needs and vulnerabilities. For people who write about personal relationships, Christine and David are not very astute observers of their spouse's outer layers or inner dimensions.

Christine goes into a neighbor's house and sees how her addition is blocking the neighbor's view; the neighbor asks, "What the fuck did you think?" Christine replies that she was not thinking. But David is right in claiming that in the conversation with the architect, the couple was warned that their neighbors would be adversely affected. That was why they would need a special permit from the city. Christine subsequently interrupts the Mexican construction workers, telling them to go home. David comes out of the house and countermands her order. He confronts his wife, asking her how she could not know this was happening. (As Olivia had told Franny, the couple need marriage counseling more than an addition to their house.) The deeper issue soon surfaces when Christine burns herself. She tells David that he never asks how she is, with all her banging and toe-stubbing, and now minor burning. Christine wonders whether David has even noticed, and he replies that he guesses so. "Does it ever occur to you to say, 'Are you alright?'" But he misses the point when he retorts, "But you *are* alright!"

Christine persists in her complaint because what matters between friends, including husbands and wives, is caring and expressing care. What we need is the attentiveness of noticing, as Christine explains, followed by a genuine expression of concern. Even if we think the friend is not seriously injured, what counts is that we have been emotionally engaged by the incident. We are involved because the welfare of our friend matters, a lot. For example, when we are clearly not the cause of the pain of someone we care about, we might nonetheless say that we are sorry. Not for our culpability, since there is none, but because we wish the untoward event had not happened. We connect with sympathy. And knowing that someone sympathizes with what we are going through makes all the difference. When Christine later bangs herself, her maid asks from another room if she is all right. The contrast with the now-departed David is funny, but it is also poignant.

For a more developed and marital contrast, consider Aaron's solicitousness of Jane. Earlier in the story, when he made an amorous overture in bed, Jane put him off, saying that she was tired. Although rejected, Aaron strokes her and says that he thinks her forty-third birthday was especially hard on her. That she underestimated its impact on how she saw herself and her life. Aaron expresses care and sympathy for his wife's mid-life malaise in a way that David cannot for his wife's more overt bumps and bruises. Life is full of bruising and friends help us deal with it, often by letting us know that they notice, worry and—should the situation warrant—are available to take care of us. Indeed, when Jane breaks her nose, all the female friends show up at the hospital, along with Aaron. And when Christine turns to Jane to talk about her marital woes, Jane listens and offers comfort.

But David does not or cannot cross the psychological space to enter into his wife's physical knocks, however inconsequential they may turn out to be. Sometimes we do need a friend to come to our aid: to help us with a serious injury, an emotional crisis, or a financial morass. But sometimes, we simply need to hear that a friend is concerned and wants to make sure that our difficulty is not severe. In those cases, the expression of care is like a balm, reassuring us that the friend is aware enough about our need to be comforted and that were we in serious straits, the friend would rise to the occasion. Expression of care thus works on the immediate level of emotional resonance as well as indirectly as a surety against a time of greater vulnerability.

V. Looking for love: From Mike to Marty

While all this is going on, the trainer Mike continues to accompany Olivia on her cleaning rounds. He allegedly helps her in her work, but we see him lounge and then receive a portion of Olivia's meager wages. During their last house-cleaning date, Olivia opens a present from Mike—a skimpy, sexy maid outfit. A reclining Mike directs Olivia in her vacuuming and then in her dusting, to show her outfit-clad body off in the most fetching of poses. She is also to address him as "Mr. Mike." Olivia objects that she thought the role-play was supposed to entail sex, but when they do make love, it is perfunctory. As Olivia has told Franny, the

matchmaker, Mike does not look at her. We wonder exactly why Olivia has loveless, joyless sex with Mike and why she allows him to take advantage of her.

Following their cleaning-cum-sex tryst, Mike kisses Olivia and tells her that he already has dinner plans. Olivia is visibly disappointed. After she thanks him for her so-called present (the maid get-up), Mike asks for his share of the money. Olivia asks, "You really want this money?" Mike falsely claims to have helped. Although Olivia says, "You're a fuck," she gives him the money, and then follows him in her run-down, economy car. Mike is driving a BMW convertible, emphasizing what a heel he is to cut into Olivia's skimpy pay. Olivia follows Mike to a restaurant where she sees him at the bar with the old girlfriend. She stares after him, angry and hurt.

Olivia soon begins calling her clients, leaving voice-mails to say that she is through cleaning for them. While doing so, she slathers her feet with liberal dollops of the expensive skin cream from a large jar, clearly not a sample. We infer that she has pilfered it from a former client, the woman who left a troubled voice-mail for Christine, who referred her to Olivia for cleaning work. Olivia is then surprised by Marty, who actually answers his phone. Under his questioning, she lies and says that she has another job, in cosmetics, the fabrication most ready-to-hand, or to-foot. When Olivia asks Marty what he does, Marty answers redundantly that he is "recently not employed at the moment." He says that he used to do a little bit of everything and a lot of nothing, and then asks Olivia for a date. Marty seems to be a slob and a loser: unkempt, unshorn, and unemployed. Probably worrying that she will wind up paying the bill, Olivia nevertheless accepts Marty's invitation to get together. We worry that she has gone from bad to worse. From a cad (Mike) to a n'er-do-well, Marty.

Intermittently, throughout the film, Olivia had been calling her former lover, hanging up the phone when she heard his voice. When she finally talks with him, he reminds her that she cannot call him. Olivia tells him that she wants to see him and asks if he misses her. He quickly dismisses her and hangs up. Olivia calls back and this time the wife answers and tells her off. Olivia explodes in frustration and rejection. Her track record with men is not good: brief flings with married men and a self-denigrating, sexual dalliance with a self-absorbed lout. And now Marty.

Their date turns out to be Marty accompanying Olivia to the ALS fundraiser where he will, in a manner of speaking, replace the departed David. Where Olivia had been without a partner at the earlier dinner, now it is Christine who is unescorted. Marty greets Olivia at his door; somewhat scruffy, he lights up at the sight of her and tells her she looks amazing. We realize that it is the first compliment paid her by a man in the film. As Marty goes to put on a tie, off-screen he echoes Olivia's earlier complaint about throwing fancy parties to raise money when the money for the party could itself be given to the charity. Olivia smiles and nods. They are soon chatting, sharing a laugh and a joint, with Olivia telling Marty that he is funny.

They seem to be hitting it off. Yet Olivia's relationship with Marty is perhaps the one false note in the film. Not the relationship so much as the fact that Marty is given the

attribute of great wealth. On the way home from the ALS benefit gala, Marty tells Olivia that he does not work because, "I'm really rich." Olivia chuckles, "Yeah. You wish." Marty reveals that he has inherited all of his father's money and so does not need to work. What had seemed like the evasions of a good-for-nothing over dinner now turn out to be the playful puttering of a man of independent means. When asked what he did, Marty had said that he "dabbles in some stuff," does investments, "gets stuff done." Vague and not very encouraging at the time.

But notice that for Olivia's uncertainty in career and finances, Marty functions as a *deus ex machina*. His money is a convenient plot mechanism to transport Olivia into the realm, at last, of friends with money. She does not have to make an important career decision, as Franny had rightly but inopportunely urged. Instead, she has finally found someone with whom she clicks, and lo! he is loaded. Olivia is saved, as if by a 'Prince Charming' disguised as a lay-about. Of course, she gets credit for not judging the frog harshly before he revealed his royal pedigree. Only because she gives Marty a chance does she discover his humor, sweetness, intelligence, and immense inheritance. We wonder, though, why his personal characteristics could not have been enough without all the loot. Could not Marty and Olivia have lived happily ever after, smoking grass, and working at low-paying jobs? We will never know because the movie's happy ending for Olivia had to include a millionaire, with no redeeming effort on her part except a kind heart and an open mind about a grubby, apparent loser.

VI. Variety and verity in friendship

Vibrating through the film is the question of Aaron's sexual orientation. We watch as several men are attracted to him and either approach him directly or, as with the waiter, are flirtatious. Various friends and spouses speculate on Aaron being gay or simply assert it as evident. After one man tries unsuccessfully to pick Aaron up at a ("Tse") cashmere clothing sale, he soon meets his doppelganger. Not only is the man also named Aaron, but he is interested in clothing and décor, and is married an identical eight and a half years. The Other Aaron's wife ironically claims that the primary Aaron is gay when her own husband fits the stereotype just as neatly.

Yet continually raising the question of whether Aaron is gay does not seem to go anywhere, unless that is the point. By the story's end, we really do not care whether Aaron is gay, and maybe that is what *Friends with Money* is trying to get across. Aaron is caring. He is attentive and kind to his wife and son, as well as to his wife's friends. Aaron tries to be helpful and is sharp only when Jane persists in bemoaning her fate. Even then, he asks good questions, questions that compel her to think seriously about herself and her sour outlook. It is as if his penchant for soft, yielding material, such as cashmere, expresses the suppleness of Aaron's emotional scope. He wraps his thought and feeling easily and unselfconsciously around the people he cares about, and responds nurturingly. Unlike Christine and David, Aaron

pays attention and is compassionate. He takes care of himself, with clothing and his new friendship with the Other Aaron, but not at the expense of his friends.

Although clever and breezy, *Friends with Money* manages to enlarge our appreciation for the subtleties and complexities of friendship by immersing us in the daily details of women whose lives overlap but diverge tellingly. The task and privilege of helping friends is shown to require sensitivity and judgment. Providing comfort and aid in times of marital stress, financial woe, or midlife despair is no mean feat. Even if we know what needs to be said or done, we may not be the person best situated to say or do it. The relative positions of friends and their history together may mitigate in favor of someone else helping the friend with just this problem. This is because inequality in wealth, marital happiness, or career, for example, can create barriers to giving or accepting help.

The sharp contrasts among the married couples underscore the facets of friendship that promote the resolution of disagreement and show why expressing care is so important. We see how much the lives of Franny and Matt are entwined; they do things together and share money, values, and interests. The mutual regard and sharing promote concord, enabling the couple to resolve their differences before they swell into tempests. But Christine and David lack sufficient mutual engagement and appreciation to see them through their conflicts. Because they have no common ground from which to proceed or to which to return, they are caustic with each other and their disputes mushroom, out of control.

Finally, the film dramatizes the role of expressing care and concern for our friends. Where David seems not to notice or care that Christine bangs, bumps, or burns herself, Aaron tries repeatedly to lift Jane out of her perpetual funk. He suggests that her forty-third birthday has taken its toll and encourages her to delight in the sight of women wearing the dresses she designs. When all else fails, Aaron lovingly but firmly forces Jane to confront herself and what it is exactly that she does not like about her life. By the time the story ends, critical dimensions of caring friendship have been vivified and, at least for some of us, shown with unusual clarity and depth for a successful Hollywood film.

Chapter 4

From Despair to Care: Self-Transformation in *Monster's Ball*

I. Life without care

About a third of the way into Marc Foster's *Monster's Ball* (2001), a young man shoots himself to death in front of his father and grandfather. We in the audience are as stunned as his family at the self-destructive climax of the violent confrontation between Sonny and his father, Hank. After Hank admits that he has always hated him, Sonny retorts, "I've always loved you," and then turns the gun with which he has been threatening his father on himself. It is a powerful scene, ending Sonny's despairing life, but it does not end Hank's relationship with him. The scene functions as the time-honored turning point in the story and life of Hank. It rouses him to self-awareness, awareness of the hollowness of a life bereft of caring relationships. As a result, Hank consciously sets out to change who and what he is.

Monster's Ball illuminates care ethics by developing the connections among its core features through the trope of self-transformation. The portrayal of Hank Grotowski's self-conscious decision to redefine himself makes salient the social nature of selfhood and autonomy; sympathetic imagination; tension between care ethics and the authority of the state; and the importance of narrative to the ethics of care. We will see how Hank is moved by his relationship with Sonny to reevaluate and transform his life. Realizing that his own deepest needs are not being met, Hank breaks off from the social relationships that have defined and confined him, and thereby opens himself to the intimacy and sympathetic relationships central to the ethics of care. Because he enjoys a socially conferred autonomy, moreover, Hank is able to take control of the narrative of his life and change its course.

The film also subtly reminds us of the specificity of personal narrative by what it elides from the story. Not knowing such things as how Hank's wife died or the crime for which Lawrence Musgrove is receiving the death penalty weighs on us. Was Hank's wife a suicide, like his mother and son? Why did Lawrence Musgrove kill someone and was it a white person? Wondering about these narrative gaps draws our attention to the concrete particularity of the lives of these characters and the cinematically rendered story that does not quite capture it. We should not, then, view *Monster's Ball* as about racism, white southern

men, or black women *simpliciter*. Rather, the film is aligned with care ethics in constraining us to take into account the specifics of the main characters' current circumstances and prior histories. When we do so, we find that questions of race and power are repositioned and more open-ended.

The plot moves by means of the intersection of the families of Hank and Leticia. Although their families revolve around them, Hank and Leticia are nevertheless two isolated individuals who are lost without caring relationships to support them. We are led to reflect on the social nature of the self through the portrayal of their isolation and Sonny's overwhelming, explicit need for caring relationships. The conception of the self endorsed by care theory includes the notion that our identities are the result of relationships with other people. The ability to understand ourselves as individuals, for example, presupposes human relationships, as well as a minimal level of care within them.

We learn to understand ourselves by discovering how we are viewed by others. Our self-conception, then, is freighted with the conceptions other people have of us. In the film, Sonny is viewed by Hank much as Hank has been understood by his father: as part of a family line of white males enforcing the laws of a racist society. As Hegel observes, "The individual finds concrete duties and social situations, which are what they are, before he entered them and which offer opportunities and demand fulfillments."[1] We will see how difficult it is for Sonny to resist these duties and social expectations, and for Hank to repudiate them.

Because our identities are social, change of identity has a strong interpersonal component. To transform who we are, as Hank does, requires changing our relationships. Crucial to this identity are also the ends that direct our thought and govern our action. These ends are socially shared as well as derived from our associations with other people. The social character of our goals will prove to be pivotal in Hank's self-transformation, as he must distance himself from his long-held aspirations and the social relationships that reinforce them.

Besides influencing the ends that we pursue, interpersonal relationships also shape our habitual modes of thought, action, and emotional response. Whether we are even disposed to care about other people is itself a matter of our entrenched forms of social interaction. We will see that the habitual modes of feeling and interaction engendered by prison work are antithetical to dispositions that animate the ethics of care, such as sensitivity to the needs of others and motivation to meet these needs. The antagonism between the guiding values of care and the norms that govern successful prison duty is responsible for Sonny's failure as a guard. Once he internalizes Sonny's caring orientation, Hank necessarily finds his career in law enforcement intolerable. And this leads to the next social aspect of our personality.

The self is further socially constituted by virtue of our identification with other people. Incorporating the values and interests of others into our own identities often occurs unwittingly, through family life and group affiliation. *The Squid and the Whale* dramatized the way in which over-identification can stultify the development of autonomy for an adolescent. *Monster's Ball* inverts the order, portraying how a father's identification with his son can liberate him from a suffocating life devoid of care. We are given to understand that

Hank and Sonny have identified with their fathers and prison work. But crisis may move us to embrace new values because we begin to identify with a different person.

In the film, we see how Hank is impelled by his identification with Sonny's caring perspective to sever the social relationships at work that harden and hollow him. His sympathetic identification with Sonny also enables Hank to find his way toward relationships that will meet his deepest social and emotional needs. In its characterization of Hank's reinvention of himself, the story also emphasizes the importance of self-care and how it can be in tension with taking care of others. This tension has long existed in women's work and is crucial in dealing with the exploitation and oppression of women. *Monster's Ball* varies this theme by setting the care for a parent against a male's self-care.

As with *The Squid and the Whale* and *Saturday Night Fever*, the film returns us to the roots of care ethics with its focus on the parent–child relationship. However, Hank and Leticia are not merely lacking in care for their sons, as are the parents in the previous films; they are abusive and are ultimately responsible for the deaths of their sons. Yet we also see a parent do a very good job with his children. It is an irony both of the film and of its somewhat jaundiced critical reception that the most successful parent in the film is a black man whose narrative is also incomplete. From what we see, Ryrus appears to be yet another single parent, but we cannot be sure. Unlike Hank and Leticia, Ryrus is effective, able to defend his children against racism and the intimidation that typically augments it. In the course of protecting his sons against Hank's bullying, Ryrus provides his sons with a compelling example of the caring exercise of autonomy.

The film insightfully examines the meliorating and destructive relationships that can hold between autonomy and care. In interrogating the conditions that further autonomy as well as those that limit it, *Monster's Ball* extends our understanding of the social nature of autonomy. Proponents of care ethics are regarding autonomy more favorably than in the past, no longer viewing it as necessarily antagonistic to the conditions and values of care. As noted in earlier chapters, it is useful to think of autonomy as including competency in those skills needed for self-definition and self-direction. Inter-subjectivity is relevant even at this basic level of competency or skill because our various relations with other people can be crucial to our range of choice. Caring relationships further our autonomy even as oppressive relationships, such as those driven by racism, obstruct it.

The dependence of autonomy on relationships with others includes the processes by which we reflect on our selves and make our decisions. Much serious self-reflection and decision-making requires caring relationships buttressed by trust, sympathy, and unselfish concern. We see an example of this in *Friends with Money*, however unproductive, in Christine's conversation with Jane and Aaron about her marital problems. As Linda Barclay observes, "Our ongoing success as an autonomous agent is affected by our ability to share our ideas, our aspirations, and our beliefs in conversation with others."[2] Most of us require a caring upbringing to develop the competencies of autonomy, but the need for others does not end there. We also need people we trust to help us examine our values, order our priorities, and make important decisions. The ability to evaluate social norms

and values from a critical perspective is pivotal in feminist ethics. Because the care-giving that is usually the province of women is reinforced by roles and norms that involve their exploitation and domination, critical assessment is necessary in order for women to free themselves from these social constraints.

The film emphasizes the ways in which Leticia's autonomy is severely undermined by the absence of caring relationships in her life. She has no one with whom to share the burdens of child-rearing and no one whose counsel can help her make tough decisions. As noted, the initial development of autonomy typically depends on the caring relationship between parents and children. Although Hank and Leticia are not good at nurturing their children's autonomy, Ryrus is a caring father whose own exercise of autonomy is likely to foster the autonomy of his sons.

The story also explores the dialectic between care and autonomy from the other direction, by depicting autonomy exercised for the sake of care—sometimes on account of its absence. Sonny's suicide is a response to the desolation of his life without care, and yet it may be the most autonomous act he performs. Moreover, Hank's redefinition of himself is inaugurated by severing relationships that frustrate care and has as its ultimate goal emotionally rewarding attachments. Hank's autonomy enables him to understand the implications of the absence of care in his life and enables him to do something about it. He epitomizes Virginia Held's (perhaps overly narrow) claim that "the autonomy sought within the ethics of care is a capacity to reshape and cultivate new relations."[3]

While *Monster's Ball* is thematized by the values of care interwoven through the trope of self-transformation, its plot is energized by striking parallels in the lives of the characters. Hank and Sonny, for example, are motherless but live with their fathers, do the same work and engage the same prostitute. Yet Hank's life also mirrors his father's in their shared work, home, and widowerhood. Hank and Leticia are socially stranded, single parents who fail to properly care for their children: similarly abused sons whose deaths are decisive to the plot. And, finally, Lawrence Musgrove's parting words of love to his son intimate the more full-blooded parental care of Ryrus with his two boys.[4] As the parallels play out, sometimes undercut or upended, the lives of Hank and Leticia first brush against one another, then collide and finally become entwined. The final phase of Hank's redefinition arrives when he establishes a domestic relationship with Leticia, thereby completing the transgression of the racial boundaries that had shaped his previous identity.

Monster's Ball serves as a transition from the intimate realm of family and friends of the previous films to the public sphere of society and the state, which are central to *Radio* and *Gandhi*. The family life that occupies the foreground of the story takes place within and against the context of state power and a glaring paucity of sustaining social relationships. Where *Friends with Money* is, as the title indicates, bursting with interpersonal relationships, the main characters of *Monster's Ball* are friendless and without communal ties outside of work. The state and its authority, displayed through law enforcement and the penal system, are depicted as opposed to the perspective of care. Sonny cannot escape the conflict between

care and authority (state or parental); Hank must break with prison work to find caring relationships; and Leticia is almost undone by the forceful hand of the state.

II. A family of men/men in family

The story is set in a generic South. We see evidence that the locale is Georgia but the prison uniforms are those of Louisiana. Hank Grotowski (Billy Bob Thornton) lives in a womanless home with his son, Sonny (Heath Ledger) and Buck (Peter Boyle), his father. The three generations of Grotowski men also share careers as guards at the state penitentiary, from which Buck is retired and at which Hank currently heads a crew that includes Sonny.

The opening scenes of the film establish the plot and the issues of care that unfold throughout the story. Hank's passing conversation with the waitress at his usual diner directly precedes Sonny's quick and perfunctory sex with a prostitute in his customary motel. Father and son are thereby temporally joined in the narrative sequencing of the film, but also are alike in meeting their bodily needs in impersonal transactions with women at their paid work. Significantly, Hank also frequents the same motel with the same callgirl Sonny is seeing. When the prostitute tells Sonny that he looks sad, he asks her if she would like to get something to eat. He meets her silence by asking, "Talk?" uttering perhaps the saddest word in the movie. She ignores his invitations to something more than sex, telling him to "take care" as she brusquely leaves. He will have to take care of himself since she could not care less about him as anything more than a john. To eat or talk together would mean face-to-face socializing instead of the rear-entry, faceless sex in which they do engage. Soon we see Sonny try to strike up a conversation with a barmaid, only to have his overtures at something more than commerce again dismissed.

Sonny is clearly reaching out, hoping to connect on a personal level with a woman. He needs conversation more than sex or drink, but such transient, bodily pleasure is all he can get. We will also see that Sonny is a gentle, sympathetic man who befriends two neighboring black boys and gives comfort to the black prisoner Lawrence Musgrove (Sean Combs) on the night of his execution. Race is either irrelevant to Sonny or he is intentionally violating the norms of his culture and family. But however we read him, Sonny embodies basic values of care—relationship, sympathy, and responsiveness—signified in the film by Hank scornfully identifying Sonny with his deceased mother. This feminization is later ironically echoed in the feminizing of Hank by *his* father when Hank quits his job. The apparent deprecation of women (and the ethics of care) intended by the pair of disparaging, gendered remarks is used to ironic effect in *Monster's Ball* to reveal the insensitivity of the Grotowski fathers—Hank and Buck.

The opposition between Hank and Sonny is made apparent by Hank's coming between Sonny and his black neighbors, and later, coming between him and Lawrence Musgrove. Baited by his racist father, Hank accosts the preadolescent black brothers for being on his property. The boys point out that they have come to see Sonny who has just arrived in his

pick-up truck. When Sonny does not respond to Hank's insistence that he get the boys to leave, Hank fires his rifle in the air to frighten them off. As if still a child told not to play with Blacks, Sonny glares at his father. Hank tells Sonny to watch his ass, a harbinger of Hank's strict instructions to Sonny on the execution of Lawrence Musgrove.

Driving to work in his prison uniform, Hank is met on the road by Ryrus Cooper (Mos Def), the father of the neighboring boys. As his sons look on, Ryrus confronts Hank about frightening them. When Hank defends himself by saying that the boys were on his property, Ryrus replies that they are Sonny's friends. All Hank can do is repeat that Ryrus needs to keep the boys off his property. Ryrus reasonably rejoins that his children were not trespassing because Sonny invited them. He proceeds to protect his sons by issuing a challenge, saying that if Hank wants to "play cowboy" (by firing his gun), "I live right here." Hank mechanically reverts to his property rights, refusing to acknowledge the friendship between his son and Ryrus's children.

The scene of Ryrus confronting Hank may be overlooked by viewers (and reviewers) because its early occurrence in the story veils its immediate significance as well as what it portends. The scene does two things that are important from the standpoint of care. First, it contrasts Ryrus as a caring parent with the fecklessness of Hank and Leticia. Ryrus shields his children against danger. He shows them that a black man need not be cowed by a white man, particularly one who wears the quasi-military uniform of penal authority and has the power to execute other black fathers. Ryrus nurtures autonomy in his sons by giving them a demonstration of its exercise—calm, reasonable, and decisive. He is also unlike Lawrence Musgrove, the condemned black father. Where Ryrus stands his ground with Hank and stands up for his sons, Lawrence has been cut off from Tyrell (Coronji Calhoun) for most of *his* son's life.

Secondly, the exchange between Ryrus and Hank also pits considerations of care against the impersonal authority of rights. Hank's stolid recourse to property rights seems flimsy in the face of the friendship relationship to which Ryrus appeals. Where Hank stubbornly reiterates his rights, Ryrus rebuts him with a developed argument from care. We are left with the view that here, and perhaps elsewhere, the caring relationship overrides or disengages rights claims, especially their reinforcement with the spectacle of violence. Moreover, before ending his work as a prison guard, Hank will assert his rights as an authority to deny Lawrence Musgrove caring access to his son by phone.

By portraying Hank conspicuously in the uniform of a prison guard, the film inscribes the authority of the state within the confrontation between rights and care ethics. Hank's appeal to property rights thereby implicates the political and legal apparatus by which the state enforces all rights, including those that oppress Blacks. By privileging care over rights in this encounter, *Monster's Ball* may be construed as calling into question the legitimacy of a power structure that is not informed by the values of care. The film suggests that rights claims by themselves abstract from the particular lives of both Blacks and Whites living in an unjust society. Abstract principles of slave reparation, for example, would be inadequate unless supplemented with the particular narratives of care. Indeed, *Monster's Ball* superimposes

the confrontation between care and state's rights over the particular relationships between black and white individuals. Later in the story, we will see how the institution of prison problematizes the reach of care in an unjust social structure. The film will again employ prison to mediate the relationship between the care ethics and the state authority that subjugates Blacks and undermines their families. When we return to this conflict in the context of Hank ending his career as an officer in a correctional facility, we will see how the film implies the interpenetration of public and private, political and personal.

The scene between Ryrus and Hank, and the tense incident with Sonny as bystander that provokes it, broaches a variety of conflicts—social, familial, and individual. When Hank shoos the neighbor boys off his property, he appears to be acting on Buck's behalf. Buck watches Hank frighten the boys off from the window, having complained of the brothers on their land, saying that soon Blacks will be watching his television. And this does come to pass when Hank removes Buck from the family domicile in order to make a home for a black woman, Leticia (Halle Berry).

After the self-transforming decision to leave the prison, Hank will pick up the dangling ends of Sonny's life: talking amiably with Ryrus and his sons, giving Ryrus business, and embarking on a relationship with a woman, and a black woman at that. The film elegantly folds the story back on itself. Hank will come to embody the needs and values of his son, but instead of threatening *his* father with a gun, as Sonny had threatened Hank, Hank will calmly assert himself against his father's racism. Because Hank's identity has been shaped by the social fabric of the South, he will have to rend that fabric, transgressing its norms, in order to change his identity.

During his last visit with Leticia and his son Tyrell, Lawrence Musgrove does his best as a father, offering a muted version of Ryrus. Lawrence tells Tyrell that the boy is not like him, not bad. To Tyrell's reply that he *is* like is father, Lawrence says, "No, you're not. You're everything that's good about me. You're the best of what I am." Too late to care for his son as he should, Lawrence nevertheless urges Tyrell to develop the artistic talent that he has indeed received from his father. Unfortunately, Leticia is overwhelmed with the work of caring for herself, let alone her son. She escapes from herself with alcohol just as Tyrell comforts himself with the sweetness of secreted candy. Included in the film's parallel structure is this motif of transient, immediate pleasure as a distracting substitute for the sustenance of caring relationships. The alcohol and candy of the Musgrove household mirror the prostitute sex of Sonny and Hank, and Hank's indulgence in ice cream. Angry with Tyrell for being overweight, Leticia abuses him verbally and pummels him to tears. Not realizing that Tyrell is feeding himself to compensate for nurturance not forthcoming from her, Leticia lashes out at him. Tyrell is without a father's presence and his mother's care is inadequate, a representation of black, male youth that is all too realistic. Nevertheless, *Monster's Ball* does offer the hope of a future for Ryrus's sons. We are not left simply with the negation of young Blacks, but are presented with black boys receiving the parental care that is denied to Tyrell.[5] Tyrell's abuse and death parallel Sonny's and make it possible for Hank to empathize with Leticia's grief. In apposition to Leticia's harsh treatment of Tyrell, Hank yells and strikes his son after alleging

that Sonny has interfered with Lawrence's "last walk," prior to execution, by falling to his knees and vomiting. Hank is especially upset because Sonny's exhibition of weakness comes after Hank had warned him that he had to maintain professional distance from Lawrence on the night of his electrocution. Sonny is to avoid the trap of involvement in the story of Lawrence's life and empathy for him: "Can't think anything about him. Just do the job."[6]

III. The social self, autonomy, and care

The crux of the movie is Hank's response to Sonny's suicide. As a result of Sonny's volatile ending of his life, Hank initiates a radical renewal of his own. In its portrayal of Hank's surprising redefinition of himself, the film elaborates upon the social nature of the self, the exigencies of self-care, and the interrelationships between care and autonomy. We do not see Hank reevaluating his life and deciding to change after Sonny's death, but his subsequent behavior indicates that such deliberate reevaluation and decision-making has occurred. What we do see on the screen is Hank quitting his job at the prison. The implications of this for the social conception of the self are multi-layered.

Leaving the prison means abandoning his successful career as the leader of his guard team. Hank's identity has been rooted in relationships of authority and power with fellow guards and inmates. The self that had been shaped through these relationships of control was a dispassionate one, concerned above all with a martial procedure that excludes emotion or personal involvement. To be effectively carried out, prison work bars caring behavior: staying within roles and rules, eschewing interest in the narrative history of inmates, feeling no sympathy for the prison population. Clearly, Sonny's failure as a corrections officer stems from his caring nature. Sonny sits near Lawrence during his last hours and when he tries to help the condemned man through a panic attack, Hank intervenes (as he did with the black neighbor boys). Hank has to tell Sonny three times to sit down and then refuses Lawrence's legitimate request to telephone Tyrell.

Imbued with the perspective of justice, Hank understands responsibility from the administrative point of view, which accentuates supervision and control. On the other hand, Sonny's sense of responsibility flows from the care perspective, in which responding to the particular needs of individuals is central.

Here the film situates the ethics of care in the wider sphere of the state and its authority. It indicates that prison work is inimical to care by inuring its practitioners to emotional connection in favor of detached procedural efficiency. Sympathetic attachment for inmates would surely make disciplining and executing them that much more difficult. The domination of any group, including Blacks and miscreants, requires maintaining its otherness. Breaching difference, as care demands, opens the floodgates to the social fortifications presupposed by hegemony. This is why Hank's relationship with Leticia is impossible until he disavows his identity as a prison guard. Besides the film's grim depiction of the execution of Lawrence Musgrove, Hank's break with the prison (contra

Buck's allegiance) calls into question the pervasive impact of institutions of punishment. We are led to look more critically at the penal system and the state whose laws it enforces, given Hank's change after leaving prison work.

The dominance of the impersonal and rule-governed over the sympathetic and responsive is reinforced by Hank's father, who continues to define himself as a former officer of the prison. He maintains a scrapbook of newspaper stories covering executions, and at Sonny's funeral only says, "He was weak." Severing his ties with the prison, therefore, is also breaking Hank's institutional continuity with his father. The rupture is not lost on Buck, who bemoans Hank's decision as a mistake, as if sensing his son's incipient estrangement from him. Buck egotistically complains that in quitting jail work, Hank is after all quitting on him. And this now feminizes Hank because his desertion resembles Buck's wife (Hank's mother) deserting him: first sexually and then completely through *her* suicide. Just as Hank has berated Sonny for his womanly weakness, Buck returns the favor by so characterizing him. Although both fathers mean to denigrate their sons, the shared feminization actually valorizes Hank, preparing us for Hank's radical reinvention.

Answering Buck's charge that ending his prison career is a mistake, Hank simply says, "I can't do it anymore." He can no longer identify with the viewpoint of a jailer and leader of an execution team. He can no longer tell guards like Sonny not to empathize with prisoners or help them through their final, anxious hours on earth. It is revealing that Hank uses similar language when attempting sex with the prostitute. He tells her, "I can't do this tonight, Vera." Vera calls forth veracity. The truth is that Hank cannot perform: impersonal and uncaring sex or impersonal, uncaring work. His inability to perform is literally linked with his suicidal son by the prostitute asking him about Sonny just before Hank's unmanning. Figuratively, Hank commits a kind of suicide. Resigning from work, he terminates his former life.

Hank dramatizes just how much of our identity is shaped by social relations by symbolically burning his prison uniform and refusing the warden's offer to keep his badge as a memento. Because of what soon takes place in the story, we can infer that Hank has reflected on what these relationships had made of him and decided to change—changing his work is the start of changing his identity.

Following Hegel's well-known master–slave dialectic, the guard is himself trapped by and in his objectifying treatment of the prisoner. The prison guard faces an unpalatable dilemma. If he carries out his duties effectively and dispassionately, then he is alienated from his subjectivity, as Hank is so alienated. On the other hand, if the guard allows himself to be emotionally available to the prisoner, then he cannot function efficiently according to the official institutional norms, as befalls Sonny. Indeed, the gaze of the prisoner, within which the guard is himself delimited as an object, is represented in Lawrence's sketches of Hank and Sonny. The guards become defined as the prisoner sees them. The prisoner's power over his captor is thereby itself objectified, "captured" in a likeness.

Since the prison is a socio-physical manifestation of the state's power, the film depicts the interpenetration of the political and the personal. Guard and prisoner alike are conditioned by their place in the state institution that is the culmination of the state's subjugation of

the black male. The story indicates that such an institution, as currently configured, is incompatible with the ethics of care. The law and policies through which the penal system functions must conflict with care. A truly caring society could not have these laws nor would it incarcerate and execute as it now does. Interpreting *Monster's Ball* as a critique of the death penalty, Sharon Holland writes that Forster "exposes the work of prisons in the extended take on Musgrove's last day on death row."[7] She points out that after Musgrove is shaved and diapered, his day culminates in the staged spectacle of electrocution, during which he is "literally screwed into the electric chair."[8] Replete with an audience in the mini-theater to watch, "The cap is pulled over his face, and we fade to black for a few seconds as Musgrove smolders."[9]

The perspective of care, invited by the pacing and filming of Musgrove's final hours, not only condemns the brutalizing manner in which capital punishment is carried out. It also connects state execution to the control of black males and the ensuing devastation of their families. We will pursue the relationship between the ethics of care and the social structure in the succeeding chapters on *Radio* and *Gandhi*.

IV. Redefinition and identification

What interior dynamic accounts for Hank's apparently impetuous break with the past? The story implies that two psychological processes, articulated in care ethics, undergird Hank's overt behavior: a socially informed imagination and sympathetic identification. In turning his back on his career in the prison, Hank imaginatively distances himself from his "habitual modes of self-understanding," which results in externalizing an element of himself.[10] To externalize his role as a prison official is "to reject it as a motivating factor in [his] actions," and to conclude that what he has valued is no longer "worth caring about."[11] By dissociating himself from an institution of incarceration and execution, Hank is repudiating what it has made of him—a man who feels nothing, as he later tells Leticia.

As if writing with Hank and his relationship to Buck in mind, Catriona Mackenzie claims that "what matters to us may be connected with commitments to others, for example parents, that are not of our choosing."[12] Hank and Sonny appear to have unreflectively followed Buck into penal work, illustrating how our identities may be defined by relationships and values whose influence we accept without question. But Sonny's tragedy alters what matters to Hank, or rather, opens him to seeing what has mattered all along but had been obscured. Hank has had the positive cultural image of head prison guard from which to derive his self-esteem; however, he now deliberately disowns it. The crisis of his son's suicide precipitates Hank's break with his past by (ironically) providing him with the more promising image of his son—in particular, Sonny's longing for a caring relationship.

Sonny's sudden suicide, as if performed as a final offering to his father, propels Hank to a sympathetic identification with his son. Sympathetic identification provides an emotional enlargement of self to include the experience of other people. Of particular

72

relevance to our analysis of the story is Genevieve Lloyd's insight that sympathetic identification facilitates the "transformation of identities."[13] We can change, often self-consciously, by internalizing another individual's suffering and aspirations. Embracing Sonny's most pressing desire and need, Hank opens himself to the sort of relationships that Sonny craves. These relationships will prove to be decisive to Hank's reinvention of himself. He interacts affably with Ryrus (father of Sonny's young black friends), helps Tyrell and Leticia, and then enters into a serious relationship with Leticia. The film lays the groundwork for Hank's identification with Sonny by pointing to the many similarities that already unite them. Consider again: both their mothers are dead (buried in adjoining graves on the Grotowski homestead); they do the same work—the work of their fathers; they share a womanless, loveless home; and they share the same prostitute, even to the extent of duplicating the impersonal, rear-entry sex with her in the same seedy motel. And, as indicated, Hank demeans Sonny in the same fashion that Buck later berates Hank, for being weak like his mother.

It is as if Sonny's death has awakened Hank to the other, hidden but critical, similarity between them: their fundamental human need for the caring relationships of which each of them is deprived. Although Hank burns his guard uniform, he keeps mementos of Sonny, including the portraits of the two of them that Lawrence Musgrove sketched during his final hours and gave to Sonny.

V. A new life, a new relationship

The trip that Hank makes to the prison to resign from his position is rendered in a style that is visually fractured. As he drives past familiar landscapes, sometimes populated with inmates working outside the prison, the camera repeatedly cuts back to images of Hank's car on the ferryboat or disembarking from it. The shots are accompanied by stark and portentous strains of synthesized organ chords. The repeated intercuts may be meant to convey the chronic span of Hank's daily routine, telescoping all his workdays, thereby intimating that Hank has thought about this particular moment during that routine, taking stock of his life as it has unfolded over time. The disrupted visual images supplant a depiction of Hank pondering his past and realigning his future.

We soon see Hank circle an advertisement for the gas station that he will buy, and can again infer that he has been thinking about the direction of his life. Running a full-service gas station, moreover, will involve him in helpful and convivial interaction with customers. When Hank optimistically tells his father about the station, he announces that he bought "us" a gas station. He clearly sees the new work as a social venture, further substantiated when he later names the gas station after Leticia. One way or another, with either his father or girlfriend in mind, Hank does not envision the gas station as a solitary enterprise. Indeed, just as Leticia will replace Buck as Hank's figurative business partner, so will she displace him as Hank's domestic companion.

Leading to a pivotal moment in the story, *Monster's Ball* almost casually deploys the road as the familiar metaphor of transition. Driving into town to inquire about the gas station, Hank passes Leticia and Tyrell walking alongside the sunlit road. The scene is repeated during the dark, rainy night after Tyrell has been struck by a passing car. Hank stops to help the screaming Leticia, dirtying his back seat with the muddy and bloody Tyrell. After telling the police what he knows of the accident, Hank is prodded into driving a numb Leticia home, where he takes in the eviction notice tacked to her door. Presently, he picks her up once again, walking by the roadside in daylight, on her way to her job at the restaurant that Hank patronizes. After his usual black coffee and chocolate ice cream, he leaves her a decent tip, unlike the eight cents the first time Leticia waited on him.[14] On his next visit to the restaurant, Hank offers to take Leticia home, implying that he intentionally synchronized his snack with the end of her shift.

Leticia is unable to fend for herself. The film intimates that being a black female in the South, poor and uneducated, is only partly responsible for Leticia's inability to care for herself or her son. She is also without friends or an available spouse, and does not have the support provided by a black community or church. Leticia's lack of social support is another important fact that is unexplained. Recall that we also do not know the nature of the crime for which Lawrence is receiving capital punishment or whether Hank's wife was a suicide. By prompting us to wonder about such omissions, the film calls attention, however inconspicuously, to the singularity of the narratives of concrete individuals.

What is clear is that Leticia's lack of autonomy, the competencies to run her life with a modicum of effectiveness, is as much a result of a dearth of caring relationships as a poverty of personal wherewithal. She is plainly marginalized. The film presents a variety of images of Leticia clinging to the margins of existence: abandoning her broken down car by the roadside; walking by the side of the road, night and day—with Tyrell and alone; bumbling at a menial job; on the curb with her belongings; and exhausted by a history of visiting a man on the veritable margin of life, death row.

Granted, Hank's autonomy does not appear to depend on a social network or caring relationships. He seems to single-handedly end his career in prison work, purchase a gas station, embark on a romantic relationship, and relocate his obdurate father. However, Hank's independence of mind and action are in fact socially grounded. He enjoys the privileged position of being a white male in the South and has been in charge of his family's household. So, too, has Hank occupied the position of a socially sanctioned authority in his work. Being a head prison guard has provided Hank with a robust social image with which to identify and from which to derive the self-esteem that drives autonomy.

Hank's redefinition of himself harbors an irony about his autonomy. Being a successful prison guard buttresses Hank's autonomy, but he then uses that autonomy to jettison the very identity that has empowered him. Although lacking the immediacy of caring relationships that can fortify our autonomy, Hank has developed and honed habits of decision-making

in his domestic and occupational relationships. In short, Hank's socialization has fostered in him the competencies of autonomy even as Leticia's barren social life has impaired her independence.

Hank's ability to separate himself from his past and embark on an uncertain future clearly requires the decisiveness and determination of autonomy. The wariness exhibited by care theorists over the role of autonomy stems in part from its potential to jeopardize relationships; however relationships are fundamental to the care perspective. Discussing this risk, Linda Barclay points out that "the exercise of individual autonomy may threaten certain relationships to particular others."[15] However, feminist philosophers also rightly note that ending particular relationships may be necessary to help individuals care for themselves or another, or to live autonomously. Although the relationships in question typically involve women who are being exploited or oppressed, *Monster's Ball* depicts a man having to sever relationships that oppose the values of care.

When Hank later tells Leticia that he has bought the gas station, she exclaims that she could not stand the former owner. From what she says, we gather that Hank has taken over from a racist, as if symbolically replacing his former self at the gas station. When his father criticizes him for the purchase, bemoaning the fact that Hank did not stick to what he knows, being a corrections officer, Hank mildly points out his new identity, "I ain't a corrections officer no more. I'm a gas station owner." Gas station proprietorship is later inscribed with Hank's intimate relationship with Leticia when he repaints the station with her name. Hank puts an exclamation mark on his commitment to a new life when he informs the questioning Ryrus (who might after all be working for Hank at the station) that Leticia is his girlfriend. The assertion is at once telling and humorous because at the moment Leticia is distancing herself from Hank, having met and been humiliated by Buck.

Driven home from the diner by Hank, Leticia asks him why he helped her. He replies that he was doing the right thing. Hank has been moved to do the caring thing through an empathic response to Leticia's plight. Seeing her holding the dying Tyrell, Hank feels her grief for a damaged son. Yet by itself empathy is an emotional contagion, the other person's passion transmitted to us. If we disliked the other individual, for example, our empathy could lead us to permit her to suffer or even to exacerbate her pain. In order for empathy to lead to help, we must also have sympathy for the afflicted individual. For Hank, empathy engages his sympathetic imagination and identification, both of which had been enlivened by his posthumous relationship with Sonny. Internalizing the importance of care to Sonny prepares Hank now to identify with Leticia over the death of her son.

The film suggests that Hank's sympathetic identification with Leticia takes him unawares, impelling him to act spontaneously. In the hospital, he is drawn into Leticia's life in ways he did not anticipate and are a bit more than he bargained for. But sitting in the car outside her home, Hank opens up about himself and Sonny, telling Leticia that his son also died and that he was never a very good father. Hank is honest about himself and his feelings. Besides earlier admitting to Sonny his long-held hatred for him, he later will reveal to a nursing

home administrator that he does not love his father. These moments of candor also promise self-knowledge. Hank's self-disclosure with Leticia continues, "You know when you feel like you can't breathe? You can't get out from inside yourself. You know, really." Leticia quietly connects with Hank's emotional truthfulness and invites him into her home.

For all the socio-erotic implications highlighted in critical interpretations of the couple's interracial lovemaking, much transpires that is simply about emotional need and mutuality. Hank tells Leticia that he will help her feel good, something he has not done for anyone in the story. After rear-entry sex, an allusion to the habitual Grotowksi style, Hank and Leticia make heated love face-to-face. Successfully realizing Sonny's abortive attempt to talk after his sexual encounter, Hank says, "I felt it, too." Leticia tells him, "I needed you. I needed you so much," and Hank reveals that he has not "felt anything in so long."

The pair gently thank each other, as much for the emotional vitality of their intimacy as the sexual joy. Hank and Leticia are forging a relationship in which they share histories, emotional need, and fulfillment. To take the intense sexuality out of this context, as many commentators tend to do, ignores how their sexual passion involves mutual revelation and trust. When next they make love, Hank is tender and solicitous, amplifying the contrast between Hank's intimacy with Leticia and the earlier prostitution sex. Leaving prison opens Hank to possibilities of care and relationship. Had Hank remained a corrections officer, he might very well have driven on, leaving mother and son hapless, by the side of the road. Hank does not seem to self-consciously transgress racial boundaries. Rather, blackness seems to have become irrelevant to Hank, as it had been for Sonny. Because Hank is no longer imprisoned by the racism of his previous life, he can respond with empathy and sympathy to Leticia. And it is only because Hank feels for Leticia and comes to her aid in the pouring rain that an intimate relationship is later possible.

VI. Fathers and sons, again

Hank's identification with his son is completed when he engages Ryrus as a mechanic to ready Sonny's truck as a gift for Leticia. Hank does business with a black man in order to help, and woo, a black woman. Over Leticia's objections to taking the present, Hank tells her, accurately, that Sonny would want her to have it. Hank expresses Sonny's values both in his business transaction with Ryrus and by making a present of his son's vehicle to Leticia, wife of the condemned man of whom Sonny was so solicitous. As we see, Leticia and Ryrus are also narratively linked when Ryrus asks about her upon seeing Hank paint "Leticia" on the gas station.

Leticia reciprocates the gift-giving by pawning her wedding ring and buying Hank a hat to replace the one that was ruined when he helped Leticia with bloodied Tyrell. By literally using the ring money to buy Hank a gift, Leticia is symbolically replacing her late husband with Hank. She is acknowledging, in almost formal terms, a new life as Hank's woman. Unfortunately, when she shows up at Hank's house to give him the hat, Hank is out, and she

encounters Hank's racist father who relishes demeaning black women by sexualizing them. All Leticia has to say when Hank asks her what happened is, "I met your daddy."

Leticia drives off enraged by Buck's lewd, racist conversation, despite Hank imploring her to give him a chance to explain. His entreaties again fall on deaf ears at the diner when Leticia tells him that she has not got time to talk. The once taciturn Hank reprises Sonny's forlorn request of the prostitute, when he says, "I wish you would talk to me." Hank has come to understand the importance of speech for establishing a relationship, and then, for repairing it. He needs Leticia as much for a companion with whom to share a bruised past and hopeful future as for a sexual partner. We should also notice that Leticia is here represented as someone possessing self-respect. No matter her reduced state, she forces Hank to recognize her as rightfully indignant over Buck's denigrating treatment of her. Withdrawing from Hank is Leticia's way of asserting herself and affirming her worth.

Already on oxygen-support, Buck has been falling and failing, making his placement in a nursing home plausible on grounds of care. But Buck also has to leave Hank's house to make room for Leticia—for her to have an emotional and social place in Hank's new life. By putting Buck in a nursing home, the last vestiges of Hank's former identity—the racism, sexism, penal authority, harsh parental authority— are removed, re-placed. In similar fashion must Leticia be dis-placed before entering the home that Hank spruces up for their life together.

Foreshadowed by the eviction notice tacked to her door, Leticia and her belongings are put out on the street by the sheriff's black officers. Black legal authority is but the extension of the white power structure. The men who turn her out of her home are the most significant black presence in her life—a painful and ironic reminder of Leticia's lack of black friends, family, church, and community. The Southern legal system either confines Lawrence to the jailhouse or throws Leticia out of her house. Yet *Monster's Ball* also depicts Blacks with authority over Whites. Recall Ryrus asserting his parental authority against Hank, a threatening white authority over his children. The film also slyly inverts Leticia's plight in the details of Buck's relocation in the nursing facility. Not only is the administrator of the nursing home a black woman, but Buck (the nickname often given to strapping black men in their prime) will now have a black roommate as well as black attendants. It is hard to resist joining in the film's understated display of such poetically just schadenfreude.

In Hank's decision to remove Buck to a nursing home, *Monster's Ball* also conveys an important insight about the nature of care. Hank still cares for his father even though he is not personally taking care of him. The film shows that by arranging for the care of Buck by a third party, Hank is indirectly caring for him. We need not be directly taking care of individuals in order to care for them. To meet the demands of self-care, as is the case for Hank, we may have to arrange for other people to provide the direct care for a family member or friend.

Leticia soon discovers the portraits that her late husband has drawn of Hank and Sonny. She becomes distraught at the realization of what Hank's prior status must have been and his involvement in Lawrence's life. But when Hank returns with ice cream for them to share,

she joins him for an evening dessert on the stoop outdoors. Because the ice cream is now shared, its consumption is more celebratory than compensatory for lack of care, as it had once been for Hank (just as liquor and candy had been for Leticia and Tyrell respectively). The ice cream is the sweet reminder that in taking Leticia into his repainted home, Hank is caring for her. He had told Leticia that he wanted to take care of her, and she had replied, "Good. Cause I really need to be taken care of."

Sitting on the steps and letting herself be fed by Hank, Leticia seems to be following his lead in leaving the past behind and starting a new life. Leticia will live in the house that Buck and Sonny once occupied. Buck has been moved to a nursing home and Sonny is dead, as is her own boy. Hank will be the everyday partner that Lawrence was unable to be. Perhaps Leticia will work with Hank at the gas station; perhaps Ryrus is already in Hank's employ. These are open-ended aspects of the story, as is the nature of the relationship that Hank and Leticia will have together. That they have a relationship at all, however, is due to Hank's deliberate transformation of himself.

The film adds to our understanding of the ethics of care through its application to concrete particulars. For example, we see how the absence of care affects autonomy in the narratives of particular lives. Leticia's lack of autonomy is due as much to the absence of friendship and community in her life as it is to her intellectual and economic impoverishment. And Hank exercises his autonomy for the sake of a serious emotional relationship with Leticia. Hank has to work through the decision to remove Buck from his home in order to care for himself. Yet because of Buck's identification with the penitentiary, Hank is thereby completing his severance from prison work and state executions.

In addition, *Monster's Ball* points to the importance of care for the public sphere. Encouraged by the film to assume the viewpoint of care, we feel the oppressive weight of the state on the poor, the deviant, the Black, and the female. Just as Lawrence Musgrove could have been treated with compassion, as futilely evidenced by Sonny, so would a society informed by care find a way to keep individuals like Leticia in their homes. We are left to wonder further what a caring society might have done, earlier in their lives, to prevent the harsh fates of Lawrence and Tyrell. The film also suggests that only through care can we become integrated as individuals and perhaps, by implication, as a society. The film opens with fractured shots of Hank sleeping beneath a fan (which further interrupts the image) and driving his car, visually suggesting that his life or personality is fragmented. Similarly sundered shots of Leticia later disclose her seeing only parts of herself in the bathroom mirror. Only when Hank's relationships with Ryrus and Leticia take shape can he begin to become whole. And only when Leticia enters into an intimate relationship with Hank does her life stabilize. The film thereby mediates our understanding of care. Through its cinematography, characters, and the arc of plot, the movie keeps us aware of the centrality of narrative in approaching life through a care perspective. Bearing out the care perspective, *Monster's Ball* emphasizes the particularity of the personalities of Hank and Leticia as well as the contingencies and accidents that help delineate their histories.

Notes

1. G. W. F. Hegel, *Encyclopedia of Philosophy*, trans. and annot. by Gustav E. Mueller (New York: New York Philosophical Library, 1959), pp. 245–246, sec. 431.
2. Linda Barclay, "Autonomy and the Social Self," in *Relational Autonomy*, eds. Catriona Mackenzie and Natalie Stoljar (Oxford: Oxford University Press, 2000), pp. 61–62.
3. Virginia Held, *Feminist Morality* (Chicago: University of Chicago Press, 1993), p. 14.
4. Ryrus may also have a daughter, as we see a young girl running about the auto shed in his yard.
5. Kwakiutl Dreher is concerned with the difference between cinematic renderings of young white males and depictions of young Blacks. She claims that movies tend to portray young white males as capable of the resiliency and resourcefulness that Tyrell lacks, "A Eulogy for Tyrell Musgrove: The Disremembered Child in Marc Forster's *Monster's Ball*," *Film Criticism*, Vol.29, 2004, pp. 65–81, 68–70.
6. The scene in which Hank reminds Sonny to be professional and not let the personal intrude is the occasion for telling Sonny about the party thrown by British guards for the condemned man the night before his execution—the "Monster's Ball." Aimee Carrillo Rowe suggests that such a party is the opportunity for empathy between guards and prisoner, "Feeling in the Dark: Empathy, Whiteness, and Miscege-Nation in *Monster's Ball*," *Hypatia*, Vol.22, #2, 2006, pp. 122–142, 131.
 It is telling that in the film by this name no farewell bash takes place. Instead, Hank works to keep the deathwatch vigil dispassionate in opposition to Sonny's empathic responses to Lawrence.
7. Sharon Holland, "Death in Black and White: a Reading of Marc Forster's *Monster's Ball*," *Signs*, Vol.31, #3, 2006, pp. 785–813, 803.
8. Ibid., p. 805.
9. Ibid., p. 806.
10. Catriona Mackenzie, "Imagining Oneself Otherwise," in *Relational Autonomy*, p. 128.
11. Ibid., pp. 134–135.
12. Ibid., p. 135.
13. Genevieve Lloyd, "Individuals, Responsibility, and the Philosophical Imagination," in *Relational Autonomy*, p. 17.
14. Leticia has just begun working at this diner, having been fired from her previous waitressing job for chronic lateness.
15. Linda Barclay, "Autonomy and the Social Self," p. 60.

Chapter 5

Tuning into Caring Community in *Radio*

I. Fenced out of society

The opening shot of Mike Tollin's (2003) film is of the title character, a young black man pushing a grocery cart along railroad tracks, listening to the radio. He smiles and waves a little too enthusiastically as a train goes by. Sitting in the cart, he propels himself down the road with a long branch, like a land-locked gondolier. We soon realize that he is a high-functioning, mentally disabled, loner. His apparent isolation is reinforced by the repeated image of him watching football practice from behind a fence. As the story unwinds, the image takes on symbolic meaning. The young man is effectively fenced out of the life of the town through which he routinely makes his way, pushing his cart about, like a homeless man. Although he lives with his loving mother, James Robert Kennedy spends his days on the street, bereft of meaningful social interaction.

The film traces the trajectory of Kennedy's opening up and into the world under the guidance and solicitude of the football coach, Harold Jones. It is Jones who nicknames Kennedy "Radio," prefatory to lifting him out of his alienated life by shepherding him into a growing circle of community in Hanna, South Carolina. In so doing, Jones intuitively works out the larger role of community in the ethics of care. When we think of care ethics, we typically focus on the personal sphere, typified by family and friendship. More recently, care ethicists have expanded the scope of their theorizing to include public issues and institutions. Sara Ruddick, for example, argues for an ethics of care as most appropriate for tackling issues of international politics, war, and prospects for peace.[1] Grace Clement develops Ruddick's views on political pacifism, and also implements the care ethics in her analysis of the public funding of long-term provisions for the elderly.[2]

But in between the realm of intimate relationships and such public policy domains as international trade and health care lies the familiar yet public world of community: school, neighborhood, and town. The film indicates why the ethics of care must include the individual's relationship to community by exploring the ways in which participation in communal life is essential to personal growth and well-being. Without a place in social

groups, for example, it is difficult for individuals to develop and express their talents and virtues. As befits a story, the film implicates narrative in the inclusion of Radio in the concentric communities of Hanna. Coach Jones implicitly fashions a narrative for Radio that weaves him into the town's social fabric: first of the football team, then of the school and wider culture of town folk. Jones understands, as much with his heart as with his head, that Radio's only chance at a vibrant life is for him to engage in the daily interactions of social networks, larger than just the domestic one he shares with his widowed mother.

By focusing on the story of an extreme, an individual who is mentally challenged but nonetheless high functioning, *Radio* illuminates the human condition for the typical, non-extreme—even as we gain clarity about everyday life by pondering extreme cases such as lifeboat survivors, wartime decisions, or disaster relief. Tracing the arc of Radio's growth, the film portrays the ingredients essential to the happiness of us all. We flourish by engaging in meaningful pursuits, achieving the technical purposes found in work and avocation. Following Aristotle, our well-being also has the moral dimension of acting virtuously—realizing such excellences of character as honesty and generosity, compassion and courage.

Yet neither achieving technical ends nor exhibiting our moral virtues occurs outside a social setting. We engage in work within institutions and organizations, usually in concert with other people who are pursuing similar or complementary ends. We act generously, compassionately, and courageously for the sake of others and through our social interactions with them. The story of *Radio* explores the social context of human fulfillment that most of us simply take for granted, so immersed are we in sports, education, and commerce—to cite a few salient examples from the movie.

But because James is mentally handicapped, bringing him into the community poses a special series of challenges for Coach Jones. Arising naturally from the school context, the principal and school board are concerned for the safety of the student body. Although such concern has a legalistic cast, it cannot be dismissed as merely pitting rights and state authority against the care ethics, as was predominant in *Monster's Ball*. Rather, the welfare of the many must be taken into account in striving for the good of the (handicapped) individual. An ethics of care counsels us to be creative and figure out ways in which each can be achieved with as little sacrifice as possible to the other. For all its heart-tugging melodrama, the film is realistic in confronting the tensions that often develop between responding to the most needy and honoring the claims of the more fortunate.

II. From loner to team assistant

Although he makes friendly overtures to James (Cuba Gooding Jr.), it is not until Coach Jones (Ed Harris) rescues him from harm that a relationship begins to form. The star of the football (and basketball) team is Johnny Clay (Riley Smith). His unattractive self-centeredness and cruelty, combined with his father's myopic ambition for him, provide the story its most dramatic conflict. The conflict surfaces when Johnny and several other

football players lock James in the equipment shed, binding his ankles and wrists. Coach Jones frees the whimpering black man, who scurries and stumbles out of the shed and off the field to his waiting grocery cart. When Jones's wife (Debra Winger) later suggests that the boys who were responsible do not normally do these things, Jones tells her that the young man was terrified. We realize then that Jones carries the look on James's face with him like a foreboding snapshot and that he is not your run-of-the-mill jock. The Coach has been blessed (or cursed) with a strong sympathetic imagination that impels him to feel the suffering of another deeply. We suspect that he also can imagine James's loneliness, ambling around town and watching football practice from a distance.

Principal Daniels (Alfre Woodard), a black woman, has heard of the incident and confers with Jones, who is also the school's athletic director. She tells him that the young man has been around for a long time, not causing any problems, and that she wants to keep it that way. Understandably, the principal is approaching the welfare of the school from the side of negative freedom, as the absence of trouble. But the coach will take a more positive approach by encouraging James to come to football practice and help him out. After telling James to keep the football that he has picked up from a practice, Jones apologizes for his players' behavior and assures him that there will be no more trouble. It is as if Jones knows that the caring relationships that James needs are found within community, between the individual and each social network of which he can be a part.

The prank the football players play on James invites us to reflect on the nature of cruelty, particularly within the framework of the ethics of care. Coach Jones's response to the incident and to James suggests that cruelty is the opposite of care. Cruel individuals delight not merely in the misfortune of other people, but deliberately inflict pain on them and take enjoyment in their active role as well. Here there is a parallel between the opposition of cruelty to care and Kant's notion of how contempt violates respect for persons. Where respect acknowledges the inherent value each person possesses, contempt projects an individual's total lack of worth. Similarly, whereas care signifies concern for and commensurate effort on behalf of another, cruelty purposely promotes and revels in the suffering of the other person. Rather than merely ignoring James, Johnny Clay goes out of his way to torment him. Blessed with impressive athletic talent, Johnny seems to hold James in contempt—possessed of so little intrinsic value that he can be used merely for Johnny's sport.

In establishing a relationship with James, Coach Jones can barely get a word out of him, including his name. Because James moves about listening to his radio and immediately gravitates to the radio in Jones's office, the coach nicknames him "Radio," and it sticks. Even after finding out from the young man's mother that he is James Robert Kennedy, Coach Jones continues his affectionate nickname. It is significant that a medium of communication performs a mediating role in the early stages of the relationship between Radio and Jones. Presently, Jones will come to play the mediating role between Radio and the overlapping communities that will give structure and meaning to the young man's life.

For the rest of the film, we see Radio performing odd jobs, first for the football team and later for the basketball squad: folding towels, gathering balls, holding the blocking stanchion

and carting supplies. Perhaps just as importantly, Radio cheers both teams on. He yells encouragement at practice and during the games, often repeating the words of his mentor, Coach Jones. Within a few weeks, Radio is waving to the crowd in the football stadium and the crowd is waving back. He has become a fixture, both in practice and at the game. As this is occurring, Radio is coming out of his shell. He talks more, is more animated and bestows his radiant smile freely.

It is apparent that Radio thrives on having purposeful work, work that occurs within the context of social interaction. Besides his primary relationship with Coach Jones, Radio connects with the team's players, the Coach's family, and the broader community of Hanna. The larger lesson for the ethics of care is that care includes providing people with meaningful activity and that activity is itself socially situated. We do our jobs for the sake of others. And the pursuit of our interests inevitably involves the cooperation of other individuals. The same is true for most other purposeful activities: recreation and play, worship and politics, appreciating the arts or performing them. We engage in these activities and delight in their performance within relationships with other individuals and for the sake of the ends we share with them.

Coach Jones first exhibits his care for Radio by enlisting his participation within the athletic give and take of the football team. As the story unfolds, Radio will also assume a place in the life of the school itself. The film offers no evidence that Harold Jones has actually planned for Radio's growth as a result of including him in the football fraternity. What does seem evident is that Jones appreciates that Radio's isolated daily routine is not good for him and that communal inclusion will certainly give him a fuller, more stimulating life.

But not everyone is delighted with Radio's presence at football games. Johnny's father, Frank (Chris Mulkey), is the town banker. With the authority that his position and his son's talent command, Frank challenges Coach Jones. At the weekly gathering of the town's men in the local barbershop, Frank jabs at the Coach, asking whether he's "running a football program or a social club." Although Frank chortles at his own barbed observation, Jones neither replies nor smiles. Frank is narrow-minded in his ambitions for his son as well as in his antipathy toward Radio. Frank had earlier complained that his son should be given the football more, and he will later make more strenuous efforts to oust Radio from his humble niche on the team. The film is none too subtle in pitting Frank and Johnny against Radio and Harold Jones. Nevertheless, the opposition does reveal important issues confronting the ethics of care: possible tension between care and the welfare and rights of other people; the relationship of the individual to community; and the opposition between care and individualistic ethics.

Coach Jones asks Radio's mother if he can accompany the team on the bus to the upcoming away game. He then asks her what is wrong with her son. She replies that he is a little slower and that the doctors never provided a diagnosis. Radio's mother then confides her worry that the authorities might institutionalize her son. We cut to the principal voicing her objection to Radio riding on the team bus. She tells Jones that Radio is not a student and that they do not even know the nature of his handicap. The principal is clearly worried about

legal problems should Radio get hurt or should he injure an enrolled student. In depicting the potential for conflict between the legalistic or rights perspective and the approach of care, the film is realistic. After all, caring for one individual can threaten the interests of other people.

Historically, caring was the province of women, and continues to be in most cultures. Women often had to compromise or sacrifice their own aspirations, talents, and happiness to care for the family. In *Radio*, it is the welfare of the members of the school community that may be jeopardized by caring for Radio. We admire Coach Jones for not thinking about the risks his inclusion of Radio poses, especially since he is the school's athletic director as well as its football coach. We admire him because of his single-mindedness in trying to insure that Radio enjoys the benefits of participating in the football program. Nevertheless, Radio's presence in the life of the school does create genuine problems.

Later in the story, Jones is asked to meet with the principal and a representative of the school board. The potential danger posed by Radio to the student body is voiced in the more legalistic language of school liability. The tension is not between the ethics of care and individual well-being, as in the personal relationships in which women were compelled to forgo their goals in the service of care-giving. Here, the tension is between caring for an individual and the needs of the community, the student members of the school. Harold Jones expresses the care perspective in replying to the school board advocate, "This is a young man who's been spending his entire lifetime wandering around all by himself out on the streets." By depicting Radio's (non-domestic) isolation as extreme, the film underscores the importance of social relationships to the growth and flourishing of all of us.

Only when Radio is brought into the vitality of community does he thrive. He is able to think, imagine, and feel more fully and, what is more, articulate this inner life. His personality and character emerge as he establishes relationships with students and members of the greater community. The story encourages us to extrapolate from the example of Radio to ordinary people in their everyday lives. Community is the social environment that enables individuals to develop their talents, personality, and character. Inclusion in community activities is essential for most of us to realize our human potential. Consequently, we see Radio's flair for the roles of team assistant and cheerleader, as well as his emotional warmth once he is taken in from the cold—the anonymity of isolation.

As Radio gets involved in school activities beyond the football team, he continues to blossom emotionally, personally, and socially. In the school, he is Mr. Gregariousness, greeting everyone, and announcing himself the hall monitor, he chides students for running. Jones has gotten Radio a job with the basketball coach (Jones's football assistant) so that he can be involved in purposeful social activity when football season is over. We see Radio helping and happy during basketball practice and cheering the team on at games, wearing a coach shirt. In the school administration office, one of the older ladies reminds Radio to give her a hug. His warmth is easily returned. She compliments him for being a good hall monitor, and (as the principal looks on warily) Radio proceeds to make announcements

over the PA system, including the lunch menu. We see the students enjoying Radio's style. He is at home outside his mother's home for the first time in his life.

III. Moral virtue

Just as inclusion in the community is necessary for the full emergence of Radio's winsome personality, so too is it essential to the expression of his moral virtues. For example, loyalty cannot be cultivated without sustained, important relationships. Radio needs other people, and meaningful relationships with them, to provide the objects of loyalty. Similarly, Radio's gratitude and generosity also occur within the fabric of social connections. We need other people to be grateful to and toward whom to express our own generosity. As the story proceeds, we see Radio's varied and firm moral virtues emerge within the contours of the social relationships he has formed. Most dramatically, we see Radio's excitement over decorating the town Christmas tree and the truckload of presents the town folk have bestowed upon him. Back at his mother's house with Coach Jones, Radio opens the lovely new radio Coach has bought him. His mother exclaims that they have never had a Christmas like this one. She and the Coach revel in Radio's glee. But Radio is not content to keep all his gifts to himself. Bearing out his mother's earlier assertion that her boy "has a good heart," Radio soon sets out to distribute most of his loot. He goes around town depositing his gifts on the doorsteps of the unsuspecting recipients of his largesse.

An eager, but misguided, young patrolman takes Radio into custody, suspecting him of mischief, perhaps taking the presents rather than bestowing them. But the more seasoned police officers soon have Radio out of his jail cell, watching television and sharing a meal with them. Radio is clearly one of the boys, much to the chagrin of the rookie cop. Making the punishment (of the rookie) fit the crime, we watch the erstwhile arresting officer chauffeuring Radio through the streets as he spreads his Christmas cheer. Radio enthusiastically commands the beleaguered policeman to, "Give another one. Give another one." Yet unless he is part of the town, there are no presents for Radio to give and no one to be the recipients of his generosity. Membership in the wider community of Hanna provides the occasion, the means, and the context for eliciting and enlarging Radio's generosity—an important moral virtue and one that explicitly includes caring for other people.

The implicit message is that communal life is vital to the moral growth of the individual. As with Aristotle's noble man, Radio takes pleasure in performing moral acts. He gives freely and with delight in sharing his bounty. Moreover, Radio does not need coaching in this matter, deciding on his own to give away most of the presents. We will see other examples of Radio's moral virtues as they bear on Johnny Clay and his mean-spiritedness.

Radio needs a champion, however, and he has a stalwart one in Harold Jones. When asked by the principal why he is sticking his neck out for Radio, the coach simply says, "Same reason you are." Later Radio's mother asks the same question, and Jones answers, "I figure it's the right thing to do." The coach continues by reassuring the mother that her

son is no problem. But the truth will come out later, in a response that Jones makes to his daughter. Buried in Coach Jones's childhood is a haunting image of human isolation in which a domestic fence locks another boy away from the social world.

In the story Jones eventually tells his daughter we find the deep, emotional basis of care: empathy for another's need and suffering.[3] Jones confides to someone for the first time that when he was 12 years old, working his paper route, he heard a noise coming from a house in the woods. He saw fingers coming through wire around the bottom of the house and a boy about his own age with "something wrong with him." They looked at each other through the wire mesh and we imagine that in the preadolescent boy Jones saw something like a mirror-image of himself, one bereft of the social air we all need to breathe. Jones tells his daughter that during the next few years he never did anything about the caged boy and is still ashamed of himself for his inaction. The daughter thanks her father for explaining his need to care for Radio.

As generous with his time and energy as Jones is, his caring relationship with Radio is characterized by mutuality, the sort that enriches both the giver and the receiver. He never seems put upon in his efforts for Radio. He delights in Radio's personality itself, in addition to the fulfillment of the work of looking out for him. In the character of Harold Jones, the film offers us the ideal of the caring person: he enjoys the relationship, as well as the care-giving, and finds neither burdensome. For example, in the diner, Jones treats Radio to lunch, wipes his mouth, and asks which of two kinds of pie he prefers. Coach happily accedes to Radio's request for "both" kinds of pie, taking pleasure in his protégé's healthy appetite and uninhibited manner of expressing it.

We also see Jones try to teach Radio to write his name, gently and patiently. But to no avail. Here again the film does well by not making Radio's metamorphosis so grand as to be melodramatic and implausible. He never does learn to write, despite Jones's repeated attempts. Nevertheless, Jones does not seem to regard the effort or its failure to be onerous. He seems to illustrate the ways in which genuine care rewards the caregiver as well as the person receiving care. Of course, being caring is not always a total joy, even for Harold Jones. The demands of caring for another can interfere with our plans or create large-scale dilemmas. In fact, another ugly incident involving Johnny Clay will force Harold Jones to choose between the growth and well-being of Radio and his own personal passion.

IV. A crisis of care

Recall that Coach Jones had secured a job for Radio helping the basketball coach, Honeycutt, performing tasks similar to those he handled for the football team. Things had been going well for Radio: folding towels, cheering on the team, even taking to the basketball court himself during practice. One day as he is wheeling in basketballs, Johnny Clay tells Radio that the female coach wants to see Radio next door (in the girls' locker room). Radio knows enough about the ways of the world to say that he "can't do that." Radio is agitated

because he wants to please the star athlete but is worried about gender boundaries. After successfully egging Radio on, Johnny and a small group of athletes follow him to enjoy the ensuing havoc.

And havoc there is. Radio blunders into the girls' locker room, is shocked to find the girls half-dressed, contra Johnny's assurances that they would not be there, and flees in a panic. Once again, Johnny takes malicious pleasure in discomfiting his dupe. Radio runs, repeating to himself, "Bad Radio. Bad Radio." Despite being in trouble, Radio stonewalls Coach Jones's questioning about why he went into the girls' locker room. He refuses to implicate Johnny because he does not want to get Johnny in hot water. Jones, of course, has his suspicions. He confides to Radio, "I don't know what I'm supposed to do here." Radio answers, "Be mad at Radio." Jones asks him if he is willing to take the blame for someone else. When Radio makes no response, Jones continues, "You're a better man than me. I'll say that for you." Radio affectionately straightens the coach's collar.

The incident not only precipitates the final turning point in the narrative but also produces a reversal of character. The first is a consequence of Radio's status being jeopardized by his boundary violation. The second results from Johnny appreciating Radio's moral virtues. By connecting these two major changes in the fortunes of Radio and Johnny, the film weaves the threads of the story more tightly together. As Johnny boasts in the school hallway to his friends that he is being recruited for athletics by a good college, Coach Jones confronts him, saying that he would like to "lay into" him (clearly, for his nasty prank). Johnny plays dumb. An angry coach tells him that he will not be suiting up for the next night's basketball game. Johnny smirks and sarcastically spits out, "Right." The principal comes over and backs Jones who is, after all, the school's athletic director as well as its football coach. Jones proceeds to disabuse Johnny of his belief that Radio sold him out, telling the mischief-maker that "there are plenty of other people willing to do that."

Johnny is soon stunned by Radio's kindness and loyalty to him. He finds a "note" from Radio in his locker—just scribbles on a piece of paper—along with a small radio. Johnny is visibly moved by this gesture of camaraderie. When he approaches Radio, Radio tells him that he is sorry Coach Jones got mad at him. Johnny truly sees Radio for the first time. Perceiving the gift as Radio's attempt to soothe his wounds, Johnny finally appreciates the deep and steady virtue of the person who has borne the brunt of his thoughtless malice. Johnny is speechless. All he can do is pat Radio and walk away. We soon see a different Johnny on the basketball court. During the next basketball game, he drives to the basket and passes to a teammate instead of taking the shot himself. When he does score, he soon takes pleasure once again in creating a good shot for a teammate. We can infer that as a result of Radio's steadfastness, Johnny has reflected on his own character and learned a bit about friendship and teamwork.

After the game, Johnny's father (Frank) tells him that he could have scored more had he passed less. Johnny interrupts their conversation to bid Radio goodnight. The father challenges Johnny for talking to Radio, saying that the team's assistant is getting in the

way. It is a refrain that we hear from Frank throughout the film, including during a scene when Jones comes to the bank to discuss Frank's complaints about his protégé. At this moment, even Johnny sees the smallness of Frank's perspective and replies to his father, "Radio's not the one getting in the way," implying that Frank is. Accepting Radio as part of the community is a concomitant of Johnny's less egotistical play on the basketball court. As far as promoting the values of cohesiveness and teamwork, Radio is an asset not a liability.

We realize that banker Frank had imbued his son with the values of individualism: competition, independence, ambition, and relative indifference to the fortunes of others. Consequently, up until now Johnny had viewed his teammates merely as auxiliaries to his success. At halftime during an earlier football game, he had demanded, "Any chance I can get the ball!" The story makes clear that unless something had happened to make him rethink his moral perspective, Johnny would have become just like his father. It requires Radio taking the blame for Johnny's mischief for the star athlete to simultaneously see the error of his ways and the joys of team play.

But despite its salutary upshot for Johnny's character, Radio's misstep in the locker room is nonetheless a costly one. Besieged by phone calls from troubled parents, Principal Daniels points out to Jones that Radio is indeed a liability since anyone may be able to talk him into doing something worse next time. It falls to the principal to try to balance care and the law, to navigate between helping the disadvantaged and protecting the majority of her students. The film is good at portraying the often-difficult task of negotiating care in the concrete situations of the world, including the need to adjust our expectations and behavior to competing demands. The official from the school board returns and the principal remarks that everything has changed now that Radio's mother has died. Jones explains that the school is the reason Radio is doing as well as he is, "You take him out of this school, you may as well take his life."

Radio's place in the school is rendered tenuous and the situation is to be resolved at a meeting of the townspeople, led by the principal, in their informal gathering at the barbershop. Frank brays that Radio is a disruptive force in the community and a serious threat to the students. Coach Jones enters with wife and daughter in tow. He recalls his own coach counseling him to keep his priorities straight. He continues, recounting how much football means to him. The audience is virtually spellbound by the Coach's football rhapsody, "I love football. I love everything about it. I love Friday night when you're lookin' for a win and Saturday morning, when you've found one." Yet Jones catches the nodding audience up short when he adds, "But that's not what's important right now." He reminds the good citizens of Hanna that the young man who makes morning school announcements could hardly talk when they first met him.

He proceeds to the insight that although Radio's learned a lot, he has been teaching the town, "The way he treats us all the time is the way we wish we treated each other even part of the time." The film suggests another mutuality besides the give and take between Radio and Harold Jones. Even as Radio flourishes because of inclusion in community, so

too does his example instruct the town folk about the meaning of community. Perhaps Frank does not like the lesson that his son, Johnny, has learned from Radio about treating people. Coach Jones acknowledges that changes have to be made. He tells his friends, neighbors, and supporters that he is stepping down as football coach, to keep an eye on Radio and spend more time with his wife and daughter. And then he leaves. Human flourishing is a higher priority than even the euphoria of football.

V. Football vs. care

At the heart of the story is an unlikely reversal of the well-known, and much analyzed, plight of woman-as-caregiver. Historically, it falls to women to sacrifice their interests and often well-being for the sake of those for whom they provide physical and emotional sustenance. Daughters, wives, mothers, and sisters typically did not question the family structure that dictates this sacrifice. And in society as a whole, women usually fill the roles and jobs of caring for the young and aged, infirm and handicapped. It is a merit of the film, then, that Coach Harold Jones gives up his beloved football for the benefit of what may plausibly be considered his adoptive son.

Compounding the gender reversal (metalepsis as the relevant figure of speech) is the irony that Jones relinquishes the macho delights of the gridiron—the manly joys found in blocking, tackling, and contending against the opposition in the fierceness of football competition. It is as if Jones cannot be truly caring with Radio and also be a football coach because the features that define the sport are antagonistic to care, to the vulnerability and emotional availability essential to seeing to the needs of others. Sacrificing football could be seen as the final phase of the feminization of Jones. He must turn his back on the violent combative world of battering and bruising in order to provide nurture and familial support. Radio can continue to thrive in the school environment, but only if Jones is there to guide him and protect him from unintentional errors of judgment or the unscrupulous character of other people.

What is also illuminating about the film is that Jones does not provide all the care directly; instead, he facilitates Radio's membership in the several communities that are embedded, or nested like Russian dolls, within one another. Radio flourishes because of his involvement with the sports teams, the school, and finally, the town as a whole. Jones is perceptive enough to understand that human growth occurs in the daily give and take of a robust social life. Therefore, caring for people involves including them in communal activity. While this happens naturally for most of us, some individuals, such as Radio, require a special effort. As we have seen, Radio's abilities to communicate, and develop and express his moral virtues, expand through his involvement in football, basketball, and everyday school activities. He folds towels, fetches balls, cheers the teams on. He makes announcements and walks the halls. In short, he finds purpose and meaning within community.

That Harold Jones appreciates all this on an intuitive, almost visceral, level is perhaps not so surprising. But that the person with so keen a sensitivity to the human need for social meaning is a football coach is surely a fine irony.

Notes

1. Sara Ruddick, *Maternal Thinking: Toward a Politics of Peace* (Boston: Beacon Press, 1989).
2. Grace Clement, *Care, Autonomy, and Justice* (Boulder: Westview Press, 1996).
3. See Nel Noddings, *Caring: A Feminine Approach to Ethics and Moral Education* (Berkeley: University of California Press, 1984).

Chapter 6

Gandhi: The Ethics of Care in the Nation-State

I. Care, justice and the public realm

Early in Richard Attenborough's film *Gandhi* (1982), we see Mohandas K. Gandhi (Ben Kingsley) as a young barrister riding first-class on a train in South Africa. Dapper in proper British attire, he is ordered to get back to third-class where people of color ride. Gandhi protests that he has a first-class ticket, infuriating the British rail officials with his impudence in flouting the rules of segregation. When they rudely toss him from the train, the British authorities have unwittingly set Gandhi on his life's work of liberating Indians from oppression—by the British and their own countrymen.

More specifically, the film portrays Gandhi dealing with Indian independence from Britain, the subjugation of women and Untouchables, and strife between Hindus and Muslims. Gandhi responds to each of these issues from the perspective of an ethics of care. The film thereby expands and deepens our understanding of how the virtue of care can function in the public sphere of national politics. In the process, we see how narratives, and film stories in particular, can elaborate, clarify, and sharpen our understanding of philosophical theory. Before examining just how the film accomplishes what I claim for it, a brief characterization of the care ethics and its main rival would be helpful.

Some of what follows was sketched in the Introduction, but interpreting the film demands a more developed discussion of the relationship between care and justice. As articulated by such feminists as Nel Noddings and Carol Gilligan, the ethics of care provides an alternative to what may be described as the justice approach to moral issues.[1] An ethics of justice takes the isolated individual as its theoretical starting point; hence, it begins in separation.[2] The individual is the bearer of rights against others and these rights safeguard his or her person. The social cornerstone of the ethics of justice is negative rights that protect the individual's autonomy and property from interference by other people. Positive rights and obligations arise, then, from the unencumbered exercise of autonomy. The agreements or contracts that individuals enter into create these positive rights and their corresponding duties. Justice involves an abstracted conception of individuals and their

rights, and proceeds by applying abstract principles and rules that function universally, regardless of individual history or relationships that have not been freely chosen.

In contrast, the ethics of care takes as its point of departure the social self. The individual is most fully understood in terms of his or her relationships with other people. As constitutive of one's identity, connectedness rather than separation is basic. Relationships carry with them responsibilities and serve the needs of the people in them. Central in an ethics of care are responsibility and need rather than autonomy and rights.[3] Care understands inter-dependence as basic and not the independence that characterizes justice. As we saw in the discussion of *Monster's Ball*, autonomy is itself conditioned by relationships, and its exercise is subordinate to the responsibilities entailed by them.

Many of these relationships are not the result of arrangements into which the parties have freely entered. For example, relationships involving family, neighbors, and community arise from the particular history of the individuals, which creates contexts of dependence and need. Because it deals with individuals in their particular relationships with their distinctive histories, considerations of care operate at the level of concreteness and narrative context rather than in terms of abstract principles (of justice, rights, and equity). Proponents of care argue that we lose crucial moral aspects of a situation when we follow the justice model and attempt to apply universal principles in abstraction from the concrete situation in which people find themselves. This is obviously a rough summary of a complex debate involving a variety of positions, but I think it will be serviceable for our purposes.

During its early phase, care theorists tended to view ethics based on justice or autonomy as germane to the public sphere of life, confining the perspective of care to our private lives. Nel Noddings, for instance, found care suitable only to the private sphere because she believed it required the intimacy of face-to-face interaction.[4] On this separation of function approach, the abstract, universal principles of justice that focus on rights and equality seemed more suited to public issues of civil society, government, the law, and international politics. On the other hand, an ethics that begins with human connectedness (the social self) and works at the level of concreteness and narrative context was thought to function more fruitfully in personal domains. The care perspective initially struck many of its advocates as best suited to the intimate give and take of friendship and family.

More recently, however, many philosophers have begun to question, and reject, the division of moral labor that cedes the public realm to theories of justice while granting the private domain to the ethics of care. Feminists and others have urged that questions of justice do indeed arise in the private sphere and that the care perspective sheds light on public affairs. Susan Moller Okin argues that the scope of justice ought to include the intimate sphere of family life as well as more traditional public domains. She persuasively points out that male member of families will continue to subjugate and exploit women and children unless we apply principles of justice in our assessment of so-called private family interactions. Other ethicists have reversed Okin's direction by applying the care ethics to public policy and practice. Extending the maternal thinking that animates care, Sara Ruddick articulates the implications of the care ethics for international politics, war, and the

potential for peace. Grace Clement develops Ruddick's views on political pacifism but also utilizes principles of care in her recommendations for public funding of long-term support for the elderly.[5]

What we have then is the more complex and interesting inclusive understanding that both justice and care ought to figure in both the public and private areas of life. However, we still need to distinguish two variations within this inclusive understanding. The first position sees justice and care working side by side, in a complementary manner. The two moral views are understood as radically different in nature and therefore each supplies what the other lacks. Thus does Carol Gilligan conceive care and justice as "two moral perspectives that organize thinking in different ways."[6] Allison Jaggar offers this summary of the theoretical landscape, "Most proponents of the ethics of care now dispute the possibility of any easy synthesis of care with justice."[7] When Okin argues that we must root out injustices in the family, for example, she is adopting a conventional view of justice, not one that has somehow been informed by care.

A second position is more integrative, suggesting that each moral view may, in some cases, infuse or collaborate with the other. Grace Clement brings considerations of justice *into* the care perspective when she claims that care demands that an individual not neglect herself in order to help others. The injustice of neglecting oneself actually undermines the would-be care with which one approaches the world. Without considerations of justice, then, care is deficient and can lead to the self-destructive sacrifice that has long characterized female care-giving.[8]

In the film, Gandhi employs such an integrative approach to care and justice. In order to institute and maintain caring communities, whether ashram or state, Gandhi promotes arrangements that are just, tending toward an egalitarian understanding of justice. For example, dirty work such as latrine cleaning is not to be left to Untouchables; everyone must pitch in. Alternatively, the justice of India's independence from Great Britain ought to be attained through non-violent resistance, a caring approach toward one's oppressors. Just treatment for those who hurt fellow Indians demands caring creativity instead of another dose of punitive retaliation. Gandhi addresses virtually all of the social and economic problems of India through a care perspective that includes collaboration with principles of justice. The result is a refurbishing of those principles, on the one hand, and a clear objective for care, on the other.

Running through Gandhi's caring responses is the theme of inclusiveness and the framework of narrative. For Gandhi, the care ethics impels us toward inclusiveness. Even as Coach Jones sees the necessity of incorporating Radio into the life of the team and school, so does Gandhi perceive the importance of including women and Untouchables as equal participants in community. India is best served, he thinks, by harmonizing all religious groups instead of separating Muslims and Hindus into independent states. Odd as it may at first seem, the fidelity to non-violence also partakes of the value of inclusiveness. One of the strengths of non-violent resistance is that it includes the oppressor as a legitimate party to rational discussion of perceived injustice. Consequently, when India is finally independent of Great Britain, the former colonial power will be included as a friend or

ally of postcolonial India. The theme of inclusivity operates at three levels: international (India's relationship with Great Britain); nation-state; and personal–social. For each level of inclusiveness, Gandhi frames the direction of his care ethics with a suitable narrative.

The narrative within which Britain can be a partner to India is a transformative one. It proposes redefining a relationship of dominance and exploitation into one of cooperation and mutual benefit. Moving from the international picture to the level of the state, Gandhi constructs an emancipatory narrative for the masses of India, Untouchables, and women in particular. India is to be governed with the needs of all paramount, without regard to station or gender. Unlike his fellow leaders, Gandhi is wary of a home rule that merely supplants British oppression of the masses with Indian oppression of them. At the level of social offense and harm, Gandhi casts care within the narrative of redemption. Instead of the standard responses of punishment to wrongdoing, such as imprisonment, Gandhi proposes a narrative whereby the wrongdoer can take an active role in making restitution to the community. The proposal is especially caring because in the process the wrongdoer restores himself to wholeness and reestablishes himself within society.

Narrative is fundamental to the ethics of care because, as we have seen, care charges itself with dealing in the particular and minimizing the role of general principles. Only narratives that afford details of relationships, their histories and interests, can be rich enough to enable considerations of care to yield definitive moral guidance. *Gandhi* extends the significance further, demonstrating the role of narrative within a larger story, instrumental in giving form or shape to the ways in which an individual expresses care. With *Gandhi* we come full circle, back to *Saturday Night Fever*. More so than in our other movies, narrative provides guidance and direction for the protagonists of this pair of films. In this respect, narrative is like attentiveness and responsiveness in being a constitutive element of the care ethics in practice. Whether in the personal life of Tony Manero or in the socio-political arena of Gandhi, creating narrative is shown to be a valuable resource of the practitioner of care.

II. Thrown into the public sphere

Gandhi develops our understanding of how the perspective of care can be employed in the public realm of social, economic, and political problems. In the film, care is portrayed as the basis of a coherent public stance by consistently shaping Gandhi's political decisions and public policy. We see how the public expression of care is structured by the building blocks of the care ethics: attentiveness and responsiveness to need, relationship and mutual dependency, context and narrative.

The film opens with the assassination of Gandhi, after which we view throngs of mourners so numerous as to seem beyond counting. Gandhi's tale, then, is told in flashback. Throughout the film, the face of the assassin haunts various scenes like a watchful, implacable angel of death. The arc of the story and Gandhi's life is thereby established and we are encouraged to reflect on the meaning of the life rather than exercise ourselves about how it will end.

As indicated, the episode that launches Gandhi on his vocation of freeing India from British rule and furthering its social integration occurs in South Africa. British officials summarily pitch Gandhi from his train when he insists that his first-class ticket entitles him to ride where only Whites are permitted. Although Gandhi has legally obtained his ticket, he is not treated as an equal. From the perspective of justice, the abstract laws and rights that ought to protect him are being violated. His rough introduction to British discrimination rouses him to fight back by attacking the Indian Identification Pass law in his earliest display of civil disobedience.

Gandhi proclaims the peaceful means of protest and then issues a call across religious boundaries to rally Hindus, Muslims, and Sikhs to burn their passes. It is civil disobedience because, as with US Selective Service cards, the passes are government property. In the face of violence by the police, Gandhi continues to burn the passes he has collected. He keeps getting hit, knocked to the dusty ground, and he keeps burning. The scene sets the tone for the entire film. Gandhi will lead his people in non-violent resistance, sometimes disobeying British law, in an attempt to end injustice.[9] At first, the injustice is a matter of abolishing or changing particular laws, such as the Pass law. But ultimately, it extends to the British rule of India itself.

The film suggests that the perspectives of justice and care are more than compatible and that the goals of justice can be achieved (may best be achieved) by means based in the ethics of care. For Gandhi the only morally acceptable way to change the law is non-violent resistance. Non-violence alone treats the oppressor in a respectful, caring way and only non-violence keeps the protester from descending into the viciousness that violence produces.

Gandhi reads in the paper how he would have been within his rights to prosecute the police for assault since he did not resist arrest; however, he declines legalistic remedy and the ethics of justice, in favor of continued non-violent protest. From the outset, Gandhi's strategy expresses his intention to engage the British as participants in an ongoing relationship. As with his aims with regard to different groups within India, Gandhi is intent upon inclusiveness. Even the oppressors are included—as fellow citizens in the debate over the law. The conflict intensifies as humiliating laws are passed authorizing the fingerprinting, Christian marriages, and house searches of Indians. To an aroused gathering of Indians, Gandhi says that he too is prepared to die, but not to kill. The virtue of care counsels reconciliation through communication and understanding rather than coercive response.

III. Attentiveness, responsiveness, and inclusiveness

South Africa is but prelude to India. After securing repeal of new laws that subordinate Indians, Gandhi goes home to India where he is encouraged to start a journal to disseminate his ideas and spearhead the movement for home rule. An aerial shot of a train going through the Indian countryside is accompanied by traditional sitar music. Inside the train, Gandhi observes and writes, soberly and thoughtfully. He has begun his prolonged

immersion in the everyday life of ordinary Indians. From now on, Gandhi will ride (wearing homespun cloth) third-class by choice, not only to experience peasant life first-hand, but to help forge a relationship of mutual regard and trust between the peasants and the Indian elite.

Before he can respond to the problems of the peasants, Gandhi must understand them; he must be attentive. I am inclined to view attentiveness and responsiveness as part of the perspective of care; however, they could also be thought of as separate virtues that are necessary to caring behavior. Either way, attentiveness and responsiveness are essential to the expression of care. In order to promote the welfare of other people as caring motivates us to do, we must pay attention to who and what they are without reference to our own purposes or needs. As M. Scott Peck notes, paying attention is work.[10] Where Peck emphasizes listening (especially to children), Iris Murdoch stresses looking, "Love ... is an exercise of ... really *looking*. The difficulty is to keep the attention fixed upon the real situation," rather than what serves our own selfish interests.[11] The film portrays Gandhi expending great effort in both looking at and listening to the everyday life of India. He is attending with his whole self in order that he may respond judiciously and helpfully.

Gandhi also exhibits another facet of the perspective of care—sympathy, or what may be considered the sympathetic imagination. Nel Noddings describes such sympathy as a "feeling with" the other person, a receptivity or openness to what the other person is going through.[12] The sympathetic imagination is needed to link attentiveness with responsiveness. Only by being receptive to what other individuals are experiencing can our listening and looking yield a response that is suited to the actual needs of the individuals in their particular situation. That Gandhi is genuinely open to the harsh experience of the peasant population of India is in evidence throughout the film, in his smallest gesture as much as in his boldest initiatives.

For we soon learn that unlike most of the Indian intelligentsia, Gandhi's thoughts are chiefly occupied with improving the brutal lives of India's masses. At his first major public rally, Gandhi takes those assembled to task for not truly representing India. He tells the crowd that the politics of the masses is about sustenance, bread and salt, and that the present group represents just another form of oppression. India is about "700,000 villages, not a few hundred rich urban lawyers." In telling the educated well-to-do that they cannot challenge the British without popular support, Gandhi is pointing out the interdependence between the upper class Indians and the masses.

The notion that all Indians are connected, their welfare entwined, is a familial one, evoking the care ethics on the personal level but applying it in the public sphere of politics. Later, Gandhi makes the family metaphor explicit, saying that Hindus and Muslims are all born of mother India. As if to underscore Gandhi's perspective of care, he is addressed with familial affection as Bapu or father by those close to him. As a counterpoint, he is formally referred to as Mahatma, Great-Souled One, by others. And both are accurate. Gandhi must employ the wisdom that helps make him a great soul in order for him to sire a postcolonial India.

The oppression the British visit upon Indians is based on an economic hegemony that leaves most of the population impoverished. The British landlords exploit the native peasants, altering their crop and rent demands to suit British homeland manufacture or trade. We see Gandhi digest what is told to him by an old peasant who describes the poverty that has resulted from the British landlords demanding cash instead of payment in crops. Attentiveness and responsiveness do more than motivate action. They select what is perceived and what becomes salient within perception; they organize and direct thought.

What stands out for Gandhi in India's relationship with Britain is that the needs of the Indian people are not being met. An ethics of care takes meeting needs within the relationship as a primary responsibility. British dominance is thereby translated by Gandhi into failure to meet the central requirements of a caring relationship. Economic protest and independence, as in the making of salt and reliance on homespun rather than British manufacture, flows from the virtue of care as taking responsibility for meeting basic needs. They are ways in which Gandhi is responding to the poverty and powerlessness of the people of India. Gandhi regards this as the responsibility of the wealthy, educated leaders of India who seem more concerned with jockeying for power in anticipation of Indian home rule. For Gandhi, the welfare of Indians is primary even though, as we shall see, his care extends to humanity in general.

Gandhi's rejection of all hierarchy is grounded in the desideratum of meeting the needs of the people as well as the fundamental equality that he believes defines human life, and therefore necessarily justice. In attacking hierarchy, then, Gandhi is simultaneously pursuing an agenda of care and furthering the just organization of society. Gandhi decries the way British exploitation of Indians is mirrored in Indian subjugation by caste and gender. Hierarchy, external and internal, is destructive because it fails to care for those least powerful within the relationship. It also erects distinctions among groups of people that are simply false. Just arrangements, for Gandhi, will always reflect relationships among people that are true to what is ultimately real. Gandhi alone seems sensitive to the parallel between British oppression and the oppression of Indians by their own leaders. Gandhi makes his point gently as well as stridently.

At an informal gathering of the Indian brain trust, Gandhi takes a tray of refreshments from a servant, saying that he wishes "to embarrass all those who would treat us as slaves." His action implies that wealthy Indians are, after all, treating their brothers and sisters in this exploitative way, even if they do not quite realize it. Then, too, Gandhi is ever aware of the need for consistency in his own person, living simply and dressing like a peasant. If he is to be accepted by the masses, he must decline privilege as well.[13]

Acting from the perspective of care, Gandhi includes all religions in his ashram ("community") and values each person's labor equally. When his wife protests that cleaning toilets is the "work of Untouchables," Gandhi replies, "In this place, there are no Untouchables." Neither are women relegated to second or third class. Gandhi understands that rejecting British oppression of Indians entails rejecting the oppression of Untouchables and women by their fellow Indians. The ethics of care seeks to promote the well-being of all,

especially those whom we identify as our people. First for Gandhi are Indians, but not too far behind is humanity, including the British. Members of the Indian elite will be hypocrites if they denounce British oppression and injustice while practicing their own.

The historical context is one of class and gender subjugation, for which Gandhi creates an emancipatory narrative grounded in the ethics of care. The social constitution of the self, foundational in the care perspective, is evident in Gandhi's insistence on the interdependence of all Indians: each member of the community, regardless of class, gender, or religion, contributes to the identity of Indian society. Gandhi thinks and speaks of India as a family. Just as the maternal thinking championed by Sara Ruddick demands that parents take responsibility for the welfare of everyone in the family, so does Gandhi demand that the leaders of Indian society take responsibility for all the people in India. The self that is configured socially by Gandhi, of course, exists in the public sphere of ashram, village, and country.

IV. Non-violence and the ethics of care

Just as the ordinary peasants must see themselves as one with Gandhi and the other native leaders, so must the British come to view Indians as their equals, capable of self-governance. To this end, Gandhi preaches and practices non-violence. Non-violent resistance and protest enable people who lack institutionalized forms of power to assert themselves in ways that are consonant with caring about their adversaries. What are the features of non-violence that embody the perspective of care?

Non-violence expresses the intent of changing the behavior and policies of those in power but without doing them physical harm. Avoiding harm is arguably a minimal requirement of the motive of benevolence and the perspective of care.[14] Violence, on the other hand, can predictably be expected to damage people with no expectation of compensatory benefit for them.[15] The intent of non-violence is to treat oppressors with respect and good will. By awakening in oppressors a similar humanitarian regard for the protesters, non-violent resistance can pave the way for constructive discourse and reconciliation.

Non-violence also reflects care in its need for sensitivity to the particular circumstance and the narrative history of the relationship. The non-violent protest zeroes in on prominent aspects and moments of the shared history in order to call attention to the injustice or cruelty. As Sara Ruddick points out, "The work of peace is always specific, a particular resistance to particular violence."[16] By calling attention to the particular, the acts of defiance typically have symbolic resonance, as with Gandhi's burning of the identity cards in South Africa or, later in India, the march to the sea to make salt. The non-violence thereby acquires the characteristics of speech, John Rawls going so far as to identify civil disobedience as a speech act.[17] And this leads directly into the next dimension of non-violence that commends it to the ethics of care.

Engaging in speech acts or speech-like protest respects the oppressors as rational agents and invites them to participate in reasoned discourse. Where violence often stirs up distracting passions and violent retaliation that cloud reason, peaceful protest keeps attention fixed on the injustice being contested, such as discrimination or colonial rule. In this way, non-violence strives for rational discussion of differences with the aim of reaching reconciliation. Rather than force the opposition into submission, Gandhi's civil disobedience seeks freely given agreement to alter the oppressive relationship in a peaceful, respectful way.

Non-violence also displays care in trying to maintain, but improve upon, the relationship between oppressor and those who are dominated. As with the relationship between Britain and India, those who act from care have an eye toward the future as well as the prior history of the relationship. By showing respect and concern for those in power, non-violence holds the most promise for a worthwhile future relationship between the antagonistic parties. History did, in fact, bear out Gandhi's hope, for India maintained close ties with Britain after gaining its independence.

Here we should be careful to distinguish Gandhi's commitment to pacifism from what the ethics of care itself might entail. There seems little doubt that the Gandhi of the film (as well as the historical figure) is committed to using only non-violent resistance. And care certainly plays a central role in shaping Gandhi's pacifism. As for the perspective of care itself, at the very least it commends non-violence as the morally best route to the political goals one is pursuing. Care demands that non-violent strategies be given every opportunity to succeed. The stronger claim, of course, would be that care entails non-violence and precludes any acts of violence. Of this, I am less sure. There may be circumstances in which care permits or even requires violence, Gandhi's own viewpoint notwithstanding.

Recall that the ethics of care permits partiality for those who are closest to us. Such preference reflects the roots of care in the private domains of family and friends. After all, care would seem to require that we do more and better for family and friends than for others, at least *prima facie*. Following Michael Slote, care involves a balance—between concern for our own people and humankind in general. But giving priority to one's own, cautions Sara Ruddick, can itself be an impetus toward violence. As with Slote's view of benevolence, Ruddick sees maternal practice as allowing, even requiring, favoring one's own (children, for example). Consequently, Ruddick worries that maternal non-violence is typically limited by this commitment to those closest to us and hence can be a source of maternal militarism toward others.[18]

The character of Gandhi provides two responses to Ruddick's worry. First, the ethics of care does not license inflicting harm on others as a concomitant of partiality to those who are dearest to us. The balancing of the welfare of humanity (or the oppressor) is shown by Gandhi to put limits on what we are permitted to do for the sake of our own. Gandhi thereby supports Slote's intuitive appeal to balanced care by indicating in concrete political terms moral restrictions on how the balance is to be struck. The stronger reason to forgo violence is that it is not truly in the interests of the people we care most about to allow or encourage them to do violence. We are not exhibiting the ethics of care, as parents or as political

leaders, if we preach non-violence within the group only to permit it toward outsiders. And this because violence toward others inflicts moral damage on ourselves. Gandhi believes that the perpetrators of violence feed their own violent passions, sabotage their reason, and cripple their compassion for others. In other words, violence toward anyone is bound to undermine the integrity of care.

As the non-violent resistance gains momentum, Gandhi still must defend it against those who would take arms against the British. Gandhi repeats the rational goal of non-violent resistance: to change the minds of the British not to "kill them for weaknesses we all possess." Gandhi organizes a day of prayer and fasting in protest of the latest British anti-sedition law. By stopping everything in India—including communication, transportation, and government administration—Gandhi expects to strip away the veneer of authority and expose the true relationship of the British to India as one of dependence.

Unfortunately, before the British are convinced that, in Gandhi's words, it is time that they leave India, much blood is shed. The most gruesome event occurs at the Amritsar massacre and perhaps the most pivotal one takes place at the salt works. The scene at Amritsar is horrific. Thousands of defenseless men, women, and children dash frantically to and fro to escape the British onslaught. Volley upon volley of rifle shots shred the shrieking crowd until all that is left are piles of dead bodies. The bitter irony of the slaughter is that non-violence toward the British was being preached at the gathering of Indians![19]

On the anniversary of the massacre at Amritsar, Gandhi leads a march to the sea to defy the British law against Indians making salt. The making of salt symbolizes the need for Indian economic independence from Britain by focusing on a necessity of life that is under British control. A leisurely, long pan of the gracefully moving group of marchers telescopes to Gandhi at the sea. Aware that the world is his witness through news media, Gandhi establishes relationships with third parties by enlisting their sympathy and care. Gandhi wisely understands that Indian home rule will involve relationships besides India's ties to Britain.

The world-relationship is especially crucial when Indians subsequently march on the British controlled Dharasana salt works. Old and young, Indian men walk to the gates of the salt works and are beaten by Indian soldiers in the British service. The protesters are determined and persistent, like the sea itself, wearing away the rock of British domination. Their dogged determination is reminiscent of Gandhi's initial burning of identity passes in South Africa, as if the multitude of protesters have sprung from him. As the relentless beatings continue, American journalist Walker (Martin Sheen) tells the world that "whatever moral ascendancy the West held was lost here today."

The tide has turned. The British are boxed in. If they ignore the march and subsequent production of salt, they are humiliated in the eyes of the world. If they beat the protesters, they are brutish bullies. The role of the press and the watching world points out that the rational, moral thrust of non-violence helps establish Indian relationships with those not directly involved in the struggle. Gandhi tailors his non-violence to the particular circumstances in which he finds himself, one replete with newspapers, telegraphs, and newsreels.

When a subsequent summit meeting in Britain leaves India still under British rule, Gandhi nevertheless rejects taking advantage of the demands of war (the Second World War) to wrest home rule from Britain. Perplexing most of India's leaders, Gandhi speaks perspicaciously in the language of care when he says, "We have come a long way together with the British. When they leave we want to see them off as friends."

Gandhi's attitude toward Britain exhibits the emphasis that care places on the social nature of the self. He sees the identity of India as determined by both its external and internal social relationships. Chief among the external relationships is India's historical entwinement with Britain. Saying that India has "come a long way" with Britain indicates Gandhi's appreciation for the significance of that relationship as well as the narrative that captures it. Freeing India from British rule is not merely negative, terminating an unjust relationship. Rather, Gandhi is trying to realize a transformative narrative, one that reconstructs the hegemonic history of the two countries into a postcolonial narrative of mutual dependence. The welfare of both Britain and a self-governing India is not served by severing all ties, but is best realized through a relationship of interdependent cooperation.[20] In pursuit of this future state of affairs, Gandhi rejects using British embroilment in the Second World War to wrench India free of its dominance.

As we have seen, the perspective of care requires the auxiliary virtues of attentiveness and responsiveness. They are essential to its function in the world. Yet there are other virtues that, while perhaps not indispensable to care, are often crucial to its effectiveness. Patience would seem to be one of these auxiliary virtues. It takes great patience on the part of Gandhi and his people to wait for the British to finally see that they cannot continue to rule India. Now, in the midst of world war—a golden opportunity to push Britain off their shores—Gandhi still counsels waiting, for the sake of a long-lasting and amicable peace. Peacemaking typically takes time, time for the adversaries to discuss their differences and reach agreement. So too with Gandhi's non-violence. Violence is usually the quicker route, at least to short-term gains. But Gandhi's responses to the needs and problems of India require patience and endurance. The character of Gandhi, then, suggests that the ethics of care calls for the patience to endure frustration for the sake of a peace that will be genuine and mutually beneficial.[21]

Because Gandhi conceives of India's identity as social, he embraces the view of the care ethics that autonomy is strengthened by relationships of mutual dependence. Consequently, Gandhi projects a future in which India the nation-state will need allies; in the personal language of care that he employs, India will need friends. When Gandhi advocates seeing the British off as friends, he clearly has in mind India's long-term need for foreign alliances in order to function autonomously in a dangerous world. Gandhi is able to be patient because he is far-sighted, taking the long-term needs and well-being of India into account.

Where the viewpoint of justice construes autonomy as separation and non-interference, the feminist perspective of care finds connection and mutuality empowering. Jennifer Nedelsky, for example, urges that autonomy be understood "through relationship with others … interdependence [is] a constant component of autonomy."[22] In envisioning a

postcolonial narrative for India, Gandhi anticipates the insight of such care ethicists as Carol Gilligan, who addresses autonomy at the interpersonal level, "The interdependence of attachment empowers both the self and the other, not one at the other's expense."[23] Gandhi enlarges the understanding of relationship as vital to autonomy from personal domains of family and friendship to the nation-state. Developing a mutually supportive relationship with the former oppressor of an entire country is a prudent goal that seems almost unthinkable in terms of abstract principles of justice.[24]

V. India as a social self

For Gandhi, India's identity depends as much on relationships that are internal to it as on such external relationships as India's postcolonial alliance with Britain. The internal elements of India's social identity are themselves social groups—defined by gender, class, and religion—rather than a mere collection of individuals. Men and women, peasants and wealthy, and Hindus and Muslims create India's personality. The integrity and identity of India are determined by the genuine participation of all its groups. As we have seen, Gandhi rejects Indian customs and practices that subjugate women and Untouchables, excluding them from full membership in community because the perspective of care opposes the injustice that necessarily follows from such exclusion and oppression. Besides questions of justice, or as a concomitant of them, Gandhi sees the inclusion of all groups as essential to fully realizing India's cultural identity.

Gandhi's relational conception of social entities, informed by the ethics of care, extends to the groups themselves. Each group is defined by its relationship to its counterpart. Just as gender and class identities are formed under the influence of their respective counterparts, so are the identities of India's Muslims and Hindus mutually constituted. Gandhi's understanding of relationship as defining India's identity, as a whole and for its member groups, determines his response to the antagonism between Hindus and Muslims.[25]

Gandhi opposes partitioning postcolonial India into Muslim and Hindu nations. As he does with regard to the British, Gandhi argues for sustaining the relationship rather than severing it in the matter of carving the Muslim state of Pakistan out of the predominantly Hindu India. Keeping Hindus and Muslims united is necessary to maintain India's identity as a culture and a country. To emphasize the relational identity of India, Gandhi publicly addresses its composition in the language of family, "We [Hindus and Muslims] are brothers born of the same mother India." This image is a variation on his earlier remark that Hindus and Muslims are the right and left hands of India. For Gandhi, Hindus and Muslims define one another *qua* Indians just as each religious group is essential to the identity of India.[26]

Insistence on partition reflects more of a justice perspective: separate states will protect the rights of Muslims, insuring their freedom from domination by terminating their formal relationship with the Hindus of India. Advocates of partition seek to establish geographical boundaries, which will wall off one social self, Muslim Pakistan, from

another (Hindu India) and thereby establish rights to their respective property or lands.[27] Separation rather than connection is viewed as the best resolution of religious difference. Gandhi is disheartened at what he sees as the dissolution of India's national self. The connectedness of mutual support and invigoration of care underlies his exertions on behalf of a united Indian subcontinent.

To be sure, it could be argued that the Muslim insistence on independence from Hindus is analogous to India's earlier demand for independence from Britain. The Muslims of postcolonial India did believe that their needs could not be met without a similar divorce from the more dominant religious group. To care for their own, then, Muslims see separation as the answer. Clearly, Gandhi thinks differently. Governed by the ethics of care, he appeals to the history of the relationship between Hindus and Muslims. To divide the two religious groups is tantamount to destroying India as a socially defined entity. Gandhi also believes that keeping India intact is the responsible way of meeting the needs of Muslims as well as Hindus. Looking toward the future, as he does with Britain, Gandhi projects a narrative in which an integrated India would have greater standing in the world. Looking back, at the history of India, Gandhi appeals to the value of diversity: Muslim and Hindu subcultures have ever enriched one another, creating a vibrant, greater India. Although we can debate which alternative is more in accord with the perspective of care *per se*, care clearly motivates Gandhi to campaign for maintaining close affiliation by keeping India whole.

An aerial shot of long lines of people moving in opposite directions portrays the Muslim exodus from India for the newly created Pakistan while Hindus living in those lands head for India. The moving streams of people suddenly break and hand-to-hand skirmishing escalates into pitched battle. Even with partition, violence has erupted.

As Muslims and Hindus riot in the streets, Gandhi takes to a rooftop in a Muslim neighborhood to fast, confronting civil strife with non-violent protest, just as he opposed Indian violence against the British occupiers. Of course, fasting has a spiritual meaning, one to which Gandhi subscribes. In turning away from our corporeal concerns, we orient ourselves toward eternal values and our relationship with God. As deployed by Gandhi, fasting adds another dimension—of care. Gandhi seeks to remind all his countrymen of their relationship to one another, to mother India, and to himself as well. Drawing on the religious thrust of fasting, Gandhi is asking his fellow Indians to turn their attention to higher things. Gandhi will fast until the mayhem ends, completely.

Gandhi is also using the fast to set limits on his relationship with his countrymen, in effect saying that he will not continue the relationship unless they treat one another in a caring way. Gandhi thereby helps fill in the ethics of care with the conditions whose violation marks the termination of relationship. And Gandhi expresses these limits in a way that emphasizes the nurturing core of care. By denying himself nutrition, Gandhi makes explicit the limiting conditions of his caring relationship, conditions that usually remain implicit in our personal ties. Gandhi's fast symbolically proclaims that violence against members of society is violence toward him. If Indians cannot act responsibly toward one another, he will not remain in relationship with them.

Gandhi is also motivated by care to try to cultivate the orientation in others, especially those whom Gandhi counts as his people. Following Michael Slote, developing the ethics of care in others is likely to have a "multiplier effect" as those who adopt the perspective in turn further increase the well-being of humankind. "A caring person might thus see the promotion of caring as the best way to promote [human welfare] … the concern for and promotion of virtuous caring on the part of others would be an instance of caring itself conceived as a fundamental form of moral excellence."[28] The direct purpose of improving the moral character of others would then indirectly increase human welfare as a result of the actions of these caring people. As non-violence is basic to Gandhi's understanding of care, it is natural that he attempt to strengthen its tenets in his fellow Indians.

As Gandhi's fast continues and he fades, the civil conflict begins to abate. In a tense, riveting scene at his bedside, Gandhi is called upon to envision a redemptive narrative of care that encompasses the personal and political. The narrative concerns a crazed Hindu who approaches Gandhi toward the end of his fast. In despair over having killed a Muslim boy to retaliate for the murder of his own son, the man tells Gandhi that he is going to hell. Gandhi gently says that he knows a way out of hell. He tells the Hindu killer to find a boy his son's age, orphaned by the civil conflict, and to "raise him as your own. Only be sure he is a Muslim and that you raise him as one."

The Hindu man turns to Gandhi and quietly puts his head on the bed at Gandhi's feet. Overwhelmed with gratitude, he cries. Gandhi has imaginatively entered into the man's suffering and his need for atonement and forgiveness. As Sheila Mullett explains in explicating the ethics of care, we must be able to apprehend the world through the eyes of another.[29] Gandhi's sympathetic imagination enables him to respond in a caring way to the man's need as well as to the particulars of his crime. The recommendation that Gandhi offers is shaped by the perspective of care to promote restitution, restoration, and healing.

So often punishment is something visited upon criminals. They are fined, flogged, shunned, banished, incarcerated. Rarely will a passive offender be able to fulfill the aims of restitution as understood from the perspective of care. Gandhi understands that we *make* restitution; it is a benefit actively conferred by the wrongdoer. He sees how playing the active role of parent can restore the Hindu killer's self-respect and integrity. Having a child to love will also heal the psychological wounds caused by his own son's death.

In his proposal for restitutive justice, Gandhi demonstrates the sensitivity and flexibility of mind that is required by the ethics of care. Gandhi's response is adapted to the particular offender in his concrete situation: a man whose child was murdered, mistakenly thought to avenge his loss by killing an innocent boy, and now suffers desperately from his wrongdoing.[30] At the same time, Gandhi appreciates the context of civil strife that harms individuals willy-nilly, often inciting people to commit injustices against their better judgment and against their better natures.

In his response to the agitated Hindu, Gandhi simultaneously speaks to the interests of the individual and the requirements of the wider society. He anticipates how the Hindu man would not only meet the personal needs of the orphaned Muslim boy, but would assist

106

the Muslim community by raising one of their destitute children. Moreover, the Hindu offender would promote mutual understanding and concord between the two religious groups by virtue of his affection for a Muslim and his ongoing interaction with the Muslim community. The film extends our understanding of care by showing how it can span the personal and public as Gandhi's scenario enables the Hindu offender to make restitution to the Muslim society and restore him to himself. In Gandhi's redemptive narrative, the ethics of care operates on the personal level of guilt, alienation, and grief, as well as on the socio-political plane—replacing communal enmity with amity.[31] Although we cannot expect to find such comprehensively restitutive responses to every crime, Gandhi's restorative scenario can be viewed as an ideal toward which the approach of care points.

We do not have to decide here whether to conceive restitution as a component of punishment or as an alternative to it. What we can infer from the example of Gandhi is that restitution or restoration is the course that the care ethics recommends as the best response to harmful or criminal behavior. Here Gandhi anticipates the thinking of Nel Noddings. Noddings rejects what she calls "negative desert" as inconsistent with such goals of care as health, cooperation, and education (Noddings's own field). Speaking of home and school, Noddings favors a practice of positive incentives that gives students (or offenders) some control over their lives.[32] For Gandhi, caring behavior seems to be an alternative to punishment, since punitive remedy does little to further relationship, meet the needs of the offender, or restore the offender to community. This is why, earlier in the film, Gandhi tells a young and eager Nehru (Roshan Seth) that it is not their job to punish Britain. A less radical position on the bearing of care on punishment might insist that wherever possible restitutive solutions be sought, even though some situations may not permit restitution or restitution alone.

The fighting soon ends and, with it, Gandhi's fast, and we presently come full circle—to the assassination scene with which the film begins. Gandhi is about to embark on a visit to Pakistan to strengthen India's relations with her new neighbor. If Hindus and Muslims cannot live together as one nation, Gandhi reasons, at least they can be good friends as well as geographical neighbors. But Gandhi is viewed by a faction of Hindus as betraying the Hindu cause, and, in a healthy sense, he has. Gandhi does not favor Hindu over Muslim, nor over Christian or Jew, for that matter. When previously warned not to parlay with the Muslim Jinnah in order to avert partition, Gandhi heatedly replied that he is (himself) "a Muslim, and a Hindu, and a Christian, and a Jew." The Mahatma's soul is great enough to embrace all without prejudice and, seemingly, without effort. The perspective of care that so fully animates Gandhi disposes us to see common ground and to celebrate it. The humanitarian caring of which Slote speaks is not some dry duty for Gandhi, but a strong emotional current that carries him to regions of rapprochement, reconciliation, and political friendship.

The scene of thousands of mourners paying tribute at a huge funeral pyre fades to a shot of a ship on a sea tinged by sunset. As Gandhi's ashes are given to the waters, we hear his voice repeat the mantra that has buoyed his spirits through the bleakest times. "When I despair, I remember that all through history the way of truth and love has always won ...

[over tyrants and murderers]. Think of it. Always." Sitar music gives way to the peaceful sound of lapping water in the closing shot of flower petals floating on the calm sea, calling to mind the inner peace of those who follow Gandhi in practicing non-violence and the ethics of care with which it is imbued.

If all *Gandhi* did were illustrate what we already know about the public exercise of the ethics of care, it would be worth our scrutiny. After all, an extended example that consolidates important social and political expressions of care is a useful heuristic. But the film does a good deal more. It expands our understanding by depicting a paradigm of care in the person of Gandhi. The diverse elements of the care perspective are woven into the fabric of his character, the values of care sustaining Gandhi in his life-long labors for the people of India.

The perspective of care is evident in Gandhi's attention and response to the needs of the peasants of India. He illustrates how the imagination can resonate sympathetically with masses of people in order to fashion effective responses from careful attention. Fellow feeling as well as a sense of natural justice is the basis for Gandhi's rejection of both hegemony and hierarchy. The relational understanding of the self is made explicit by Gandhi—not only for individuals, but also on the level of social groups and the nation-state. Groups configured by gender, class, and religion are viewed as defining one another as well as forming the identity of India, conceived as a greater social self.

The perspective of care also informs Gandhi's passion to maintain and improve upon existing social relationships, whether India's postcolonial relationship with Britain or the relationship between India's Hindus and Muslims. Then, too, the non-violence by which Gandhi frees India from British dominance enables him to resolve the tension between care toward all and injustice toward his own people. Non-violence shows care toward the oppressor in its peaceful mode of opposition to the subjugation itself.

Lastly, the film draws our attention to the ways in which care embraces narrative. The virtue of care is expressed in the array of narratives through which Gandhi resolves issues of injustice. He creates emancipatory narratives for subjugated groups within India; a transformative narrative of enduring friendship between India and Britain; and redemptive narratives for those who violate the requirements of community and care. Acting from the perspective of care requires appreciation of and reliance upon narratives, narratives that shape the diverse elements of concrete particulars into coherent, intelligible accounts. I hope to have shown that the story of Gandhi is one such narrative and that it sheds considerable light on the efficacy of the ethics of care in the public sphere.

Notes

1. Carol Gilligan, *In a Diffferent Voice: Psychological Theory and Women's Development* (Cambridge, MA: Harvard University Press, 1982), and Nel Noddings, *Caring, A Feminine Approach to Ethics and Moral Education* (Berkely: University of California Press, 1984).

2. As a shorthand, I am grouping various ethical approaches under the heading of justice because they share central values and tenets. In so doing, of course, important differences are necessarily smoothed over. And this is also true for the ethics of care, within which there are also different strains. I trust, however, that the main ideas of my presentation are nonetheless intelligible and that my main contentions are nonetheless plausible.

3. Claudia Card distinguishes responsibility in the "administrative" point of view (identified with justice and contractarian ethics) from responsibility in the ethics of care. The former emphasizes supervision, control, and accountability; the latter involves committing oneself to looking after someone and seeing to his or her well-being. "Gender and Moral Luck," in *Justice and Care*, ed. Virginia Held (Boulder: Westview Press, 1995), pp. 79–98, 88.

4. Nel Noddings, *Caring: A Feminine Approach to Ethics and Moral Education*, p. 86.

5. Grace Clement, *Care, Autonomy, and Justice* (Boulder, CO: Westview Press, 1996).

6. Carol Gilligan, "Moral Orientation and Moral Development," in *Women and Moral Theory*, eds. Eva Kittay and Diana Meyers (Totowa, NJ: Rowman and Littlefield, 1987), p. 20. Other thinkers who follow this complementarity line of thought include Virginia Held, *Feminist Morality* (Chicago: University of Chicago Press, 1993) and Marilyn Friedman, *What are Friends For?* (Ithaca: Cornell University Press, 1993).

7. Allison Jaggar, "Caring as a Feminist Practice of Moral Reason," in *Justice and Care*, ed. Virginia Held (Boulder: Westview Press, 1995).

8. Because "care requires that one attend to the needs of both self and other," the self is considered as possessing equal worth as the other person in the relationship, Grace Clement, *Care, Autonomy, and Justice*, pp. 35–37.

9. Since civil disobedience is a subclass of non-violent protest, involving violation of law, I will refer to Gandhi's general practice as non-violence, and specify disobedience where appropriate.

10. M. Scott Peck, *The Road Less Travelled* (New York: Simon and Schuster, 1978), p. 81.

11. Iris Murdoch, *The Sovereignty of Good* (New York: Shocken Books, 1971), p. 91. Nel Noddings also emphasizes listening, "Because care theory is base on needs and responses ... we must listen to what others are going through in order to respond as carers," *Starting at Home: Caring and Social Policy* (Los Angeles: University of California Press, 2002), p. 241.

12. Nel Noddings, *Starting at Home*, p. 14. Noddings actually construes such receptivity as part of the attentiveness that informs care.

13. Were there time, we should discuss Gandhi's rich sense of self-reflexive humor. For instance, with regard to his humble lifestyle, he jokes that his friends say that it costs them a lot of money for him to be poor. The tie between humor and narrative in particular is, I think, a deep and interesting one.

14. Michael Slote, *Morals From Motives* (Oxford: Oxford University Press, 2001), p. 28.

15. Sara Ruddick, *Maternal Thinking: Towards a Politics of Peace* (Boston: Beacon Press, 1989), p. 164.

16. Ibid., p. 245. So too may violence be suited to particular circumstances, for example, employing guerrilla tactics at one time, but all-out assault at another. However, there is nothing inherent in violence that demands responsiveness to the particular, and often violence does in fact proceed indiscriminately, its practitioners relying on past tactics in circumstances for which they are no longer appropriate.

Furthermore, to the extent that violence is the result of volatile emotions, it will not have the benefit of the rational reflection, which so often is needed to fit our actions to the concrete situation.

17. John Rawls, "The Justification of Civil Disobedience," in *Civil Disobedience: Theory and Practice,* ed. Hugo Bedau (New York: Pegasus, 1969), pp. 240–255.

18. Sara Ruddick, *Maternal Thinking,* p. 231.

19. The British commander, General Dyer (Edward Fox), defends his refusal to issue a warning before opening fire on the legalistic grounds of the justice perspective. He justifies his unrestrained killing on the grounds that the Indians had been warned previously not to have meetings; therefore, he was within his rights as an army officer to annihilate them.

The British officials at the investigating tribunal listen in stunned disbelief to his apparent indifference to the innocent lives he has coolly slaughtered. The film suggests that even the British recognize the limits of the justice model while we in the audience see those limits underscored by the non-violence that issues from Gandhi's care perspective.

20. The interests of care sometimes require terminating a formal relationship with another individual, as in divorce, in the hopes that the relationship can improve thereafter.

21. The character of Gandhi also suggests that humility is yet another auxiliary virtue of care. Humility is needed to realize one's own limits in effecting change in other people and humility may also facilitate patiently waiting for others to listen, learn, or commit to a caring course of action.

22. Jennifer Nedelsky, "Reconceiving Autonomy: Sources, Thoughts and Possibilities," *Yale Journal of Law and Feminism,* Spring, 1989, pp. 7–36, 12.

23. Carol Gilligan, "Remapping the Moral Domain: New Images of the Self in Relationship," in *Reconstructing Individualism: Autonomy, Individuality and the Self in Western Thought,* eds. T. Heller, D. Wellerby, M. Sosna. et al. (Stanford: Stanford University Press, 1986), pp. 237–350, 249.

24. Granted independence after the war, India enjoys membership in the British Commonwealth, the very sort of association that Gandhi projects as strengthening Indian autonomy in the world.

25. I have been especially keen to draw a parallel between the individual person as a social self as found in the traditional formulation of the care ethics and the nation-state as a social self as found in Gandhi's expression of the care ethic. But the two cases, the two "selves," diverge with regard to the internal social constituents of the nation-state.

The social identity of a country, such as India, can indeed be composed of still smaller social entities (such as groups delimited by gender, religion, or socio-economic status) in a way that an individual person—however social his or her self—cannot be.

26. To ease Muslim fears of Hindu dominance, Gandhi asks Nehru to give way to (the Muslim) Jinnah as India's first prime minister. Keeping India intact is more important to Gandhi than having the abler man at its helm.

27. See Jennifer Nedelsky on how the imagery of the bounded self, qua individual, is dominant in constiutional law and conceptions of property: "Law, Boundaries, and the Bounded Self," *Representations,* 30, Spring, 1990, pp. 162–189, 167.

28. Michael Slote, *Morals From Motives,* p. 30.

29. Sheila Mullett, "Shifting Perspectives: A New Approach to Ethics," in *Feminist Perspectives*, eds. Code, Mullett, and Overall (Toronto: University of Toronto Press, 1988), pp. 109–126.

30. The flexibility needed for the virtue of care is also the hallmark of practical wisdom. The flexibility is needed because both must deal with concrete particulars for which no general rule or principle can ever be adequate in guiding action. Aristotle draws the analogy between judging indeterminate human affairs and measuring curved stone, *Nichomachean Ethics*, 1137b. Both practical judgment and architectural planning require a measure that bends with the contour of the thing being assessed.

31. Restitution and restoration are paramount in an ethics of care. A doctor who falsifies Medicare records, for example, would be viewed as needing to make restitution to the community—perhaps by providing unremunerated medical care.
 Doing so would restore him to a contributing and caring role in the community. Such a response to criminal conduct contrasts sharply with a justice perspective that would view the doctor and his crime in isolation, abstracted from the circumstances and his role (past and potential) in the community. Assessing him a fine or giving him jail time would do little to make amends or restore the doctor to the community or himself. Giving the doctor an active part to play in making restitution not only brings home to him the nature of his wrongdoing, but it helps restore the trust that he has damaged by his offense.

32. Noddings defends her view in language that could just as easily have been Gandhi's: "Reasons for my claim [rejecting negative desert] should be clear. Relations unburdened by negative desert put emphasis on mutual consideration, self-knowledge, and caring responses," *Starting at Home: Caring and Social Policy*, p. 200. Noddings explicitly rejects punishment *per se*, arguing that its emphasis on negative desert does not achieve even its limited, purported ends, such as deterrence, p. 204.

Conclusion

Just as our Introduction provided a forecast and overview of the book's analyses of films through the perspective of care, we now pull together a few of the major themes covered in those interpretations. The introduction noted that the organization of the chapters proceeds from focus on the individual, through family and friendship, to community and the nation-state: as if a movie camera were pulling back to widen the field of moral vision. Besides the expansion of scope, there is overlap from chapter to chapter of the various major themes—as would be expected in a discussion built around a central ethical viewpoint. Gathering several of the more sturdy thematic threads should give a feel for the ways in which the interpretations of the different films buttress and develop one another. What I am calling thematic overlap, then, provides a structure in content to complement the more formal enlargement of social space.

No doubt there are more subtopics to canvas than can be reviewed in any cogent or helpful way. I have chosen the following themes in an effort to highlight dimensions of care that deserve more attention than they have received. The themes we will review are parents and children; self-care; autonomy and care; and the role of narrative in care.

Parents and children

We return to the context that provided a major impetus for the surge in interest in the ethics of care, family and the parent–child relationship in particular. With the exception of *Friends with Money*, all the films clarify the place of care in the interactions between parents and children. Although *Friends with Money* includes children, their roles in the story are minimal; moreover, despite the virtual absence of children from *Gandhi*, the film nevertheless emphasizes a parent–child relationship, albeit on the level of metaphor. The film stories we discuss are striking for their stark portrayal of uncaring or careless parenting as well as for their sympathetic depiction of successful, but atypical, parental care.

The movies with which we begin present parents who fail to care for their children, yet advance our understanding of the care ethics by disclosing the diverse reasons for this failure. Tony Manero's parents, in *Saturday Night Fever,* are not caring because they project the images of their sons that most satisfy their own parental needs. Consequently, Tony's older brother becomes a priest (only to defrock himself) to please his parents. On the other hand, Tony is cast as the family loser, with only dancing and clothing on his mind. We see that Tony is made of sterner stuff than his older and apparently more gifted brother. Tony fights off his parents' disheartening projections and struggles to put together a plan that will enable him to escape Brooklyn and its adolescent pleasures. The inability of his parents to encourage his ambitions or appreciate his talent does not prevent Tony from striking out on his own. Parental failure is more decisive, however, in *Monster's Ball.*

Hank and Leticia do not know how to care for their sons. Each lacks a helpmeet, extended family, or friends to give them the caring support needed to meet the extraordinary array of demands of parenthood. The film suggests that neither Hank nor Leticia has had the benefit of truly caring parents. In Hank's case, we know that his mother committed suicide and we see his bitter father, now a retired prison guard. Leticia does not seem to have any relatives, and her husband has been imprisoned for almost all of her son's life. Their failures, then, are due to absence of care in their own lives. Both Hank and Leticia are verbally and physically abusive to their sons and are indirectly responsible for their deaths. Although they do not project a complete role for their children as Tony's parents do, Hank and Leticia express anger at their boys' weaknesses. Tyrell is overweight and Sonny is too compassionate to be the tough prison guard that Hank demands that Sonny strive to be.

Less overtly demanding, but perhaps more influential, is the father in *The Squid and the Whale.* Bernard is so self-absorbed that he barely notices how *his* two sons are coping with the separation of their parents. Lack of those cardinal virtues of care, attentiveness and responsiveness, render Bernard oblivious also to the stunting effect of Walt's idealizing of him. Because Walt idolizes and emulates his father, he does not discover his own tastes or interests. A caring parent would notice the threat to his son's authenticity of such unreflective imitation; however, Bernard's self-centeredness obstructs his perception of Walt. The result is that Bernard is more a hindrance than a help in Walt's adolescent struggles with self-discovery and self-definition. As with Tony, in *Saturday Night Fever,* Walt possesses enough intelligence and strength of character to overcome his father's paucity of care. By the end of their stories, Tony and Walt have managed to free themselves from the influence of their uncaring parents.

Tyrell and Sonny are not able to rise above the carelessness of their parents. Yet within the folds of *Monster's Ball* tale, easily overlooked, we get a glimpse of a genuinely caring parent. As with his more prominent counterparts, Hank and Leticia, Ryrus is a single parent—of (at least) two preadolescent boys. A black auto-repairman, Ryrus expresses care for his sons by defending them against the bullying tactics of Hank. He shows his boys that a black man can stand up for himself and his family by confronting a racist white man (dressed in the uniform of a state law enforcement officer). That Ryrus is later willing to do work for Hank,

perhaps eventually becoming his employee at the gas station, speaks to his flexibility and openness to change. We infer that Ryrus exercises these valuable characteristics as a caring parent as well.

Ryrus is the atypical parent (because a single, black man) who marks the transition among our films from parents who do not care properly for their children to the successful parents of our final two stories. Coach Jones is another unconventional parent in that he unofficially "adopts" Radio (James Robert Kennedy), acting for all intents and purposes as his guardian, especially after Radio's mother dies. Jones nurtures Radio's abilities and appreciates his moral virtues, such as kindness and loyalty. He goes so far as to point these out to other people in the course of acting as Radio's social and legal advocate. The Coach understands two profound things about care. First, no parent, natural or otherwise, can provide all the care needed by his child. The young person requires a community of people within which to develop and exercise his talents and moral strengths. Coach Jones works to facilitate Radio's participation in the various levels of social life on teams, in the school, and around the town.

Jones also understands that care may require sacrifice. In contrast to Bernard, who gives up nothing for his boys, Jones steps down from coaching in order to vouchsafe Radio's presence in the school. The Coach is willing to forgo the multitude of joys of football, which he articulates in a pivotal scene, so that the young man he has taken under his wing will have every chance to take flight. Jones makes a difficult decision look relatively easy. As with more common forms of generosity, the loss is more than compensated for in the pleasure of perceiving or anticipating the benefit enjoyed by the recipient of the gift. We surmise that Jones is buoyed by the prospect of Radio's continued flourishing through inclusion in the stimulating social life of Hanna.

Our concluding film, *Gandhi*, may seem like an odd choice for further exploration of care in parenthood. Yet Gandhi considers all Indians family, even as he is himself affectionately called "Bapu," father. Listening to the problems of the Indian peasants, working to free India from British rule, and fighting the oppressive caste system, Gandhi fulfills many of the duties of parenthood. He cares for all the people of India, regardless of religion or social position. Gandhi's labors are for the purpose of creating the political, social, and economic conditions necessary for his people to enjoy a good life. Before he can respond to the needs of the people, he must pay attention to them, touring the vast country and speaking with ordinary citizens. As a caring parent, Gandhi patiently teaches by example. He teaches Indians to be firm but gentle with their British rulers through non-violent resistance. He wants India to enjoy a mutually beneficial alliance or friendship with Britain after independence is achieved.

Later, when Hindus and Muslims are killing one another, like violent children, Gandhi admonishes them and fasts to end their civil strife. He is opposed to the partitioning of India into a separate, Muslim state of Pakistan because it is as if brothers and sisters will now be estranged from each other. Like a *pater familias*, Gandhi uses all his wits to keep the unruly family from splitting apart. If Coach Jones is generous with Radio in giving up football to

115

help his charge, how much more is Gandhi generous, giving his whole life for the sake of the freedom and prosperity of the millions of people of India—his children by proxy.

The virtues of care

Our discussion of parents and children touches on the virtues that are either constitutive of care or necessary for its exercise. We might consider these auxiliary virtues in that they operate beside the much-discussed central virtues of attentiveness, responsiveness, and sympathy. In particular, we noted the generosity that informed Coach Jones and Gandhi, who give their time and energy for the benefit of others. In the interpretation of *The Squid and the Whale*, recall the absence of generosity of heart from Bernard. Care often requires that we give something of emotional value, as when we give the joy of winning a ping-pong game or the relief from an obligation. When Radio refuses to indict Johnny for playing a nasty prank on him, he is generous-hearted, seeking to spare Johnny embarrassment or the pain of punishment. When Gandhi offers a man who has murdered a Muslim boy a way to make amends for his wrongdoing, he expresses generosity of heart. And when Aaron (*Friends with Money*) gently jostles his wife out of her perpetual funk, he is generous-hearted in helping her recover her emotional equilibrium.

Care is sustained by humility. Humility includes the recognition of our own limits. It is needed whenever we have to take into account what we cannot ourselves provide other people or whenever we must see that we are getting in the way of the care that another needs. Lack of humility, for example, keeps Bernard from caring as he should for his two boys. He thinks too much of himself, in both senses, to be able to give what they need. Insufficient humility also underlies the vicarious projection that animates Tony's parents, since they are trying to impose their versions of their boys on the two brothers.

Coach Jones and Gandhi are both humble enough to realize that they cannot care for Radio and India respectively by themselves. Each must enlist the help of others: the larger community of Hanna for Radio, and the peasants of India for themselves. Each views his own importance from the realistic perspective that characterizes humility. Jones understands that the welfare of another person is more important than his own pleasure in football. Gandhi understands that the plight of India's masses takes priority over the preferences of the well-heeled elite of India.

The challenge of self-care

The films examined contain a stream of characters who are faced with the challenge of caring for themselves. Some of the characters are able to rise to the challenge, while others are unable to meet their own needs when not cared for properly by individuals who should help them. Tony Manero has the inner strength to reject his parents' portrait of him as

the family flop. He seems to have the fortitude and determination to take care of himself early on in the story of *Saturday Night Fever*. It takes Walt most of the movie, however, to distance himself enough from his father to begin to attend clear-headedly to what he truly needs. Over-identification with Bernard has kept Walt from seeing himself as he truly is in *The Squid and the Whale*. Care for someone cannot proceed until we understand what is needed. For self-care, then, we have to understand ourselves. The story of the Berkman family shows that among the obstacles to self-care are the various screens that can keep us from perceiving who we are or wish to become.

Hank Grotowski has also identified with his father, following in his footsteps as a corrections officer. By the time we meet Hank in *Monster's Ball*, he is so encased in the norms and habits of prison work that he too lacks self-understanding. He does not realize that his life is hollow because it is bereft of caring relationships. Only when his son kills himself in despair over a loveless life does Hank awaken to his deepest needs. Disillusionment with his work, rather than his father (Walt's experience), is necessary before Hank can finally care for himself. Fortunately for him, he possesses the requisite competencies of independent thought and choice to make the break with his past and begin a life in which he can embark on genuine self-care. For Hank, self-care means opening himself to the possibility of the caring relationships that prison work and his father had foreclosed.

For each of the protagonists who find their way to care for themselves, there are foils, characters who are unable to meet their own most pressing needs. Recall that Bobby, Tony's friend, cannot untangle himself from the pregnancy of his girlfriend, yet is miserable at the thought of marrying her. Purposely stumbling off the bridge is Bobby's way of bowing to his failure at self-care. Hank's boy, Sonny, also gives up, ending his life rather than try to leave his work and uncaring home of father and grandfather. As with Bobby, the weight of the world overwhelms Sonny. Inability to establish any caring relationships beyond the meager friendship with the neighboring black brothers leaves Hank's son without hope.

Even as Walt works his way out of his stultifying relationship with his father, so is Bernard stranded on an island of narcissism. At the story's end, Bernard has lost his sons as well as any chance to reconcile with his estranged wife, Joan. We are left wondering whether Bernard realizes what he is missing or why he is so thoroughly alone. At least Bobby and Sonny perceive their dire condition, however hapless they feel to improve it.

We also watch as two characters who cannot care for themselves nevertheless find themselves in the safe haven of caring relationship. Neither Leticia nor Olivia (*Friends with Money*) appears to be able to meet her own needs, whether financial or personal. Yet each winds up in the arms of a man who will probably be good for her. Leticia and Olivia are, however, willing to take a chance—something that neither Bobby nor Sonny can do. Leticia puts her faith in a white man whom she does not know very well, and Olivia grants a date to someone who appears to be an unemployed lay-about. Perhaps this is the minimal capacity required for self-care: an openness to change for the better in even the unlikeliest of places or with the least promising of potential companions. With Leticia and Olivia, the films provide us with a third condition with regard to self-care: characters who

fall in between the extremes of individuals who are equipped to care for themselves and those who are incapable of self-care.

Embedded in two of the tales of self-care are issues of social identification. As noted, Walt is hindered from the self-care involved in authenticity by his hyper-identification with his father, Bernard. Defining himself uncritically by his father's values and interests keeps Walt from discovering what he truly likes or wishes to become. He cannot begin to see himself clearly until he stops looking at the world through Bernard's eyes. Only then can Walt get in touch with his genuine feelings (for example, for his mother and Sophie) and start to live autonomously, on his own terms. Only then can he truly attend to the requirements of self-care: identifying what he really needs; making the choices that he thinks will meet these needs; and establishing healthy relationships with other individuals.

Hank Grotowski most conspicuously displays self-care in changing his life precisely in pursuit of such intimate, satisfying relationships. Where *The Squid and the Whale* depicted the ways in which (hyper-)identification of a child with a parent is an impediment to self-care, *Monster's Ball* inverts the process, investigating how (posthumous) identification of a parent with a child facilitates it. Sonny's dramatic suicide, as if performed to punish Hank, awakens Hank to his need for caring relationships—to replace the relationships that he has, which are founded on authority. Hank is able to make decisions that at last aim at genuinely caring for himself when he identifies with his suicidal son's yearning for emotional fulfillment. Hank severs his long-standing ties with the prison, distances himself from his hate-filled father, and embarks on a new career and an unlikely romantic involvement. Taken as a pair, *The Squid and the Whale* and *Monster's Ball* offer contrasting sides of social identification. Not only do we see parent–child identification going in both directions, but we witness identification that promotes self-care alongside identification that strangles it.

Autonomy

Among the varied aims of self-care is the promotion of one's autonomy. We see how caring for themselves entails that Tony and Walt, for example, deflect parental authority in order to be independent in thought and action. The social dimension of autonomy is here cast negatively, with parents as social obstacles to the autonomous functioning of their children. How each young man thinks of himself is especially pivotal to whether he will be able to make autonomous choices for himself. *Saturday Night Fever* and *The Squid and the Whale* emphasize autonomy in coming-of-age stories. The teenagers are in different circumstances, but both are struggling with independence during critical years of self-discovery and self-definition. Our films also present social aspects of autonomy in the lives of adult characters, sometimes to contrasting effect.

In *Monster's Ball*, Leticia lacks autonomy chiefly because she is deprived of the social relationships needed to empower us to think and act for ourselves. She has no family, friends, or church parishioners with whom to assess her options and from whom to receive a helping

hand in caring for herself or her son. Leticia's isolation limits her choices and restricts her deliberative reach. Although Hank also appears to lack the support of family or friends, his autonomy is nonetheless informed by social relations. Hank is, after all, a prison guard who is in charge of his team, receiving esteem from his authority over colleagues as well as prisoners. Hank is also head of the family household, which includes his father and son. His strong, socially buttressed self-concept certainly encourages Hank's autonomy in thinking, decision-making, and action.

Unlike Leticia, Olivia has good, strong relationships to see her through difficult periods in her life. *Friends with Money* explores the relational aspects of autonomy within the framework of friendship. It also illustrates how equality in autonomy is vital to true friendship. Inequality in autonomy between friends can keep them from offering the help or criticism that is needed. The friend who is more autonomous, due to wealth or healthy marriage for example, is hampered by fear of being overbearing or making the less autonomous friend too dependent. The less autonomous individual is wary lest she be viewed as a charity case, pitied rather than loved. Friends can help us function more autonomously by providing advice and criticism, aid and encouragement—as Aaron does. Nevertheless, unless approximate equality in autonomy is present to begin with, friendships are constrained, often in ways too subtle or sensitive to be directly broached.

The book concludes its investigation of autonomy at the level of the nation-state. Gandhi's mission is not only to secure India's independence from Britain, but to further the freedom of all of its inhabitants: Untouchables and women, Hindus and Muslims. The state is the political context or locus for the autonomy of its members who are socially defined by gender, religion, and socio-economic class. Only by changing the political structure of India can Gandhi help its inhabitants become free. A central feature of that political structure is the self-governance that requires freedom from Britain. Yet Gandhi is insightful enough to see that the autonomy of an independent nation-state is strengthened by friends, just as it is for individuals. The prospect of a future in which an independent India functions as autonomously as possible on the world stage includes the friendship of Britain, the very country that colonized, exploited, and oppressed her. Therefore the social nature of the autonomy of India is (at least) twofold. It is constituted by relationships among her people, since India is a state. And the autonomy of India as a particular state is fostered by alliances with other states, such as Britain.

Narrative

Perhaps it is only fitting that a book devoted to the interplay between philosophy and film close its conclusion with a review of the theme of narrative. It is fitting because film is a narrative art and the philosophical orientation at work is the ethics of care, in which narrative is an essential element. Recall that the care ethics downplays abstract, universal principles, such as The General Happiness Principle or The Categorical Imperative,

in favor of analysis of individuals in their concrete relationships and circumstances. These circumstances include a historical past and various potential futures. Casting the temporal arc of the person or relationship in a narrative form has seemed both natural and wise to philosophers in the care tradition. Narrative weaves together incident and character in an intelligible fabric, giving salience to moral issues and their meaning under the aegis of care.

The narratives provided in the films considered above enrich our understanding of the care ethics by giving it particular characters and contexts with which to work. Not just any parents and children, but these parents and children with their histories, flaws, and strengths. Not just any people struggling with autonomy or self-care, but Tony and Walt, Hank and Gandhi. By examining these very particular and detailed stories from the perspective of care, we do arrive, perhaps ironically, at mid-level generalizations. For example, we recognize a cluster of variables that are operating when help or criticism is needed in a friendship: the history of the relationship; the relative equality in the relationship; the pitfalls of helping too much. So, too, do we have a firmer grip on the social conditions that influence autonomy, for better and worse. We see how self-esteem and friendship can promote autonomy, even as over-identification and lack of friendship limit it. We also appreciate the role played by community in personal growth and flourishing. Few of us develop our minds and talents outside the social interactions of team and school, workplace or town. Everyone requires interpersonal relationships to cultivate and then display the moral virtues. How can we be generous or loyal, for instance, unless we have other individuals with whom to share our bounty or toward whom to keep the faith?

Yet for all their attention to narrative, care ethicists have little noted the role of narrative *within* the narrative: the narratives constructed by individuals who are playing their parts within the overall story. A major strand woven through each of the stories in our films is the importance of narrative-creation to characters within the stories. The most obvious examples involve individuals who must overcome obstacles to imagining a story for themselves in which they will live well. But sometimes, the importance of narrative-invention lies in the failure of characters to create a narrative for themselves; and sometimes it lies in the ability of characters to envision scenarios for people other than themselves. What is paramount is that the ability to fabricate a human story is itself valuable within the horizon of the ethics of care. Perhaps this ability is as vital as the virtues of attentiveness and responsivity, or the relational underpinnings of autonomy.

Among our films, the characters who are able to fashion (or refashion) narratives for themselves include Tony and Hank, and less obviously, Walt and Joan. With these characters, moreover, we see how narrative creation is folded into the theme of self-care. The individuals are able to care for themselves because they can piece together a story that holds some promise of satisfying their most overarching desires. Tony Manero's projections for himself are plainly incomplete. But consider: Tony's narrative of himself is sufficiently developed to enable him to reject his parents' ill-considered view of him as an unambitious punk, a distant second to his brother—the erstwhile priest. Tony also knows

that he does not want to spend his life working in a paint store and that his Saturday Night dancing cannot go on forever. He has enough intelligence and intestinal fortitude to make the move out of the Brooklyn of his parents and school pals, and into the bright lights of Manhattan opportunities. Tony has paid attention to the experience of other people, mulling over their observations and words of advice, and begun to sketch the outlines of a narrative for himself.

Hank Grotowski has had to break with the story of himself that he has been unreflectively creating for most of his life. Beginning by following his father into work as a prison guard, Hank's life is, in his own words, emotionally empty. Jolted by Sonny's violent death, Hank makes the radical decision to re-invent himself: first, as a gas station owner, later as a domestic partner to a black woman. Hank's redefinition of himself seems more demanding than Tony's burgeoning biography because it requires a rupture with an identity that in many ways had rewarded him. Yet For Hank to continue living as he had is actually more risky than setting out in a whole new life. The prospect of not feeling anything, because without the social relationships that engender emotion, is more daunting than the uncertainty of the narrative with which Hank has begun to redefine himself.

Walt has even less of his future outlined than Tony, but Walt is, after all, younger. We have reason to be optimistic because Walt is smart and he has had the courage to face the truth about his father. Realizing that Bernard is incapable of truly caring has liberated Walt from his idealized image of his father, enabling him at last to start the work of adolescence: fabricating a narrative for himself that reflects his own tastes (in literature and girls) and interests. His mother, Joan, has already launched herself on the trajectory of an independent woman with a literary future. Allowing Walt to reestablish a filial relationship with her, Joan has included in her narrative the role of single parent. She appears more poised for a happy life than Bernard who, in the face of a dead-end in his writing career, seems incapable of doing anything more than trying to relive his earlier success as a youthful literary star.

With the character of Bernard, we come to individuals who cannot or will not create promising narratives for themselves. The group includes Bobby (*Saturday Night Fever*) and Sonny (*Monster's Ball*). Both are hemmed in by circumstances and relationships that leave them gasping for air. Bobby cannot imagine a viable way out of marrying his pregnant girlfriend, and Sonny cannot see himself free of the Grotowski family home and prison work. Neither character has the strength or social support needed to extricate himself from a suffocating situation. What the examples of their cinematic counterparts, Tony and Hank, suggest is that imagination is also required: the capacity to picture oneself doing different things in a different environment.

Although Leticia (*Monster's Ball*) and Olivia (*Friends with Money*) also seem unable to create stories of renewal for themselves, they are able to imagine themselves in a life with a new man. As we saw in discussing their situations in light of self-care, Leticia and Olivia are at least open to fresh narrative possibilities when such possibilities present themselves in the form of suitors. Not quite in the realm of full-blown narrative-formation, yet imbued with

sufficient imagination and courage. Leticia and Olivia represent partial successes insofar as they can project themselves into a scenario initiated, and perhaps well-rehearsed, by men who care for them. Having watched Bobby and Sonny buckle under the weight of circumstances, we may take a more charitable view of these two women. Because of history and personal endowment, it may well be that not everyone is capable of inventing a narrative for herself. Leticia and Olivia may be doing the best they can, given who they are and what they have made of themselves so far.

In our last two films, the protagonists envision narratives for others. Coach Jones projects a flourishing future for Radio in the town of Hanna and Gandhi imagines an India that is free of British hegemony in which all its people are equal. In creating their narratives, moreover, each of these visionaries will have to recast himself in a new role. As if writing a playbook of the care ethics as he goes, Harold Jones incrementally builds a life for Radio in which the young man begins by assisting in team activities, first football and then basketball. The Coach then scripts his ward's participation in the social life of Hanna's school and town. Delighting in the way Radio emerges from his shell, revealing an out-going and kind-hearted nature, Jones reaffirms the deep truth: each of us needs to have a role in a social web to realize his human potential and enjoy life to its fullest.

The more Radio takes part in the interactions of the teams, daily routines of the school, and activities of the town, the more he develops his abilities. These abilities are primarily social and moral. Harold Jones sees to it that the narrative of honorary student and town citizen replaces the implicit story of Radio as disconnected wanderer about the area. But Jones must rewrite his own narrative to accommodate his guardianship of Radio. He must give up his beloved coaching work, mirroring in miniature Hank's resignation from prison work, to make room for the caring attention Radio will need. Even though loss of football is a sacrifice for Jones, he sees Radio's well-being as a higher priority, thereby heeding the wisdom given him years ago by his own football coach.

In our last film, Gandhi creates a narrative that stretches out in time as well as space. Gandhi's scenario for the future of India encompasses all its citizens as well as its relationships with other countries in the world. Gandhi's vision actually comprises three smaller narratives. First, he operates within a transformative narrative according to which India will not only gain freedom from British hegemony, but will redefine Britain as a friendly, international ally. The narrative is based on non-violent resistance as the social force to be wielded by Indians against their British occupiers. Gandhi also creates an emancipatory narrative that would end all hierarchy in India, establishing political equality for all its citizens. The emancipation includes the liberation of the Untouchables from caste oppression and women from gendered subordination.

Lastly, Gandhi invents a redemptive narrative for those who violate the requirements of community and care, particularly during the civil strife between Hindus and Muslims. In contrast to the harsh penal measures depicted in *Monster's Ball*, Gandhi advocates that those who harm others make restitution and in so doing restore themselves to integrity

and community. Uppermost in Gandhi's thinking about responding to personal harm is establishing, or reestablishing, a caring relationship, just as he envisioned a friendship between Britain and postcolonial India.

Unlike most of the members of India's educated elite, Gandhi recasts himself as someone who is one with the masses. He travels third class (an ironic inversion of his first-class expectations at the start of the film) and lives humbly in an ashram where everyone shares equally in the menial labor. In Gandhi's view, no one should have higher status within Indian culture—including privilege conferred by class/caste, gender, or religion. To make good on his conception of the just society, then, Gandhi must live out a narrative in which he himself eschews privilege in his personal life. He also realizes that unless all Indians are united, the transformative narrative based on non-violent resistance cannot be realized. Gandhi's peasant lifestyle, then, makes him more credible to the masses and helps solidify India with his nation-building narrative and its dominant strategy.

I hope to have made good on the promissory note tendered in the Introduction: to show how mass-marketed movies can do more than entertain us by sharpening our philosophical thinking about the moral complexities of life. In particular, that popular films can promote a reconfiguring of the ethics of care. The compelling cinematic stories analyzed in this book prompt us to think more comprehensively about the moral dimensions of the social self, its relationships, and the determining conditions of both. The six films have covered a range of interlocking topics, some more systematically addressed in the ethics of care than others. Discussion of the films has been arranged according to a cinematic conceit, as if following a lengthening horizontal pan that moved back and forth to produce an ever-widening prospect. Thus, we began with the individual, family and friends, and expanded our purview to encompass community and country. We proceeded from Tony Manero of *Saturday Night Fever* to Gandhi, as the ethics of care informed a more populated moral landscape.

Care theory will continue to evolve, refining its insights and developing its substantial conceptual apparatus. And philosophers will also extend the reach of care ethics further into relatively new domains, some of which we have broached here, such as divorce, punishment, and international politics. We should expect that reliance on such narrative arts as film would contextualize and deepen the more theoretical work. Drawing on the rich resource of popular film, in particular, should keep the care perspective vibrant and demonstrate its increasing relevance to contemporary life.

Index